PASSION BY DESIGN

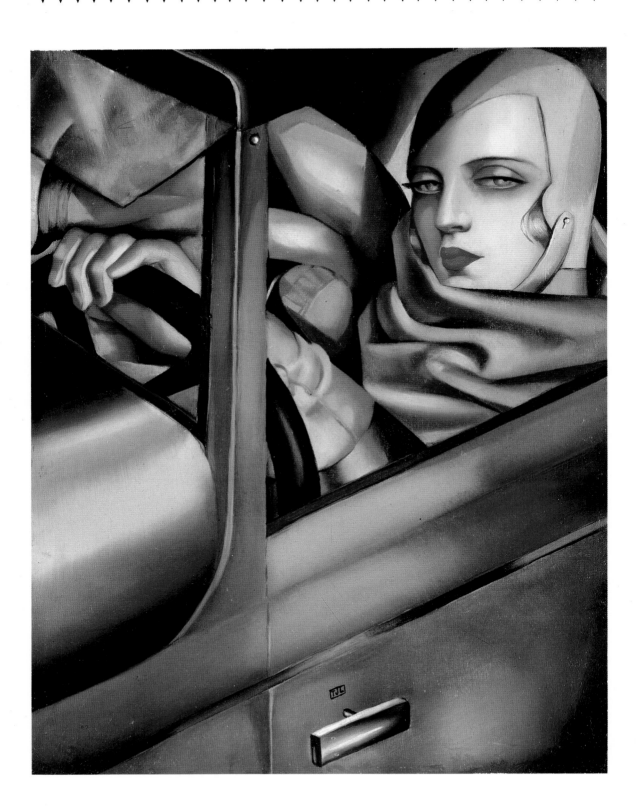

PASSION BY DESIGN

THE ART

AND TIMES

OF TAMARA

DE LEMPICKA

BY BARONESS KIZETTE DE LEMPICKA-FOXHALL
AS TOLD TO CHARLES PHILLIPS

ABBEVILLE PRESS · PUBLISHERS · NEW YORK

Editor: Alan Axelrod
Art director: James Wageman
Designer: Renée Khatami
Production manager: Dana Cole

Copyright © Cross River Press, Ltd., 1987

Library of Congress Cataloging-in-Publication Data

De Lempicka-Foxhall, Kizette, Baroness.
 Passion by design.

 Bibliography: p.
 Includes index.
 1. Lempicka, Tamara de, 1898–1980. 2. Painters—United States—Biography.
I. Phillips, Charles. II. Title
ND237.L545D4 1987 759.13 [B] 87-1858
ISBN 0-89659-760-1

Front cover and opposite title page:
Auto-Portrait (Tamara in the Green Bugatti), 1925. Private collection.

Opposite copyright page:
The artist, 1930s.

Opposite table of contents:
Calla Lilies, 1941. Private collection, California.

Back cover:
Les Jeunes Filles, 1928. Private collection.

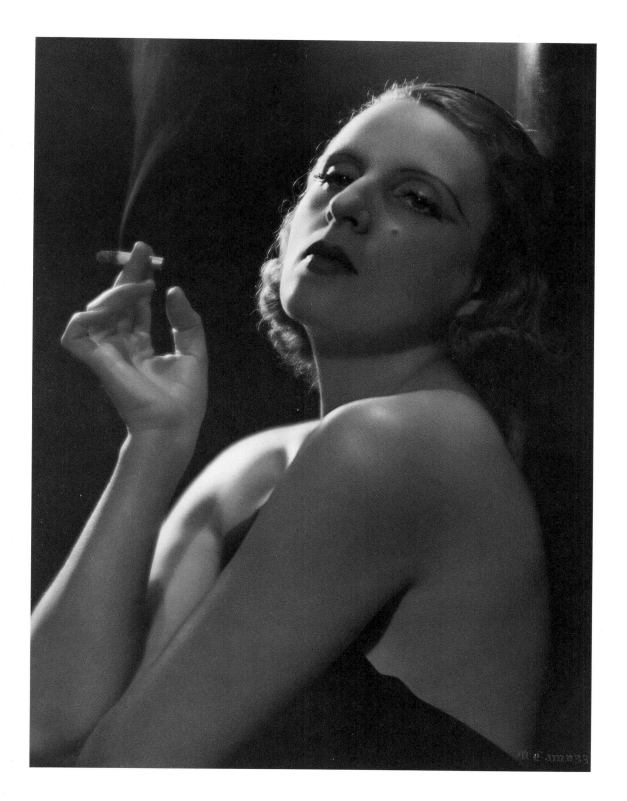

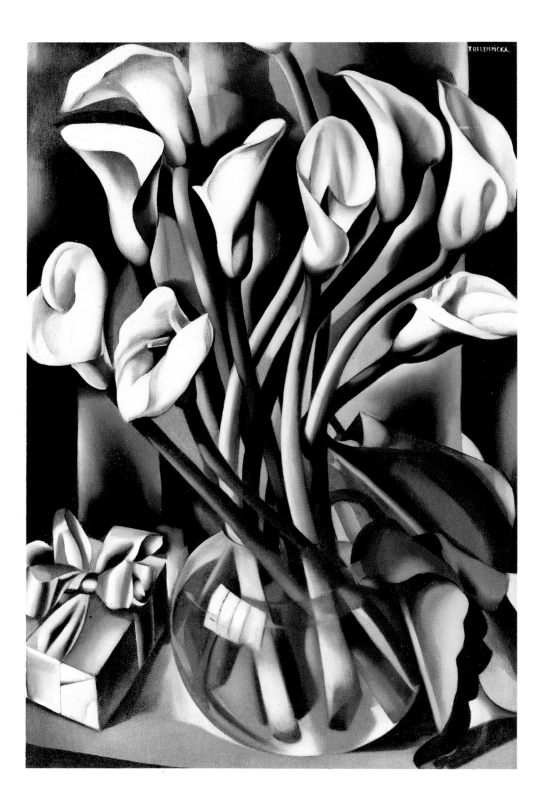

CONTENTS

PREFACE

The Baroness Kizette de Lempicka Foxhall and I thought it wise to say something about how this book was put together—why a story purportedly told by one to the other comes to be written in the third person, and why our account of her mother's life should take the form of narrative biography.

As anyone who knew both Kizette and her mother, Tamara de Lempicka, will tell you (and as the following pages amply confirm), the two of them spent off and on a difficult half-century together. Tamara was an artist and a mother in that order, and her daughter's life—like her own—was ruled by the major dictum of what we call below the artist's *hunger:* "Work before all." Always a commanding presence, Tamara dominated the lives of those close to her, and Kizette was no exception. That she cared for Kizette is not in question; that she treated her harshly is beyond question. The very intensity of the bond between the two tended to make Tamara's mothering tyrannical rather than benign.

The intense bond lasted beyond Tamara's death in 1980. Not despite but because of her stormy relationship with Tamara, Kizette felt immensely empty without her mother. Kizette had spent her first twenty years making way for Tamara the celebrity and famous artist and the last twenty catering to the whims of a proud but publicly ignored grande dame. Most of what Kizette had done in her life, she felt, had been done with reference to this great personality, whose paintings and papers and stories were Kizette's unique inheritance. She was in a very true sense of the word "haunted," dominated now by her mother's ghost just as surely as she once had been by her presence. She became obsessed with telling her mother's story, with laying to rest Tamara's always restless spirit.

Kizette began to gather together Tamara's papers, letters, notes, and written vignettes, and to make notes of her own. Tamara had been an accomplished storyteller, and she told her stories over and over, always the same way—almost word for word—each time. Kizette imagined she could hear Tamara speaking as she wrote down old stories, made chronologies, and put together lists of her mother's paintings, exhibitions, and prizes. Almost automatically Kizette's account took the form of a tale, of a narrative, like something out of a novel or a film.

When, through the auspices of Abbeville Press, I first met Kizette in Houston in the spring of 1986, she was in the throes of her own *hunger*, the hunger to get down the story she had both in hand and in her head. And while the act of putting words on paper might banish the ghost, Kizette's obsession had developed into something more than the need to rid herself of her own past. Tamara de Lempicka was a great painter who had fallen out of fashion and into obscurity, and her daughter wanted to restore her to her proper place in art history. She wanted a book worthy of a de Lempicka, a book Tamara herself would have admired. Above all, she wanted to avoid the type of "true confession" from embittered children that has of late become fashionable.

For these reasons we agreed to tell Tamara's story in the third person, in a narrative that used all the techniques of traditional historical research, including recourse to primary and secondary sources, as well as those of oral history. The story would be the one Kizette had to tell, but I would shape it, fill it out with additional research, and seek out others who knew Tamara well and had their own feelings and prejudices about her. We hoped to produce a book that had not only the immediacy of personal experience, but that also put Tamara de Lempicka in the context of her historical and aesthetic times.

The reader will judge how well we succeeded, but I must say the Baroness Kizette de Lempicka Foxhall remained faithful to this conception of the work throughout. She ever bowed to fact when it competed with memory and —with an eye artistically as cold as Tamara's—allowed the voice of the narrative rather than her own to rule.

And because she did, we have several to acknowledge and to thank. The majority of the biographical information about Tamara comes from Kizette—from a series of extensive interviews conducted with her in March 1986, supplemented by Kizette's written outlines, chronologies, and summaries of events, as well as her mother's personal papers, letters, and autobiographical writings, which Kizette had collected and meticulously arranged.

In addition I interviewed a number of others in Houston, Los Angeles, New York, Paris, and Cuernavaca, Mexico, who knew Tamara. Principal among these was Victor Manuel Contreras, Tamara's close companion in her last years, who graciously extended his hospitality in May 1986 by allowing me not only to grill him to exhaustion about the artist but also by inviting me to stay in Tres Bambus, Tamara's impressive home in Cuernavaca. There, too, I talked to Tamara's young friends, Felipe and Gabriele Ortiz-Monasterio, who did so much to illuminate the artist's final years. In March 1986, I interviewed Houston cultural affairs reporter Anne Holmes and Ms. Jane Owen, both of whom helped immensely to fill out the picture of Tamara's relations with Kizette and her family. In Hollywood, in May of 1986, Franzi Hohenlohe— who had known Tamara as long as anyone other than Kizette—recaptured for me something of the Europe in which Tamara had first made her mark, and George Schoenbrun discussed Tamara's Hollywood years. In New York, in June 1986, actor Toni Selwart helped to provide a picture of Tamara and her second husband's social circle, and Wade and Gene Barnes talked about Tamara's many trips back to New York after she moved to Houston. In addition, Wade Barnes provided me with a

written reminiscence that was quite useful as a "take" on Tamara's personality and how she struck others. In July 1986, screenwriter Bert Phillips and art collector Happy Hayes took time from their busy schedule in Paris to interview for me Alain Blondel, who owned the gallery that first brought Tamara back into the limelight in the early 1970s.

For additional—mostly written—sources, the reader may refer to the brief Note on Sources at the end of our text.

A more intangible, but no less crucial, aid in writing this book came from Kyle Young and L. Edward Purcell, who along with Bert Phillips and Happy Hayes took time to read and criticize the manuscript in draft, ever improving it with their insight and suggestions. James Summerville provided me with access to the Vanderbilt University Library, for which I am grateful. I especially wish to thank Patricia Hogan for her careful readings, her keen criticisms, and her moral support throughout.

—Charles Phillips, Nashville

OUT OF THE PAST
(PARIS, 1969-1972)

The way she told the story, it went something like this: She was back in Paris in 1969 for the summer, working in the studio she loved, at 7 rue Méchain, on one of her palette-knife paintings, working in a style completely different from the one she had used in the Art Deco portraits that made her famous in the Paris of the twenties and thirties. Toward evening, the doorbell rang. Outside stood a man, looking very young and very poor.

"What is it?" she asked.

"Madame de Lempicka, *Tamara* de Lempicka?"

"Yes. What is it, please?"

"Madame de Lempicka . . . may I come in?"

"Yes, yes, come in," she said, opening the door. They stood there for a moment, he nervously and she impatiently. Anxious to get back to her work, she demanded: "So, what is your business?"

Awkward and diffident, he told her that his name was Alain Blondel, that he and his friends owned a gallery in the rue Such-and-such, and that he would like to buy some of her paintings. At some point in the explanatory rush of words, Blondel had pulled a list from his pocket, and now he quickly began to read from it. The paintings were all twenty or thirty years old, paintings she had done in her youth, when she was famous, before the divorce from Lempicki or the marriage to Baron Kuffner, before the war, Hollywood, New York, the Baron's death, the decline of her eyesight. . . .

"Wait a minute," she stammered. "These are paintings I did years ago, decades ago. Before you were born. How do you know about these paintings, that they even exist? I don't even have them here. Some have been sold. Some . . . some I think I have up in the attic."

Blondel could hardly restrain himself. "Oh, may I go up to the attic? I would like to take a look—"

She gave him the key and directions to the seventh floor, which once had been her servants' quarters, but which she now used as storage. It was filled with old trunks, forgotten paintings—junk. She made small talk, told him he was lucky to find

13

her, that she lived in the United States and came to Paris for just a month or two a year, staying at the Ritz and visiting her studio only to paint. At length, he took the elevator up, and she went back to her work, dismissing him from her thoughts.

Hours later he came back down. It was dark now, late, and she was surprised to see him standing there with several paintings. She was still distant, distracted, doggedly engaged in her work.

"How much do you want for these?" he asked.

"Well, I don't know." They were paintings she had not thought about in years, portraits she failed for one reason or another to finish or at least to sell at the time, and a newly painted portrait has a limited market, even if you count the family or lovers of the one you paint. She did not stop to consider how much portraits can become something else—emblems of their time, examples of the style of the period—after thirty or forty years have gone by. "What do you want to give me?"

He named a sum (she would never have told you how much), and she thought for a moment, nodded, and said: "All right. Just put it there." Then, with a dismissive, theatrical wave of her big, expressive hand: "And goodbye."

A year later she was in Paris again on her annual visit, painting in her studio, when the doorbell rang and Blondel asked to come in, visit the attic, and purchase a few more paintings. This time, though, she asked him what he wanted with these old paintings. Just what did he plan to do with them?

Alain Blondel was one of four young Parisians who, dreaming of establishing themselves in the art world, had opened the Galerie du Luxembourg and hoped to launch it with a major retrospective of the works of Polish-born Tamara de Lempicka. In 1966 the Musée des Arts Décoratifs had mounted a commemorative exhibition called "Les Années '25," which was hugely successful and created the first serious interest in Art Deco, a classical, symmetrical, rectilinear style that developed and thrived between 1910 and 1940, reaching its high point in the decade between 1925 and 1935.

Quintessentially French, Deco was the art of a Paris exotic, sexy and glamorous; and, as the research of Blondel, his wife Françoise, her sister Michele Roccaglia, and Michele's boyfriend Yves Plantin revealed, no artist exemplified the style better than Tamara de Lempicka. Wherever they read, her name kept cropping up, this mysterious painter of the American upper crust, of whores and deposed kings, of sensual little girls in white and pink—hard-as-nails portraits bearing disdainful looks and painted in violent colors.

She had been a great beauty in a Garbo-like way, who escaped from the Bolsheviks to make a fortune from her work and live the high life in Paris, just one step ahead of scandal. She divorced her handsome first husband when his jealousy threatened her career and after she was famous married a member of the Hungarian landed gentry. She was almost as famous for her clothes, her parties, and her social life as she was for her painting. She fled Europe for Hollywood just before the Nazis arrived to close the show.

Blondel says that he and his three young compatriots were sitting around one afternoon, wondering whatever became of this de Lempicka, whether she was alive

and where she might be living today. Their speculation became something more than idle when he picked up the telephone book and found her listed in rue Méchain. The very apartment itself had been famous, designed by the great Mallet-Stevens in 1929, with lighting by Perzel and decorated in hand-loomed fabrics by Genie Lardeur, sporting a sculpture by the brothers Martel of a chrome lion called "Lion de Belfast" that surmounted a trickling fountain. Blondel remembers telephoning her first to set up the meeting and taking his partner Plantin with him. But otherwise his story is not all that different from the dramatic version Tamara liked to recount.

The apartment was not the stark, sleek Art Deco masterpiece in pale gray they expected. Tamara had it redone in a rococo style in the 1960s and decorated it with baroque objects from her late husband's estate in Hungary. It was softer, like the pastel tones of her new palette style, with its suggestions of lines and smudged contours, which she sold, she said, only to a small coterie of her friends and which disappointed the two young entrepreneurs.

Still, they thought of her as a great painter, with a prominent place in the art of the twentieth century as the only important portraitist of the Art Deco period, and they were awed by the presence she commanded even at seventy. She spoke loudly and moved with a dramatic flair, costumed for the part in huge hats and flowing dresses; she had piercing blue eyes and a face full of character, for all its wrinkles and hawkishness.

So very *Russian*, they thought.

They found they had some persuading to do. She talked with them about her work with the palette knife, but she seemed to them very unsure of the painting she had done in the twenties and thirties. They talked for an hour or so, until she was persuaded to show them one of her earlier works, some forty-five of which Blondel says she had "hidden" away in her studio. She showed them first one, then another, then—in response to the enthusiasm these generated—several at once. "It was a great moment," Blondel recalls. "You can imagine it."

Tamara had not exhibited her work in nearly a decade. She claimed that "because of divergent tendencies in art" she had refused all offers, but if the truth be told, she simply *had* no offers. She had sold disappointingly few of her palette-knife paintings at her last exhibition in New York, in 1962. That same year her husband—Baron Raoul Kuffner—died, and she broke down her fabulous apartment on East 57th Street, selling both the apartment and the antiques she had used to decorate it, including many of those she and the Baron had managed to salvage from his castle in Hungary, before what she called "the European debacle." She moved to Houston to be near her only daughter, Kizette, where she struggled with her painting and suffered in the silence of a wounded pride the world's neglect of her art.

When Blondel and Plantin suggested they hold a retrospective of her work at the Galerie du Luxembourg, it was not their boyish charm nor their clever entre-preneurship that persuaded her to accept, but her own desire to be once again in the limelight, once again at the center of things. Of course, she would never admit it to them, but she threw herself into the planning of the exhibition, helping to

choose the colors, inviting her old friends, even publicizing the show by agreeing to speak with an art critic on the radio—and afterward demanding that Blondel and company have nothing whatsoever to do with that critic ever again.

She found their enthusiasm charming, but she clearly let them know their real ignorance of the period. They, for their part, found her fascinating—young people always had and always would, to the very day she died—fascinating, if difficult. They were tactful. She was gracious. She was taking a chance on them, since this was their very first exhibition; they on her, because of the relative obscurity into which her work had fallen.

They all became friends, for a time.

And there is no doubt that, despite what she said later, Tamara knew exactly what she was doing. Prince Franzi Hohenlohe, a long-time friend of Kizette's who had not seen Tamara in nearly five years, ran into her at the Ritz while she was in Paris working on the exhibition. She looked radiant, he thought, and he asked her what she was up to.

"Oh," she said casually, "didn't you know? I'm in the process of being rediscovered."

And rediscovered she was. The Art Deco revival that had gotten under way with the 1966 exhibition was spurred on by the critical success of the Luxembourg retrospective, which opened in 1972, three years after her first meeting with the young people. The exhibition received a lot of press, and rather to the surprise of some of Tamara's old friends who attended the opening, her paintings sold, if not at the rates well-established contemporary artists command, at least at those of an exciting new beginner. More importantly, however, it was at the Luxembourg opening that Tamara first came to the attention of Franco Maria Ricci.

Ricci, owner and editor of the elegant, haughty art magazine called *FMR,* completed the "rediscovery" the four enterprising young art dealers had begun. Ricci was attracted to the hint of vice in Tamara's neoclassical style, a style he associated usually with virtue, and also to the subjects of her paintings—the wealthy and famous of the 1920s and 1930s. He tracked her down in Monte Carlo and persuaded her to let him do a limited edition art book, beautifully printed and bound. He did not tell her that he also planned to print in the book, along with an introduction of his own and an excellent critical essay by Giancarlo Marmori, the frank—raunchy—diary of Aelis Mazoyer, Gabriele d'Annunzio's mistress and housekeeper.

D'Annunzio, Italian poet, novelist, playwright, and sometime Fascist, was idolized in his day to a degree that now seems unimaginable as well as inexplicable. The diary covers a visit Tamara made in 1926 to d'Annunzio's infamous pleasure palace, Il Vittoriale, ostensibly to paint the poet's portrait. It is a curious account for an art book, a tale of low romance and monumental lechery that does the aged and decrepit d'Annunzio no credit as he struggles manfully to seduce the "beautiful Pole" and fails.

Tamara was furious. She objected to having her name linked with the *vulgarités* of "some housekeeper." She objected to the insult offered a great Italian poet (although she herself had once called him "an old dwarf in uniform"). She objected

to a book supposedly about her art being filled out by backstairs gossip. But she objected most to the suggestion that Ricci and the Galerie du Luxembourg had somehow saved her from obscurity, had in fact "rediscovered" her.

She had a point. All her life Tamara de Lempicka remained a working artist, even when the public and many critics apparently abandoned her. She was uncomfortable with Existentialism, which dominated postwar France, and she hated the painting "á la mode" of Andy Warhol, Bernard Buffet, and Jean Dubuffet. She avoided the "cult of ugliness," which seemed to her to have taken over; and that meant she worked alone, without recognition and without the support of fellow artists. She stopped exhibiting. She did not stop painting. It was one thing for her to announce to a friend of her daughter's, with a certain irony, that she was being rediscovered, but it was quite another to see art critics and galleries take credit for what she experienced as a single career, a whole life, with its stages, developments, and changes.

"This is not my work, my art," she would fume at the mention of Ricci's book. "All that people will remember or know about me is this servant's lies." Regardless of her objections, the book became popular among the European cognoscenti and helped to heighten interest in her painting, the prices of which began to escalate in the late 1970s. And, shortly after her death in 1980, it inspired a play called *Tamara,* written by two young Canadians, which has been playing to sold-out Hollywood audiences since it opened in 1984.

Once again, as in her heyday, Tamara is in the limelight. And, once again, also as in the early days, her fame as an artist carries with it the whiff of scandal. She lacked the temperament for anything else, and she lived an extraordinary life and painted extraordinary paintings for exactly that reason.

She simply was not a woman to go for long unnoticed.

UNE PETITE GROSSE

(WARSAW, 1898-1916)

She was born Tamara Gorska at the turn of the century in Warsaw, the capital of a Poland that had been for a hundred years under Tsarist domination. That same year, 1898, a group of Russian emigrés in Switzerland, led by George Plekhanov, founded the Union of Russian Socialist Democrats Abroad, which in 1900 would attract a young exile named Vladimir Ilyich Ulianov (a.k.a. "Lenin") and out of which would grow the Bolshevik Party, destined to destroy the life of privilege that the affluent, professional Gorskis offered their newborn.

After crushing the Polish nationalist uprisings of 1830 and 1863, Tsarist Russia proscribed the use of the Polish language in the administration and the schools, and Poles of means began to send their sons to be educated at Oxford or Cambridge, their daughters to finishing school in France or Switzerland. Tamara's mother, Malvina Decler, was one of four such daughters, including Eugenia, Franca, and Stephanie. Like others of their class, they traveled to St. Petersburg for the "season," vacationed in the watering holes of Europe—at Carlsbad or Marienbad—and gambled in Monte Carlo.

Malvina met her future husband, Boris Gorski, a lawyer traveling for a French firm, at such a spa. He fathered three children, a boy, Stanczyk, Tamara, and the youngest girl, Adrienne. In later years, Tamara seldom talked about her father, avoiding even the mention of his name. Perhaps her silence was merely a continuation of the careless disregard women of her milieu showed toward their men, treating them mostly as "background," as simply a means to a certain sort of life in which children were charged to others and cuckoldry was considered something of a feminine sport. More likely it had to do with the fact that her mother married a second time, and Tamara felt left out, ignored. She became extremely jealous. It's not clear whether the first marriage ended in divorce, which in Catholic Poland at the time would have been sufficient cause for circumspection and shame, or whether Tamara's father died when she was very young; whatever the source of the taboo against his name and memory, she carried it with her into adulthood.

She was from the beginning willful and domineering. While ragged Russian workers and starving serfs rose up en masse to plead with their "Little Father,"

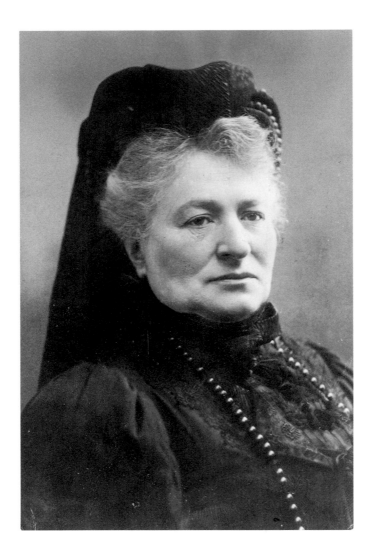

Madame Clementine Decler, the artist's grandmother.

Nicholas II, for some relief, only to have their "Revolution" of 1905 crushed under the hooves of Cossack horses, young Miss Gorska led the children—her brother, sister, cousins, and friends—on raids of her mother's off-limits dinner delicacies: petits fours, ice-cooled caviar, hams in aspic, delicious molds coated in whipped cream. She had invented a long, pitchforklike instrument to reach from the kitchen doorway, which she was forbidden to breach, to the untouchable goods that she then distributed to her loyal, adoring subjects.

She directed her siblings in family theatricals, casting herself—of course—in the starring roles. She spent hours hiding under the sofa in her grandmother Madame Clementine Decler's huge living room, dreaming of herself onstage in dramatic black velvet and strings of pearls as she listened to the matriarch of the family play Debussy

*Malvina Gorska, the
artist's mother.*

The sisters Decler: Malvina (the artist's mother), Eugenia, Stephanie ("Aunt Stefa"), Franca.

and her beloved Chopin. She demanded from her mother a piano for the bedroom she shared with Adrienne and practiced furiously for days until it occurred to her she would always only be repeating the works of others, whereupon she closed the lid on the keyboard once and for all. At eight, suffering some insult to her pride, she decided to make paper flowers to sell on the street and pay for her own room and board, but her German governess—properly appalled—put a quick end to the nonsense. The summer she turned twelve her mother had her portrait painted at their country house outside Warsaw.

"I was a little fatty, *une petite grosse,*" she told a Houston writer nearly three-quarters of a century later. "My mother decided to have my portrait done by a famous woman who worked in pastels. I had to sit still for hours at a time . . . more . . . it was a torture. Later I would torture others who sit for me. When she finished, I did not like the result; it was not . . . precise. The lines, they were not *fournies,* not clean. It was not *like* me. I decided I could do better. I did not know the technique. I had never painted, but this was unimportant. My sister was two years younger. I obtained the paint. I forced her to sit. I painted and painted until at last I had a result. It was *imparfait* but more like my sister than the famous artist's was like me."

Less a prodigy than spoiled and vain, she was encouraged by her doting grandmother in her belief that she was extraordinary. Like many temperamental, talented children, she found school boring, and she spent her time there gazing out the window, imagining the world she would one day step into, a world in which she expected to

find an "adulating throng" at her feet. It was only the *reason* for the adulation that remained a little vague for her.

On a visit to a sick school chum, a thirteen-year-old Tamara overheard a doctor advising the girl's parents to take her away from the harsh Warsaw winter if they wanted her cough to improve. Go to a warmer climate, he told them. Maybe the south of France. Immediately Tamara's dramatic instincts were engaged, and she returned home with a vicious cough of her own and several not-so-subtle hints that Grandmother ought to take her to Monte Carlo this year. Madame Clementine was a terrific gambler and loved the casino almost as much as she loved her granddaughter. No mean thespian herself, Madame feigned concern for Tamara's health and insisted that she accompany her not just to Monte Carlo, but on her whole Italian tour.

23

The artist, two years old, with her brother Stanczyk. Riga, 1900.

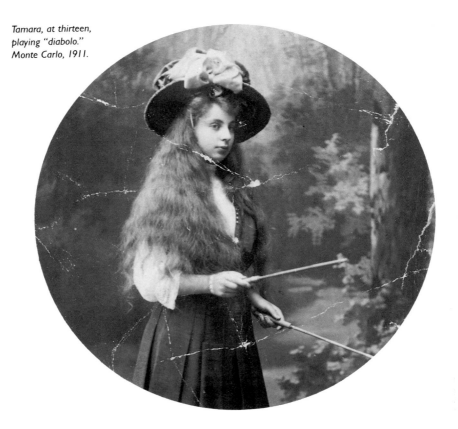

Tamara, at thirteen, playing "diabolo." Monte Carlo, 1911.

24

Madame took her protégé through every museum she could find in Florence, in Rome, in Venice, always talking, instructing, pointing out the Renaissance masters, explaining the modeling of a cheek, the foreshortening of a hand, composition, chiaroscuro, impasto. It was a trip the young girl would never forget, this first taste of the world's great art. Again and again in her prime she should return to Italy, to those same museums, perhaps those same paintings, looking for inspiration, for help, for a spark.

By the time they hit Monte Carlo, Tamara was reveling in more than the balmy breezes of the mild winter of 1911. She was full not only of herself, but of art and beauty, and while Madame Clementine Decler lost at roulette in the casino, which did not allow children, the dreamy-eyed teenager passed the time playing diabolo and introducing herself to a young Frenchman. He claimed to be a painter and taught her how to use watercolors to create the sea or the sky or mimosa sprigs or bunches of violets on the flat surfaces of the stones they gathered by the shore.

She came home cured of her cough and wearing a bright red coat and a huge, shiny black straw hat totally inappropriate for a girl her age. But after all, Grandmother had given her carte blanche to purchase clothes while they were abroad.

That spring, in May of 1912, the Bolsheviks published the first issue of *Pravda*.

In July of 1914 the working class of St. Petersburg went on strike. Russia was soon to lead the rest of Europe headlong into war by feverishly and unnecessarily mobilizing along the Austro-Hungarian border in the wake of Archduke Francis Ferdinand's assassination, but first Tsar Nicholas II, perhaps the stupidest autocrat in history, kept himself occupied by jailing hundreds of socialists in response to the strike. The people reacted in turn by throwing up barricades during the state visit of President Poincaré of France, holding tumultuous demonstrations and clashing repeatedly with the police.

A few days later, everything was quiet again. On August 1, war was declared between Russia and Germany. When Nicholas II and his family appeared that day on the steps of the Winter Palace, ten thousand people serenaded their Tsar with the national anthem, dropping to their patriotic knees. Overnight the city was rechristened Petrograd, because St. Petersburg sounded too German.

Tamara Gorska was in Petrograd at this time as a result of a little war of her own. Her mother, her fun-loving mother, who had seasoned every year in St. Petersburg with Tamara since she returned with her grandmother from Monte Carlo, who had loved the White Nights, when the sun never set and it was always daylight and she danced all night, her mother had decided to marry again. It was something the young prima donna could not tolerate, and instead of returning home from her school in Lausanne, Switzerland, Tamara had accepted her Aunt Stephanie's invitation to come to Petrograd for a while. Aunt Stefa had married a wonderful man, a banker, with financial houses in France, Switzerland, and Russia, as well as Poland; and they had two sons (one with a French, one with an English governess) who were wonderful, and they treated her so well, let her do whatever she wanted.

Tamara's aunt and uncle lived in luxury, their house decorated by the Parisian firm of Maison Jansen. All her life Tamara would remember the huge packages that arrived from France with the single word *Jansen* stamped all over them and the special joy she felt as she tore into the mountains of tissue and pulled out beautiful garments—gossamer blouses and hand-embroidered dresses with hundreds of small buttons and ribbons and bows. Sometimes Aunt Stefa would let her niece open secret, shallow drawers and choose Stefa's jewelry for the night. There was one drawer for diamonds, one for rubies, one for emeralds. Suddenly, Tamara knew precisely how she wanted to live.

While the rest of the world had been busy preparing for and then engaging in war, Tamara had been falling in love—in her own peculiar way, of course. She had first seen him more than a year before at the opera, which she was attending with her aunt and uncle's boys and their governess. He was with two gorgeous women, and his name was Lempicki, Tadeusz Lempicki. Dark, tall, incredibly handsome, he was a lawyer from a good land-owning family, something of a gadabout, and quite the ladies' man. He was the best thing in all of Petrograd, and she—a willful fifteen-year-old girl—decided she simply must *have* him. During the intermission they all traipsed out to the mezzanine, and there he was with his two women, and she could not contain herself. She walked over to him and made the most elaborate, theatrical curtsy she could muster. The bon vivant laughed, laughed at the child in her—still, he noticed.

Later that year her uncle and aunt threw a costume ball to which they invited Lempicki. Still something of *une petite grosse*, Tamara knew she could never compete with the elegant, bejeweled, sophisticated Petrograd beauties flocking around him, but she had to make him notice her again, to talk to her, to spend time with her, no matter how she did it.

She did it with humor and dramatic flair. Dressed as a Polish peasant, a "goose girl," she entered the ballroom carrying a basket over her arm and leading a live— and loud—goose on a string. She created quite a stir. Under the crystal chandeliers and amid the clink of champagne glasses, the goose honked and flapped as it slipped and slid its way behind her on the polished ballroom floor. People stopped talking, flirting, and dancing. They laughed and applauded. She was the center of attention, and she seized the moment, walked up to him, and reminded him she had seen him once before, at the opera.

"But I didn't make much of an impression on you then," she pouted triumphantly.

The family objected to Lempicki, her uncle the banker especially. First of all, he was older than she was, though probably not by all that much. Secondly, he didn't have a penny of his own, and despite the fact that he called himself a lawyer, he didn't have a job. He was a man about town, her uncle insisted. All the women raved about him, and he could have any mistress he wanted, and she did not have a dowry, so she might as well forget it.

But that was before Germany, irritated with Russia for invading from behind when it was trying to deliver a knock-out blow in the west to France and England, turned round and took away Poland. In August of 1915, the despised "Hun" set up camp in Warsaw, and there was no going home again for Tamara, even if she had wanted. When her uncle sighed and said, "Well, Tamara, what do you want to make of your life?" she told him that, if she ever married, the only one she would marry, the only one she wanted, was this Tadeusz Lempicki.

As Tamara once told Franzi Hohenlohe, her uncle knew Lempicki and called on him. "Listen," he said, "I will put my cards on the table. You are a sophisticated man, but you don't have much fortune. I have a niece, Polish, whom I would like to marry. If you will accept to marry her, I will give her a dowry. Anyway, you know her already."

The year they were married the original Russian army had been "turned over" three times, its losses estimated at nearly eight million men. Morale was so bad that officers refused to lead their troops into battle for fear of being shot in the back. Desertions assumed overwhelming proportions, and whole regiments, often on orders from their officers, surrendered en masse. The man responsible for the disaster, Nicholas II, announced he was leaving his government in the hands of his half-crazed wife, Empress Alexandra, to go to the front and direct the fighting himself. Alexandra turned the government over to the "debauched monk" Rasputin, who wrecked what little chance the Tsarist regime had of surviving, much less winning, the war before he was assassinated by Grand Duke Dmitry, Nicholas II's nephew, and Prince Yusupov, the husband of the Tsar's niece.

The year they were married more than fifteen million Russians were under arms, industrial mobilization had thrown the economy completely out of whack, the peasants could not export their produce and refused to sell food on the open market, the ruble was nearly worthless and there was precious little room for barter, the railway system had collapsed and what few supplies existed could get through neither to the front nor to the towns, and the industrial cities—including Petrograd—were threatened by famine.

Tamara Gorska and Tadeusz Lempicki were married in the Knights of Malta Chapel in Petrograd in 1916, the year the great Russian Empire heaved one final huge sigh and vanished.

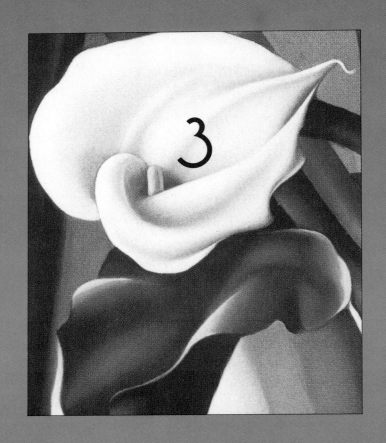

3

TO THE FINLAND STATION
(PETROGRAD, 1917-1918)

At first no one noticed it. Not the Tsar at the front. Not the liberal and aristocratic Cadets, who had been agitating for reform. Not the revolutionary leaders exiled in Siberia. Certainly not the two young newlyweds. But power lay in the frozen streets of Petrograd that winter, just waiting for someone to pick it up.

During the so-called February Revolution, when workers spontaneously poured into the boulevards from every factory in Petrograd and Moscow, only Lenin—cooling his heels in Switzerland—seemed to know what was going on and said so, doing everything in his power to book passage for the Finland station.

The winter had been a bad one, one of the coldest on record in Russia. December and January had seen temperatures in Moscow and Petrograd drop to −40 degrees centigrade. There was no bread. There was no coal. The price of food shot up 40 to 60 percent. And the rich of Petrograd continued to flaunt their wealth, living in a splendor that shocked visitors to the city. Never before did one see so many automobiles in the streets, so many diamonds glittering around the necks of fashionable women. The theaters were crammed. Fancy restaurants became the scene of what one French woman described as "incessant orgies." A bottle of champagne cost one hundred rubles, around fifty dollars, and high society amused itself by splashing it out in buckets.

The de Lempickis, too, attended parties and drank champagne. The wedding, oh . . . the wedding had been fabulous. Tamara's train stretched the entire length of the aisle from church door to altar, a dramatic effect she dreamed up herself. She once described the elaborate reception to Mexican banker Felipe Ortiz-Monasterio and his fiancée Gabriele ("Gaby") shortly before their marriage, confessing to the couple that she had met that night a stunning young Siamese diplomat (or prince—the story varied) and was so taken by him that, when they saw each other again after her honeymoon, she fell into his bed. Already she had shed any pretense to girlish innocence and had adopted the mantle of a woman of her class and time. To use Ortiz-Monasterio's words, Lempicki suddenly discovered he had a "hot little potato"

on his hands. In the tradition of White Russia's well-to-do, it was his job to handle her when he could and to turn a blind eye when he couldn't.

That year it was the only job he had—1917 not being especially propitious for high-born young lawyers just starting out in Russia. On February 22, 1917, there were mass demonstrations in Petrograd. Two days later, the leaderless workers of the city went out on a general strike, fighting bloody battles in the streets with the Tsar's police. By February 27, the army had come over to the side of the proletariat, and the powerful Petrograd Soviet of Workers' and Soldiers' Deputies was formed. A day later Moscow created its own soviet. The jig was up, and Nicholas II—quick-witted as ever—realized it. He officially abdicated on March 3.

Living off Tamara's dowry, the young couple took a flat in the city. Politics, not job hunting, was the order of the day, and even a reformed playboy turned society husband like Lempicki found it hard to avoid getting involved in a town filled day and night with throngs of citizens of every class talking about nothing but who was in charge, who should be in charge, and who ultimately would be in charge. Given the circumstances, he could hardly help entering the lists on the side of the social reactionaries. By birth, both he and Tamara were bound to wind up on the wrong side of Russia's class war.

The Provisional Government under Prince Livov collapsed in April. The same month, Lenin finally made it to Petrograd and began to lead the Bolsheviks steadily toward a takeover with his call for all power to the soviets and social revolution. Throughout the spring and summer and on into autumn, no fewer than four more governments would form and fall, at the rate of nearly one a month. The hungry and toiling masses moved further and further left, further left than Lenin, who warned them against anarchy. They demanded food and freedom from want, a living wage and an eight-hour workday, but most often and most loudly they called for an end to the senseless slaughter of World War I.

Everything seemed up for grabs that summer, and Lempicki probably saw opportunity in the chaos, especially when the whole country swung suddenly to the right in July. The Bolsheviks failed to take charge during violent antigovernment demonstrations on July 3 and 4 and consequently found themselves face to face with a coalition government that banned the party, sent Lenin into hiding, put Trotsky in jail, and appointed right-wing General Kornilov commander-in-chief of the Russian army. Reactionary skullduggery abounded, and, judging by subsequent events, Lempicki plotted with the best of them.

Kornilov attempted a coup d'état in August and failed when the army he led simply walked off the job behind his ramrod-straight back. The counterrevolution fizzled, and along with it went any hopes Lempicki might have had for a career in politics. Still, he was young, his wife had turned into a striking woman, and there were plenty of parties to attend.

By September, the Bolsheviks had regained their standing with the urban masses and won the municipal elections in Moscow. On September 24, Kerensky formed the last coalition government. Exactly a month later, the Bolsheviks took control of Russia.

Nevertheless, it was not clear to the Lempickis nor anyone of their class that the world they knew was dead and they would be, too, if they failed to get out soon—an ignorance not so surprising, since the Bolsheviks themselves doubted they would last very long.

Prominent party member Zinoviev, admittedly a notorious pessimist, on October 25 gave the new regime two weeks because of Bolshevik incompetence and the strength of their enemies. On October 28, Lenin declared a state of siege in Petrograd. The "Whites" had taken the Kremlin, and civil war was under way. By November, nothing was really settled. Power and peace yet lay in the balance, the Bolshevik Party was deeply divided, civil servants engaged in systematic sabotage, bankers kept their doors locked to the new government, municipal services ground to a halt, and the White Army was on its way. Not until December 1917 did Lenin create the All-Russian Extraordinary Commission for the Struggle Against Sabotage and Counterrevolution. Arrests began immediately, but it took several months for The Terror to get into full swing and for the commission's acronym, *Cheka*, to send chills down the spine of anyone with a bank account.

Tadeusz Lempicki was one of the lucky ones. The Cheka got to him early.

They came, according to Tamara, in the dead of night, these long-faced men dressed in black leather. She and Tadeusz were making love when the pounding on the door started. The intruders were after lists, she said. Sometimes she hinted that Tadeusz had been connected with the Tsar's secret police, but if that had been true he would never have survived Soviet prison. More likely he had been involved in some reactionary political group vaguely promoting counterrevolution. At length, they took him away without telling her where, or why, or for how long.

Such arrests became common in Petrograd and Moscow, and high society suddenly realized it was high time to head for Finland or Denmark or anywhere people were well-fed enough not to want to throw them in jail simply because they owned a few things. A summary execution or two was enough to clinch the matter. They saw the handwriting on the wall, spelled out in the French of the Russian upper classes. *Flee*, it said. *Drop everything. Run for your lives.*

Tamara's Aunt Stefa and her husband and two boys had already left for Copenhagen to join her mother, aunts Eugenia and Franca, and sister Adrienne, all of whom had managed to emigrate from occupied Poland. Her brother Stanczyk had not made it, lost with twenty million other casualties of the War to End All Wars. And neither did her mother's new husband, who, like her father, was never heard from or talked about again.

To her credit, Tamara stuck by Tadeusz. In an act of incredible bravery, given the circumstances and her youth, the nineteen-year-old stayed on in Petrograd, searching the Bolsheviks' makeshift jails for her husband, careful for the first time in her short life not to dress in style as she wandered the streets. On one of her trips out, she came across a starving horse dying a slow and hideous death in the freezing slush, and she thought, "That's it. That's what all this means. Russia—it's just a starving horse, dying in the street."

When she failed to find Lempicki, she turned to the foreign consulates in

31

Petrograd, seeking help in one after the other, until the Swedish consul hinted that he might be able to do something for her. He had connections. He would look into it. As he talked to her, she could not stop eyeing the food on the consulate table, where the dinner she had interrupted was still under way. The consul invited her to join them, but her pride made her refuse: No, she had asked too much of him already. He insisted. She must stay, if for no other reason than to tell him more about her husband, her family, where she was from, how she was managing to survive in hard times like these.

She was ashamed of herself when she accepted, but she took his offer and answered his questions. Afterward, outside in the cold, the days of tension and sleeplessness caught up with her. And so did the unaccustomedly rich food. She vomited into the gutter.

Not much time passed before the consul sent for her with news of her husband. He had located Lempicki, he said, but getting him out was another matter. It would be difficult enough at this point to get her to safety, say in Sweden, much less to rescue a political reactionary like her Tadeusz from a revolutionary jail in the middle of a civil war. Perhaps, though, he might find a way. Perhaps. But, in any case, there were certain other, ah, matters he had to consider. Certain needs. Certain costs.

She was far from naive nowadays. She paid the fare.

It was a brief liaison. The consul kept her close while he negotiated with his contacts in the government, and he began to emphasize the danger she herself faced. She should let him take her out of Russia with him while he continued to negotiate with the Bolshevik authorities through the consulate. There was nothing more she could do, and every minute she stayed she increased the risk of landing in jail herself. The Bolsheviks had none of the refined, tender feelings for the gentler sex that characterized men of his class.

They were a suspicious bunch, those Bolsheviki, he told her. But shrewd—and ruthless, the head of the Cheka, one Dzerzhinsky, the most ruthless of all. Lucky for them, Comrade Lenin was going out of his way at that point to stop and punish all excesses. That did not mean there was no brutality, no summary executions, but the Bolshevik tribunals had yet to deliver a death sentence. It was only a matter of time before he managed to have Lempicki freed, a matter of persistence, of courting the right people. Meanwhile, wouldn't she at least let him take her to Finland, then send her on to her family in Copenhagen? She could wait for her Tadeusz there, couldn't she, as well as in Petrograd?

At last she agreed, and he told her his plan. They were to leave late the next day by train for the Finland station, she to travel as one of his entourage. She was to speak only French. No Polish. No Russian. When they reached the border, her papers would be examined. She was to say nothing directly to the border guards. Let him do the talking.

The short trip from Petrograd to the Finnish border was to stay with her the rest of her life as a definition of fear. The gray sky and frozen countryside of a Russia she would never see again vanished into night before the train stopped at the station.

Red Army soldiers ambled through the compartment, checking papers. She trembled when she proffered her false passport; she stumbled on the walk across the wooden footbridge into Finland. In Helsinki, before she left for Copenhagen, the consul again promised her he would get Lempicki out. Yes, he would provide him with a Swedish passport. Yes, he would let him know where she had gone. Beyond that, though, he could do no more. The boy would have to find his own way out of Russia to Copenhagen.

She thanked him—one final time—and went to Denmark.

She had only a few weeks to wait before she knew the consul had kept his word and Lempicki found his way to her. But it seemed forever. The mood among the little Polish group and other Russian refugees in Scandinavia, though, was not yet one of despair. In fact, it was a mood surprisingly light. The Bolsheviks had been in power only a few months, and no one really expected them to hold on to it. Tsar Nicholas and his family, though under house arrest in Ekaterinburg, still lived, and the Allies—who had long been willing to fight the Germans to the last drop of Russian blood—had refused to recognize the Bolshevik government. When Bolshevik Russia signed a separate peace with Germany at Brest-Litovsk, the Allies sent troops to invade Russia from the east in support of the Whites.

Lempicki spent perhaps six weeks enjoying Cheka hospitality, but it was more than enough. He arrived in Copenhagen a changed man, moody, sullen, the life bled out of him. Perhaps he suspected what his freedom had cost Tamara; perhaps he despaired of the loss of what once seemed to him the perfect life; perhaps jail itself had been worse than the rest of the family could imagine; but he refused to talk about the time he spent in prison or about his escape from Russia into Denmark.

Tamara did not take to this new Tadeusz. She seemed to think his moodiness was ingratitude, and when in Copenhagen she again met the Siamese diplomat she had found so attractive at her wedding reception, she hardly bothered to hide their affair. She traveled to London with him, where she was dazzled by his luxury-loving "Asiatic mind," his wardrobe, his extensive staff, and his "refinement" and "very high culture." "He was the best friend of the king of Siam," she later told two Japanese authors. "And my husband was very jealous."

Throughout the time in Denmark, Lempicki skulked around, not joining in the family fun, churlishly sneering at the jokes they all made about the Communists. They, on the other hand, enjoyed themselves as if on holiday. They laughed at the dreadful seriousness of little people suddenly in power, at the idea of peasants in the Post Office, of common soldiers attempting to be diplomats, of factory workers trying to run something so financially complicated as an entire country. They said they didn't want to go back anyway after Brest-Litovsk, because Trotsky had given the best part of Russia away—the part with all the resorts.

The Bolsheviks handed down their first death sentence on June 18, 1918. A month later to the day, the local soviet in Ekaterinburg took the Tsar, his Empress, and heirs down into a dingy basement and shot them dead.

The joke was over.

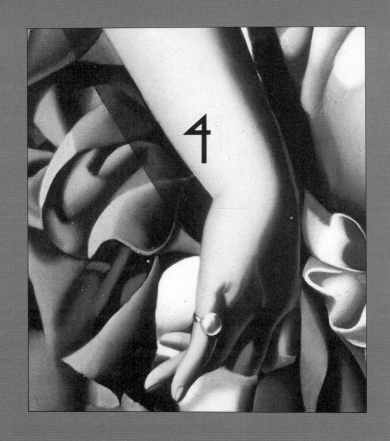

THE HUNGER
(PARIS, 1918-1923)

In 1918, Europe suddenly found itself overrun by impoverished upper-class refugees from the Russian Revolution. They clung to their aristocratic traditions, considering themselves still part of Europe's elite, and of one thing they were sure: history had done them wrong.

They lived off the sale of family jewels smuggled across half a continent, traded on their names and opened shops and tea rooms, became models in the fashion houses of Patou and Chanel, drove taxis, or took up one or another of the arts. Some simply refused to work.

Prince Yusupov and his wife—the Tsar's niece—operated a London dress shop, which failed, then published a book on his assassination of Rasputin, which became more of an embarrassment than a source of income, and finally sued M-G-M for libel in its film *Rasputin and His Empress*, and won. A nineteen-year-old Vladimir Nabokov took to writing novels in a cheap Berlin boarding house, first for his fellow emigrés, then for the world, and then for himself alone. In Paris, the Tsar's cousin, Grand Duke Gabriel Constantinovich, rejected the idea that he needed to *do* anything at all in the cultural mecca of European wealth and simply sponged off his mistress, a refugee ballerina.

Tadeusz Lempicki was not so lucky.

The Lempickis had followed Tamara's family to Paris, only to have matters go from bad to worse. Tadeusz could not—or would not—find work, and they lived meagerly by selling the few jewels Tamara had taken with her the night she fled for Finland. A year went by, two, and still Lempicki lay about the mean little hotel room they found in an unfashionable part of the city, licked his wounded psyche, read "white-glove" detective novels, and made love to his disillusioned wife, who soon became pregnant.

The rest of the family fared better. Green-eyed Stefa had sold the emeralds with which her husband once showered her to help her sister Malvina, Tamara's mother, establish herself in a *pension* in the rue Paul Sauniere with her youngest daughter Adrienne. Adrienne had enrolled in the Ecole des Beaux-Arts to study architecture.

Stefa's husband had taken up his banking interests again, now headquartered in Paris, and they ran a regular *salon* for upper-class Russian refugees. There was talk about Lempicki taking a job at the bank, but he resisted the idea, to the relief of Tamara's uncle, who had never thought much of him anyway.

White Russia carried on its social life in the cafes of the Left Bank and at elaborate luncheons and dinners given by the aristocracy and haute bourgeoisie, where they drank tea, played bridge or mah-jongg, plotted counterrevolution, gossiped about those who weren't present, and seduced those who were. Tamara attended her Aunt Stefa's luncheons, but tended even more to find herself in the company of the younger cafe set. Strong-willed and impatient as ever, she was already developing a set of friends—men and women—separate from her husband, whose morose anger served to justify her indiscretions.

Still, she was desperately unhappy. One should not imagine they lived in anything approaching "dire" poverty—they were too well connected for that. But in contrast to the early days of their marriage in Petrograd, Paris seemed to Tamara a nightmare. Generally, the Lempickis had much cause to argue, and argue they did: about his "failure"; her new-found "friends"; his resentment of her family; her family's judgments about him; his moods; her attitude; the way they lived; and the coming child. He went so far as to claim it wasn't his. She painted the wall of a nursery with chubby cherubs.

Matters only got worse when Kizette was born. Lempicki still refused to take the job at the bank; he found humiliating this step into a position he thought beneath him. Now the arguments sometimes turned into fights, violent ones.

Soon her marriage had reached such a pass that Tamara committed the cardinal sin for a woman of her class. *She talked about it to someone else.* At one of her Aunt Stefa's lunches, she took her sister Adrienne aside, cried desperately on her shoulder, and despaired openly about what she should do. We have no money. We have a child. He cannot find a job. He refuses to consider working for Stefa's husband. He blames jail, the Revolution, me, anyone but himself. He will never amount to anything. He . . . he beats me.

Adrienne was shocked. She had always idolized her older sister, who was so talented and so clever, who even now (in times so hard) had so much flair, so much life. She was so strong, so courageous, so dramatic in everything. Look at the way she had stayed behind in Russia, when everyone else had fled. Against hope, she had rescued her Tadeusz, who now treated her so miserably. Adrienne said: "Tamara, why don't you do something—something of your own? Listen to me, Tamara. I am studying architecture. In two years, I'll be an architect, and I'll be able to make my own living and even help out Mama. If I can do this, you can do something, too, something—"

"What? What? What?"

"I don't know, painting perhaps. You can be an artist! You always loved to paint. You have talent. That portrait you did of me when we were children. . . ."

That night she bought a palette, some sable brushes, a few tubes of paint, and a small canvas and began work on a still life. But it was not enough. Always something

of an actress, she did not *feel* the part, and she needed to *feel* like an artist before she could be one. Tomorrow, she decided, she would find a school of her own to attend, just as Adrienne had found the Beaux Arts.

Years later, Tamara would say that education was akin to packing a trunk for a long journey. The success of the trip depended on what you put in and what you left out, on judiciously choosing enough to get you through the journey in style and comfort without making it impossible for you to travel at all. Forever the emigré, she approached her artistic studies with exactly that notion: she would find just what she needed, and only what she needed, to become a successful artist.

She took up study at the Académie de la Grande Chaumière, which offered free

The artist with her first husband, Tadeusz de Lempicki. Paris, 1920.

classes and provided models. She stayed just long enough to learn who the students thought were the best teachers in Paris. She then went to Maurice Denis and, later, to André Lhote. She supplemented her studies with trips to Italy, which she financed on a shoestring. She visited the museums of her youth and subjected such Old Masters as Pontormo to the same technical cold-bloodedness she exercised on the painters of the Paris School.

She had purpose, and she had a plan. She told herself that for every two paintings she sold, she would buy herself a bracelet, until the diamonds and jewels stretched from her wrist to her elbow. From the beginning, she worked on her painting assiduously day in and day out. Once she had made up her mind, she seems never to have doubted herself. Yes, this was something she could do, something she could excel at, something that would bring her the adoring throngs she once dreamed about. Almost immediately she produced stunningly executed, surprisingly mature paintings—amazing pieces that would do for her everything marriage to Tadeusz had not.

She forced Lempicki to move the family to an apartment in Montparnasse, the boulevard off which lay the Académie de la Grande Chaumière. She drove a hard bargain for the place, and the landlord at 5 rue Montparnasse took her husband aside, smiling and shaking his head. He admired Tamara's bartering and described it in coarse French: "Votre femme elle m'a eut jusqu'au trognon" (literally, "Your wife sucks the marrow from my bones").

And Tadeusz Lempicki replied, "Yes, I know."

She attended all three sessions at the academy—morning, afternoon, and evening. Very early in the morning she would go to market for groceries, and she prepared Tadeusz's meals between sessions. Early evenings following the afternoon session she spent in the cafes of Montparnasse with Paris's aesthetic demimonde, talking art, life, and politics—or she partied with the fashionable friends she continued to cultivate. She held her own among even the wealthiest, scouring the right fashion magazines and imitating their designs with a few yards of taffeta and a bouquet of flowers, which she whipped into a dress in a single afternoon or evening. Late at night, when she was not fighting with Lempicki, she would paint, at first still lifes, then portraits, using as models her daughter Kizette, or an attractive young neighbor named Ira Ponte, with whom she developed a long-term homoerotic liaison.

Already she had what Françoise Gilot—Picasso's wife—would, in describing Tamara, call *the hunger*. She yearned for... something, for everything at once, for some absolute fulfillment—both aesthetic and sensual. She desired to make herself up or at least over, to create, to become greater than herself. She had the hunger, and it pushed her to immense control in her work and not a little abandon in her private life.

She would spend hours patiently at her easel, using her soft sable brushes to work over her paintings, and over them again, with slow, deliberate strokes till she got the hard-as-steel hues she wanted. But when she purchased some *religieuses* for a still life, she failed to finish the painting because she could not resist eating first one, then another, and then all of the little whipped-cream-and-chocolate cakes. She

smoked three packs of cigarettes a day and more or less lived on the sedative valerian, but she sat in public with the rigid posture of an aristocrat, impeccably dressed, every hair in place, every gesture calculated, every expression clearly calling on the world to notice that here was a woman in control of herself, self-possessed, self-assured, serene.

Within a few months she executed some dozen paintings, and Adrienne wanted to invite one of her professors from the Beaux Arts to come to Tamara's apartment and offer an opinion. The determined young artist made her place over into a small gallery, painting the walls pale gray and reupholstering the furniture in gray velvet. A striking, elegant, and fashionably dressed Tamara, churning violently inside, welcomed Adrienne's professor at the door. Her face, he noted, was a mask; her manner, well, icy. Not quite indifferent. Cool, but not insultingly so. The haughty young blonde's paintings were most remarkable, as even the white-haired professor had to admit. By trade and habit an intimidating man, he stroked his goatee and allowed: "These would exhibit quite well."

When he left, she collapsed onto the couch, her nerves shot. But immediately she submitted her paintings to various galleries for possible exhibition.

As Tamara told the story, she began to search for a suitable gallery just as she had for the right teachers. She saw several write-ups about Colette Weill's and decided that was the place for her. Armed with two of her best paintings and a few photographs, she arrived at the gallery unannounced one afternoon to look it over. She saw a woman, young and very pretty, who seemed to be in charge of the show, and simply walked up to her and said: "Madam, I am a painter. A young painter, not very well known, but I would like to show you some of my paintings."

Before the woman could respond, Tamara had pulled out a portrait of one of her friends, and the woman asked her: "When did you do that?"

"Now. Lately."

"Do you have more paintings like that?"

"This one," Tamara said. "And a few photographs."

"Show me the photographs," the woman said, and after looking them over, asked if Tamara could leave the two paintings, her address, and her telephone number. "I will call you, in a few days perhaps."

It took two weeks for the telephone to ring and Colette Weill to say to Tamara de Lempicka: "Will you come to see me in the gallery?"

"Did you sell my paintings?" Tamara asked.

"We'll discuss that later," the voice responded.

Barely able to contain herself, Tamara rushed to the gallery. Just as Colette Weill greeted her, a young couple walked into the gallery and asked its owner if she had a Chagall (or a Matisse—the story varied). "Oh no," Colette responded, "we don't keep Chagall (or Matisse). We have Marie Laurencin, however. Please, wait."

She returned with several canvases and placed a Laurencin on an easel for the couple to inspect. Next to it, she placed one of the paintings Tamara had left two weeks before. "We have Tamara de Lempicka," she said, studiedly ignoring Tamara's presence in the room.

Colette Weill placed several other paintings in front of the couple, naming the artist each time, but Tamara paid no attention to them, so caught up was she in watching the couple look over her painting and thrilled by the game Weill was playing with her. When they left, the young couple had purchased two oils—both of them by an unknown artist named de Lempicka.

Weill turned to the stunned Tamara, smiled, and said: "I'm giving you 10 percent. It is not much, but you are a beginner. If you are good, we will make a better arrangement."

The money seemed a fortune to her, and, buoyed by her success, she approached other galleries. By 1923, she had begun to show her paintings at all the proper salons—the Salon des Indépendants, the Salon d'Automne, the Salon des Moins de Trente Ans—but Colette Weill's always remained special. Years later, she would do her first one-woman show there, and Weill's father would print the first color reproduction of one of her paintings. But for now she was simply amazed that her work sold.

She signed her paintings "Tamara de Lempitzki" or, using the Polish feminine ending, "Tamara de Lempicka." She bought her diamond bracelets and flung herself even deeper into the Parisian *vie de bohème.* Now she might be found off the Champs Elysées at a party of Paul Poiret's or at lesbian Suzy Solidor's sleazy and chic nightclub in Montmartre as well as with a Braque or a Gide in Le Dôme or La Rotonde. She took a small studio, purchased a little yellow Renault, and opened a bank account of her own. Her clothes these days were likely to come from her "friends" Madame Gres, Coco Chanel, Molyneux, or Schiaparelli. She was, as they said in the twenties, *smart.*

When she could afford it, she went to Italy and even Monte Carlo, staying always at the Excelsiors—however they were called—but staying in the cheapest room, nearest the top floor. With her on such trips she occasionally took Kizette, who now had an English governess named Miss Oran. Tadeusz, perhaps out of shame, perhaps in despair, finally accepted the job at her uncle's bank and seemed to resent his wife's success, especially the trips from which she carefully excluded him.

At one point, the Bank of France became worried by the amount of money that began to appear through frequent deposits in what had been at first and for some time so modest an account. An officer came to Montparnasse to investigate. He was polite and circumspect, and it took Tamara a few minutes to understand just what the problem seemed to be. When she did, she was delighted. She laughed openly at the cautious banker and ruefully asked: "Would you like to come see for yourself?" It was his turn not to understand, but she took him to her studio and showed him her work. "And you are doing well with these?" he asked. "Yes," she smiled, "I am doing well with these."

The banker offered 50,000 francs for one of her smaller canvases, and she took it.

She would come in late from a party still excited and full of energy and awaken Kizette to tell her all about it, the famous artists and writers she had met there, the

dukes and counts she had danced with, the duchesses and contessas who had invited her to lunch, or dinner, or the opera, or to yet another party. She seemed always to be going out to meet a client or a model or a friend.

She talked all night in the cafes to artists like herself about the "humanizing" of Cubism after the war, the role of the Futurists, how she remembered the impact both movements had made in prewar Poland and Russia, where they had been more popular than they ever were in France or Italy. She followed Lhote, not Braque and certainly not Picasso—whom she liked well enough personally. She fraternized with Chagall, Foujita, Kiesling, van Dongen, Marie Laurencin, the Comtesse de Noailles, and André Gide, whose chilling portrait she later painted. She ate at Maxim's and the Ritz. As Jean Cocteau observed, she loved both art and high society, and he thought her access to the latter would one day destroy in her the former.

Still, she worked at it—her art—now harder than ever. She studied with her mentors, went to lectures, and painted, painted, painted, every day. "The day was too short," she said later, describing that period in her life. "Sometimes I went out in the evening and came back at two o'clock in the morning and painted until six, with a blue lamp." She was in the Brasserie La Coupole when E. T. Marinetti, who produced the Italian Futurists' "Manifesto," took it into his head to make a speech. She sat quietly next to him in front of a long table as he expanded on his ideas: We artists are enslaved by the past. The conventions, the cursed conventions, keep us prisoners.

He grew more and more excited. He leaped onto the table. The entire cafe came to a halt, listening.

Until we destroy the art of the past, he said, there can be no modern art. We must go *now* to the Louvre, which is a symbol of all that, of the past. He began to chant: "Burn the Louvre! Burn the Louvre!" He shouted: *Now!*

Tamara found herself, too, chanting "Burn the Louvre!" She was very excited, and she looked up at him. "Maestro," she said, "my little car is outside. We can use it, if you want, to go burn the Louvre."

In the heat of the moment, thirty or forty people ran outside with the two of them, only to discover that the automobile was gone, missing. The police had towed the Renault because it was improperly parked, and, instead of the Louvre, the now steadily shrinking crowd found itself marching to the police station. There they stood around while Tamara was forced to produce her papers to free her little yellow car from the authorities—instead of modern art from the past.

Marinetti grew very quiet. They lost the moment. All the passion to burn the Louvre had vanished, like the crowd around them.

It was a reckless, adventuresome, exhilarating time for her, and rumors began to spread. When Lempicki heard them, the fighting grew nastier, but her behavior did not change. Her art and the world that went with it had become life for her. She was the center, and Tadeusz—even Kizette—simply must accept the fact.

She was a demanding, impatient mother. Artists have always found it difficult not to impose the will they employ in their art on the lives of those around them, and

Tamara was no exception. Kizette now remembers vividly a night when *will* was precisely at issue. Tamara had come in to listen to the child say her prayers. Nanny had informed Madame that Kizette was furious with her mother for some reason no one remembered afterward. Kizette was hiding under the huge, soft eiderdown quilts of her white bedroom, warm, safe, in a world of her own far from her mother's.

"Kizette, say your prayers."

No answer.

"Child, say your prayers."

Maybe it was only ten minutes, but it seemed hours to Kizette that she kneeled there by the bed. She got to the part where she blessed her friends and family, and she skipped "God bless Mommy."

"You forgot to say, 'God bless Mommy,'" Tamara reminded her gently.

Kizette began again. "God bless Daddy, and God bless . . . Aunt Stefa, and God bless Aunt Ada—"

"Kizette, say: 'God bless Mommy.'"

"God bless Daddy, and God bless . . . Grandma, and God bless Aunt Adrienne—"

"Say it!"

"God bless Daddy, and God bless . . . Nanny, and—"

"You will be all night on your knees," Tamara commanded, "until you say it. Say it. 'God bless Mommy.'"

"God bless Daddy, and God bless . . . day, and God bless night—"

The nurse interrupted: "Oh, well. The poor child. Let her go to bed. The poor child, she is so tired."

The nurse was ordered from the room, and the ordeal continued until Kizette's father came and said sharply, "Tamara, leave the child alone." Then it became just another battle between the two of them, the kind that does not take place in front of the child.

So it was not that night that she broke her daughter's will.

And Kizette remembers, too, the hunger. Tamara found she enjoyed having Kizette with her in Monte Carlo, where the innocence of the pretty, blonde, curly-haired child supplied just the right counterpoint to her seductive, sophisticated smartness. People were attracted to the two of them together. Men particularly would approach them with presents for Kizette. "Such a pretty little girl," they would say—and invite Tamara for lunch or dinner. One offered Kizette a huge ripe pear, which Tamara forbade her to eat until after lunch, when she had taken her nap. Tamara placed the pear carefully, artfully, on the windowsill in their little room at the top, and Kizette fell asleep. When she woke, she headed straight for the window. The pear was gone. In its place was an apple, a rather small apple. And it was red.

"A little angel came," Tamara explained, "and switched the fruits."

Kizette spent much of the time in the care of her grandmother, and as soon as she was old enough, Tamara packed her off to boarding school.

It was during the early years in Paris that Tamara de Lempicka developed what her daughter calls her "killer instinct." Tamara would come to say with pride that

everything she owned she made herself, with her own ten fingers and her own good taste. And while that is not entirely accurate, it is true that in Paris she learned quickly the price of success: she subjugated everything to her work, developing a steely resourcefulness and a ruthless eye for her own advantage.

She had her code, and it was a code for the 1920s. She was interested in no one but those she called the best: the highborn, the rich, and the accomplished. She felt, as the talented always feel, that she deserved everything that came her way, which freed her to travel only with people who could help her or who fed her ego one way or another. She lived on the Left Bank, where an artist should live, and so she hated all things bourgeois, mediocre, and *nice*. She wore expensive clothes to dazzle her public and cloaked her past in mystery. She became deliberately vague about her age, her life in Poland and Russia, even her family. The Polish girl of good family, the child bride, the emigré wife, the young mother disappeared behind her paintings, as if they were screens in a star's dressing room, and out the other side emerged the glamorous, sophisticated—if not decadent—modern beauty of the famous *Auto-portrait* that she would paint a few years later for the cover of *Die Dame*.

"I live life in the margins of society," Tamara said. "And the rules of normal society don't apply in the margins."

From the start, she banked on style.

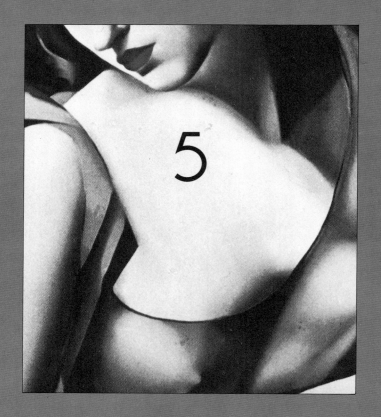

A PERVERSE INGRES
(PARIS, 1923-1925)

"Style," as Alain Lesieutre says in *The Spirit and Splendor of Art Deco*, "is the most conspicuous of the mechanisms through which we hope to alter ourselves, to become what we should like to be." We think that if we create a certain environment, if we wear different clothes, we will become different, more like our ideal of ourselves. To some extent, it works. Historians have often noted, for example, how women's bodies seem to be transformed by the demands of fashion. And we don't like to share our ideals, our dreams. Style is a badge of exclusivity, always a matter of "us" against "them." "At its height," Lesieutre writes, "Art Deco pursued exclusivity with single-minded passion."

It was originally known as Art Moderne, but the name Art Deco caught on when critics began to shorten the title of the first international display of objects in the style—the Exposition Internationale des Arts Décoratifs et Industriels Moderne—held in Paris in 1925, and it really started back with Leon Bakst's exotic colors and striking Oriental designs for the 1909 Ballets Russes in Paris. The influence of the Ballets Russes on decorative arts was interrupted by the war, but, from 1917 on, the company's director, Sergei Pavlovich Diaghilev, commissioned French painters to do his sets, artists of the first rank, including Georges Braque, André Derain, Juan Gris, Marie Laurencin, Henri Matisse, and Pablo Picasso. Through the theater, then, the Parisian public was initiated into Futurism, Expressionism, and Cubism.

With roots in the austere side of Art Nouveau, much influenced by the great prewar art movements, Art Deco mixed traditional subjects with modern techniques and concentrated on the surface of things. It was smart rather than pretty—in fact, it avoided the pretty—and it had the toughness that the term *smart* implies. Art Deco's practitioners agreed with Marinetti, who declared in the Futurist "manifesto" that "the splendor of the world has become enriched with a new beauty: the beauty of speed," and with André Lhote, who argued that Cubism needed to be humanized. Art Deco sported cold, hard textures and colors on the one hand, and luxurious, decadent, sensual imagery and detail on the other, drawn at one and the same time to metal and flesh, to the automobile and the naked body. It was primarily a French

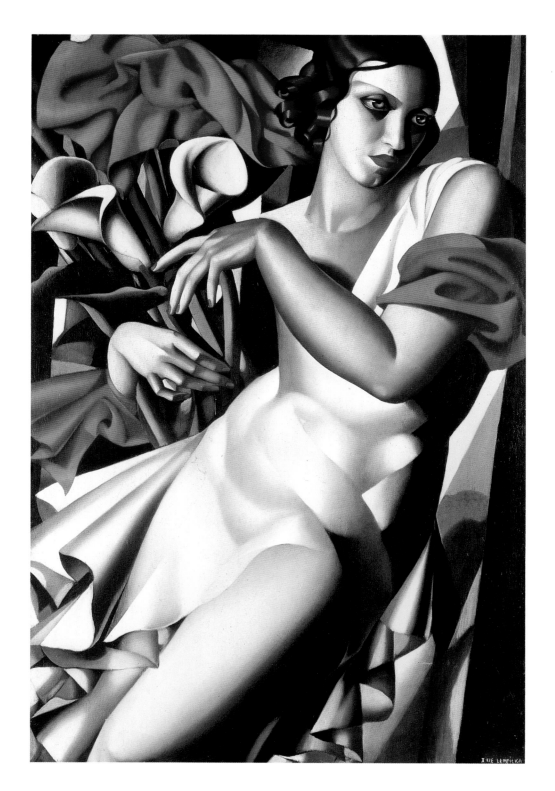

movement, developed in France and in response to the demands of primarily French patrons, and like the French between the wars, it dallied with both Fascism and hedonism but succumbed to neither.

When the Ministère des Beaux-Arts, the Association des Art Décorateurs, and the City of Paris opened the first Art Deco exposition in 1925, Tamara de Lempicka was living in precisely the place at precisely the moment to benefit from the response it created. By temperament, by training, and by practice, she was already the style's exemplary artist, though not a single one of her paintings was on view that year in the pavilions by the banks of the Seine.

She had learned her craft from two well-established painters, both of whom emphasized the decorative. She owed less to Maurice Denis than she did to André Lhote, but Denis did provide her with respect for draftsmanship and a kind of theoretical underpinning. He was one of the most popular instructors at the Académie Ranson, founded by Paul Ranson and run at that time by his widow, Francine. Before the war, Denis had been one of the Nabis, who included among their ranks Ranson and Gauguin. But he abandoned their bold color and symbolism after being won over first by the Italy of Fra Angelico and then of Raphael. He taught that before a painting was anything—a donkey, an airplane, a nude—first it was a flat surface. Consequently, the artist had the right to deform the subject of his work to the point of "emotional caricature" for sensual impact and psychological expression, all in the name of beauty. "Decorative painting," he said, "is true painting; painting could only have been invented for the purposes of decorating poems, dreams and ideas, the mural commonplaces of human edifices." He emphasized the synthetic approach and taught Tamara to simplify line and color in order better to define the object.

He was an intransigent, methodical teacher. He made his pupils start by drawing still lifes from nature and kept them away from nudes and oils until they had humbly mastered sketching and drawing. He made them study the classics and copy their betters until they became familiar with every genre and technique and could work with all the tones of a color in shades. A neotraditionalist, he is probably the source of Tamara's secondary penchant for religious subjects, which seem somehow unsuited to her sensual treatment of them. Thanks to Denis, she learned the patience to execute finished pictures and to wring from her paints the enamel-like quality of her color.

André Lhote taught her technique. The father of what was then called the "New Cubism" or the "School of Paris," and now goes by the sobriquet "Synthetic Cubism," Lhote attempted to marry the decorative with the avant-garde experiments of Braque and Gris in what he called a "plastic metaphor." This means basically that he practiced Cubism on traditional subjects and subjected the sensuality of the human body to careful, decorous geometric disintegration. Lhote was not the only one in Paris disfiguring the anatomies of his models with circles, triangles, and rectangles, but it was through him that Tamara swallowed whole this simultaneously progressive and traditional style.

Through Lhote, too, she learned to fancy Ingres, whom her teacher loved for his admirable fusion of the abstract and the palpable, for his striking, near-hallucinatory

use of color, for his cold but sensual classicism. Lhote's combination of fashionable Cubism with his worship of Ingres led not just Tamara, but a whole generation of artists to a stylization that—depending on whether they emphasized the geometry or the academicism—produced, on the one hand, Art Deco painting in the 1920s and, on the other, neoclassicism in the 1930s.

But it was her feeling for her subjects that saved Tamara from being just one of

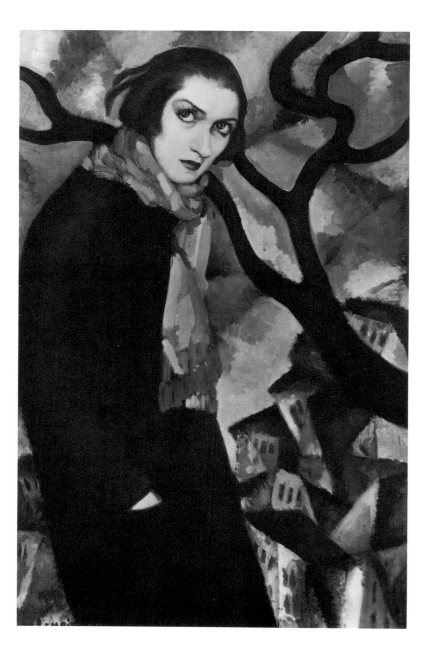

Portrait of Madame P., 1923–24. Lost.

any number of stylish Art Deco painters. She painted her friends: Ira Ponte, the Duchess de Valmy, Madame Zanetos, the Marquis d'Afflitto, the Duchess de La Salle, Count Fürstenburg-Hendringen, the Grand Duke Gabriel Constantinovich. They were the rich and the noble, and they were on the defensive. They had led the world to war and in the process nearly destroyed themselves as a class, along with millions of common people. They were left with very few countries in Europe to rule any

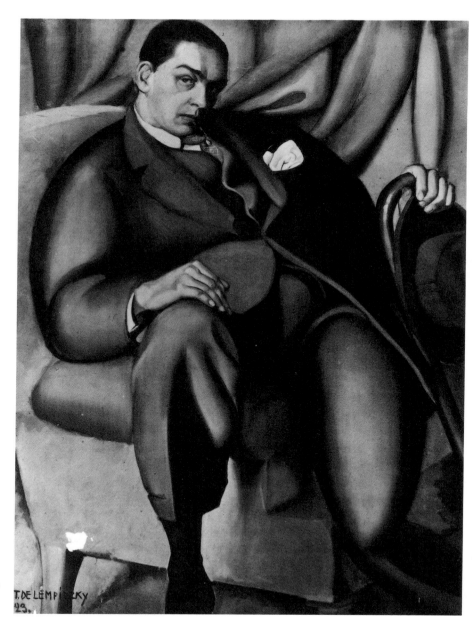

Portrait of Tadeusz de Lempicki, *1923–24. Lost.*

49

Portrait of André Gide, *ca. 1924. Private collection.*

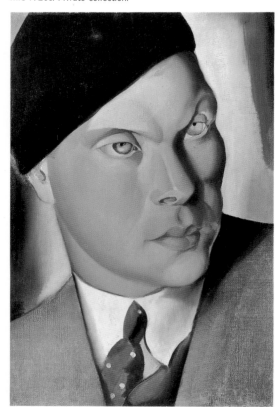

Portrait of Count Fürstenberg-Hendringen, *mid 1920s. Private collection.*

50

more, and even their money wasn't safe in a France gone mad with speculation. They retired to their estates, went private, played life on the surface. Lacking real power, the best they could imagine was pleasure (which they called beauty), lots of it, and they chased it with real abandon. They concentrated on clothes, on bearing, on style.

Politically they followed Action Française, a right-wing, purportedly royalist group led by Charles Maurras. Maurras said he wanted to restore the pretender Comte de Paris to the throne, but after the war, he actually led the world-weary aristocrats—as well as the aesthetes and artists on the Left Bank—into the arms of Il Duce. Fascism, in the words of Janet Flanner, who covered high culture in Paris for the *New Yorker* under the pen name "Genêt," seemed to them an exciting political innovation. Fearing subconsciously that they counted for much less than they once had, they hid their self-doubt behind the rigid posture, the arrogance, and the personal irresponsibility they had learned from birth, and followed the strong man who promised to give the world back to them. In short, they admired Mussolini and lived for new sensations.

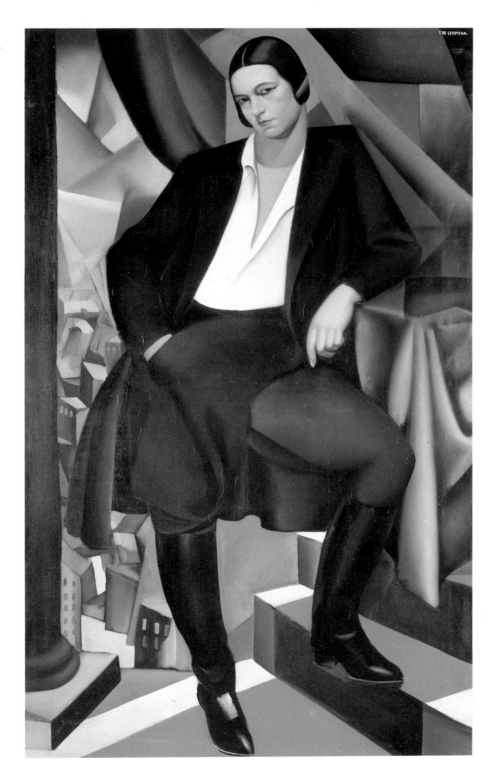

Portrait of the
Duchess de la Salle,
*1925. Collection of
Alain Blondel, Paris.*

51

*Untitled drawing, 1924.
Collection of Christie
Tamara Foxhall.*

52

Tamara used what she had learned to capture something of this mood on canvas. Experimenting with "plastic rhyming," or contrasting planes, or stylizations of light, she went beyond the confines of post-Cubism and classical Art Deco. To quote Giancarlo Marmori, hers were portraits of "creatures more than alive, sometimes caught by surprise in some of their innermost expressions." They are both "elegant anthropomorphic friezes" that perfectly document the time and very fine emotional caricatures that capture exactly the right flash of arrogance, hypochondriacal tic, or seductive challenge. None of which is surprising, because she was one of them. She understood them, how they felt, what they thought, whom they feared. She *knew* them, both the men and the women—often intimately.

"At the beginning of my career," Tamara later said of her painting, "I was looking around me and could see only complete destruction in painting. I was disgusted with the banality into which art had fallen. I felt Picasso embodied the novelty of destruction. I revolted; I looked for a métier that did not exist any longer. I was working very fast and with an easy brush. I aimed at technique, métier, simplicity, and good taste.

My goal: *Do not copy*. Create a new style, colors light and bright, return to elegance in my models."

There was, too, a certain fastidiousness about her art that grew from a personal compulsion for neatness, a compulsion that would become almost pathological in her old age. "Even when I was a schoolgirl in Switzerland," she would say, "I didn't like the paintings of the Impressionists. Cézanne would draw a few apples, but the apples were badly drawn. And the colors—why is it all so dirty? And when I went to Italy, all of a sudden in all the museums I saw paintings painted in the fifteenth century by Italians. I loved them. I thought, Why did I like them? Because they were so clear, they were so neat. The color was neat, clean. The Impressionists painted from imagination more than from nature; they did not paint well; they did not care about technique. I said to myself: They are dirty. It's not precise. Mind the precision. A painting has to be neat and clean.

"I was the first woman who did clear painting—and that was the success of my painting. Among a hundred paintings, you could recognize mine. And the galleries began to put me in the best rooms, always in the center, because my painting attracted people. It was neat; it was *finished*."

By 1925 she was beginning to attract attention. The year before, she had held an *exposition de l'escalier* in Paris, and she continued to show her paintings at the official salons, adding to the list the Salon des Tuilleries and the Salon des Femmes Peintres. An art critic in New York wrote that he had become familiar with her startling work as early as 1923, that she was the best of the new modern Art Deco painters, and that her works were incredibly sensual. Arsène Alexandre saw her work for the first time that year in the Salon d'Automne: the portrait of *Irene and Her Sister, The Model, The Widow,* and the audacious *Rhythm*. The latter especially prompted him to accuse her of "perverse Ingrism" and marvel at the way expression and plastic qualities mingled in her work.

Tamara found it agreeable to be classified with Ingres and flattering to be accused of perversity. It made her feel she was getting somewhere. Already in 1925, American fashion magazines had picked up on her, *Harper's Bazaar* running a page of photographs of Tamara and Kizette, commenting on the stylish dress of both.

Early that year, she took off for Italy, on her longest trip yet, to study the great classical works. Traveling with her mother and Kizette, she would leave them to tour on their own while she spent hours in Florence copying the Mannerists, Pontormo, Botticelli. From a friend she learned of Count Emmanuele Castelbarco's new gallery, the Bottega di Poesia, and wrangled a letter of introduction. On the train back to Paris, she told her mother she planned to get off at Milan to visit with the well-known patron of the arts, publisher, and impresario who had married Arturo Toscanini's daughter. Perhaps remembering the success she had had with the direct approach at Colette Weill's, she said she wanted to show him a few photographs of her work and copies of the reviews she had been attracting. Her mother was to take Kizette on to Paris with her.

Group of Four Nudes,
*ca. 1925. Private
collection.*

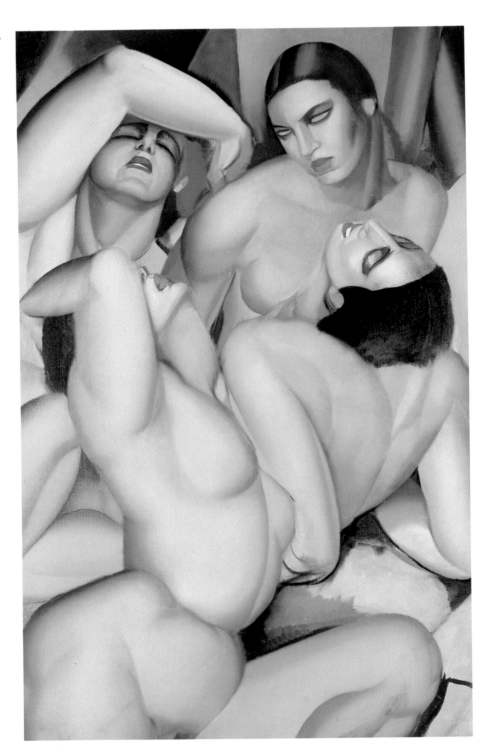

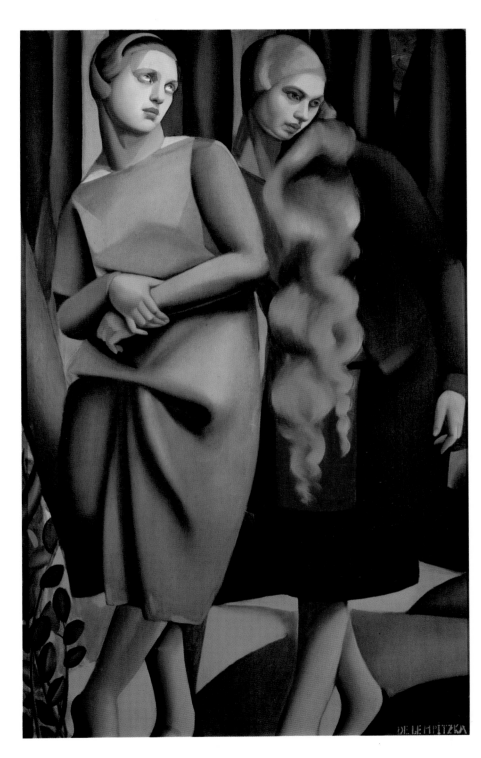

Irene and Her Sister,
1925. Private
collection.

55

Kizette,
about 1925.

56

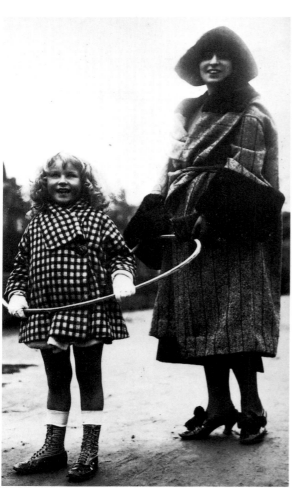

The artist and daughter.
Bois de Boulogne,
Paris, 1925.

Kizette, about 1925.

Portfolio tucked under one arm, yellow hair streaming behind her little French beret, she walked up to the door of the gallery, knocked, handed the letter over, and asked to speak to Castelbarco. At length the Count consented to see her. He admitted later he did so only because the doorman told him she was young, blonde, and good-looking.

He was taken aback by the photos she shoved at him. "Ah, who did this, who is the artist?" "Well," she said. "I am." She pulled from her portfolio the work she had done in Florence.

In no time at all, he was walking around the gallery, waving his hands and showing her which of the paintings he saw in the photographs he would hang in what spots. We'll paint the walls gray, he announced. Don't you think? Do you have thirty paintings? Six months. For thirty paintings. It should take six months. That's it, then— we open in six months!

She accepted his offer, she said very formally, and she was pleased to do so, but she simply did not have enough money to produce and ship that many paintings in so short a time. I live in Paris, she said. It is far from here, and the shipping and insuring of them is expensive. All right, he responded, the gallery would cover the expense, but he would take 40 percent rather than his usual 20.

They struck a deal, and she left. She had only one trouble with the arrangements. She did not have anywhere near thirty paintings. Two or three completed that she might show, at most half a dozen she could pull together.

Armoire and stool designed by the artist for her apartment on rue Guy de Maupassant. Paris, 1925.
Gold and silver on gray lacquer.

Portrait of the Marquis d'Afflitto, 1925. Private collection.

Back in Paris, she painted fiendishly. She worked nonstop, and all her friends were forced into sittings. In six months, she finished twenty-eight new pieces, and the show opened on time. The work she exhibited revealed an artist fully in control of her craft. It became a milestone in her career.

Castelbarco proved to be an accomplished promoter who knew absolutely everyone. He moved in even better circles than she, and he felt no hesitation in introducing her to his friends. She was soon the darling of the Italian nobility, the press announced her as a major new talent, and even people outside her group of friends and lovers sought her out in order to commission portraits.

That year in Italy Tamara did the first of her three portraits of the Marquis Sommi Picenardi, who became her lover. As she told others, "When I had to leave, he came to me and he said: 'In three days, you will come to Torino. And I will wait for you.' And I came to Torino. And waited for him. And he came. The first day we went to the opera. The second day we went to bed. We were three days in bed that first time."

Lempicki now called her sardonically the woman with "the golden hands," attacked her for humiliating him in front of the world with paintings of her lovers, and demanded to know why she spent so much time in Italy.

Her head does seem to have been turned by her Italian success. "I refused myself nothing," she said later. "I had always *innamorato*, always. For my inspiration, I liked to go out in the evenings and have a good-looking man tell me how beautiful

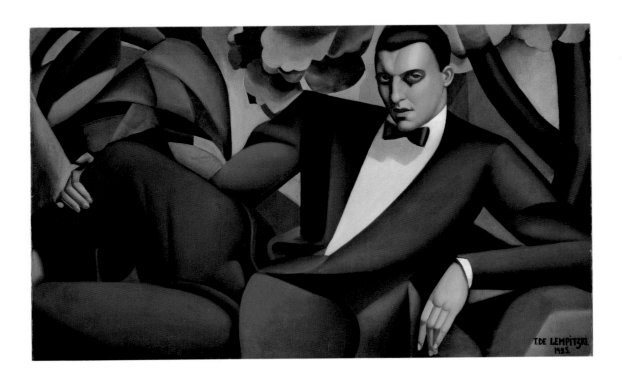

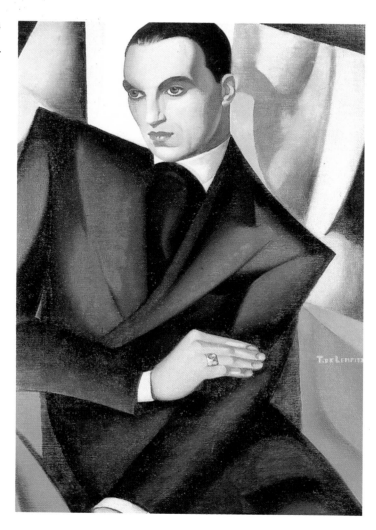

Portrait of Marquis Sommi Picenardi, *1925. Private collection, Paris.*

I am or how great an artist I am—and he touches my hand . . . I loved it! I needed that. And I had many, many."

Tamara had moved from *la vie de bohème* to *la dolce vita,* and Lempicki found himself in an emotional cul-de-sac.

One of Castelbarco's oldest and best friends was Gabriele d'Annunzio. To call d'Annunzio famous would be an understatement. For thirty years he had been celebrated as a novelist, poet, playwright, and lover, not only in Italy but throughout Europe. He was the first writer to worship the new god Speed, which, along with his work's Neo-Romantic *Sturm und Drang,* its exotic sensuality, its sadism, its morbid aesthetic, and its grandiose soulfulness, anticipated perfectly the Fascist sensibility.

Born of a leading family in provincial Abruzzi, he married a Pre-Raphaelite and already pregnant beauty above his station named Donna Maria Gallese—much to the chagrin of her family. Indeed, the Duchess Gallese once called her son-in-law "a painted woman." He went on to fulfill her worst fears by leading a life of absolute decadence, if also one of the highest achievement. Fathering a number of illegitimate children, he managed to bed along the way most of Europe's famous women, many of her beautiful ones, and not a few of her highborn—including Anna de Noailles, Romaine Brooks, Eleonora Duse, the Marchesa Casati, the Duchess de Gramont, the Countess Mancini, Ida Rubinstein, Cecile Sorel, and the American expatriate free spirit, Isadora Duncan. Despite the fact that he was incredibly ugly, his fame as an artist and a lover was such that, in 1914, Miss Natalie Barney summed up the situation this way: "He was all the rage. The woman who had not slept with him became a laughing-stock."

Before World War I, d'Annunzio's writing had become patriotic and political, and he followed his own call to action. He got himself elected to the Italian Senate, but that proved not to be enough. When hostilities broke out, he joined battle against the Austrians; already middle-aged, he took up soldiering. They called him ever afterward "Il Commandante."

A petit bourgeois become a prince, he called for regeneration through violence and touted the Nietzschean cult of the strong man, the leader who, without pity or sentimentality, would lead the modern state to some great but vague destiny. He attracted a following not unlike Mussolini's, mixing socialism and reaction, and his popularity rivaled Il Duce's. Many had hoped that he, not Mussolini, would become the head of a new Italy, and for a while it seemed a possibility.

But he lacked Mussolini's political skills and ruthlessness, if not his ambition. In November 1919, d'Annunzio led a successful rebellion against the city of Fiume and actually ran the government as a kind of poet-regent for little over a year. At first he had Mussolini's support, along with the help from Action Française, certain Italians in the Argentine and the United States, and even Marinetti and a few Futurists, but ultimately he made such a mess of things that Mussolini was able gently to retire him at government expense to a combination opium den, sacristy, and museum called "Il Vittoriale" in Gardone near Brescia. There, by a mysterious protocol, he ran his own private principality, and the echoes of public life reached him only through the chit-chat of his little court.

In 1926, d'Annunzio left his more or less forced retirement at Gardone to go to Milan and salute Il Duce, who had more or less forced the retirement on him in the first place. While there, he visited the Bottega di Poesia of his old friend and publisher Count Castelbarco, where he first became acquainted with the work of Tamara de Lempicka. The hint of perversity in her paintings, their obvious sensuality, even their androgyny appealed to d'Annunzio's luxurious and decadent tastes. He had heard of the woman herself from Castelbarco, on one of the Count's many trips down to Il Vittoriale, and d'Annunzio, even at sixty-three, was never one to pass up the opportunity for a new conquest. He pressed the Count for an introduction.

When they met in Milan, Tamara and d'Annunzio talked about their mutual

friends, Paul Poiret, Marinetti, Chanel, Prince Yusupov, the Comtesse de Noailles, Prince Pignatelli. Had she seen Marinetti since Il Duce appointed him to the Accademia d'Italia? No. Had he heard about Poiret's merry-go-round at the new Parisian exhibit? Yes, it must have been grand. He told her she would have to come visit his infamous castle near Brescia one day soon. She told him she had just received a commission from Prince Pignatelli to paint his portrait and his wife's next year in Milan. Good. It was set. She would come then. He would telegraph her with the details. Unlimited access to the national telegraph service was one of the honors with which Mussolini tried to soften the old poet, hero, and cad's exile.

The twenty-eight-year-old Tamara felt finally as if she had arrived. She had just met and talked on equal terms with the most famous man of letters in Europe, perhaps in the world.

She was charmed.

LA DONNA D'ORO
(ITALY, 1926-1927)

It had all seemed so spontaneous. First the grand summons from the great man: "Come to Vittoriale, the Muses of Music, of Art, and of Literature should get together." Then the Prince ushering them all into his gleaming Isotta. The mad trip down from Milan at breakneck speed, chickens splattering and children scattering in the dust kicked up by spinning whitewalls. A hot, dry, crazy summer day—and, at the end of it, Gabriele d'Annunzio lingering by the gate of his mansion to welcome them.

She and d'Annunzio had not kept in touch, despite the idle plans they had made last winter at Castelbarco's Bottega di Poesia. She had been busy with her work, and d'Annunzio forever played the recluse—Europe's famous and talented came to *him*, and then only when he allowed them past the gate. He was in the habit of forcing potential guests, no matter how well known, to stay first at suites he maintained in Gardone's Palace Hotel to await an audience at his villa only minutes away. Sometimes they waited for days.

Women were occasionally accommodated more promptly. Tamara had come back to Milan that summer of 1926 to work on the portrait of Prince Pignatelli. His wife, the Princess Pignatelli Aragona Cortes, was intimate with d'Annunzio and a regular visitor to Il Vittoriale. It had been the Princess whom d'Annunzio had called the "Muse of Music" in the four-page telegram he sent to Milan when he heard Tamara was a guest there.

From the moment Tamara stepped out of Pignatelli's now-dusty Isotta, d'Annunzio made it perfectly obvious that he had marked the stunning blue-eyed blonde as his next conquest.

D'Annunzio's public life may remind one of Yukio Mishima, the neo-fascist Japanese author of *Spring Snow* and many other works of fiction, who commanded a following almost as fanatically adoring as the Italian's had once been. Mishima committed *sepuku* because he found life intolerable in a debased and unheroic world. D'Annunzio's private life calls to mind not Mishima, but mad King Ludwig II of Bavaria, a dedicated aesthete of the mid nineteenth century who fled the brutality of daily life by building fabulously decadent castles into which reality simply was not allowed to penetrate.

Like Ludwig, d'Annunzio had made his Vittoriale into a dream palace designed to keep out those who might have disturbed the dream, a dream fueled by daily doses of cocaine.

Once the home of Professor Thode, who had married the daughter of Richard Wagner and Cosima Liszt, Il Vittoriale was originally a simple and comfortable house, surrounded by cypresses, with terraces bordered by rose trees and paths running between the azaleas down to Lake Garda. To this d'Annunzio added useless arches, with poles from which flags of several nations flew, and over which ran grandiose inscriptions. The house was filled with coats of arms fixed on the walls like medals on a general's chest, with theatrical steps that led nowhere, with fragments of ancient sculpture, with grotesque Medusa masks—a stage architecture for the daily theatrical performance that d'Annunzio had made of his life in exile.

The performance began at the gate. D'Annunzio led Tamara on a tour of the villa, leaving the others to travel behind like afterthoughts. He chattered on about himself, his tastes, his temperament, his lifelong search for beauty and perfection, taking her now by the elbow to show her this statue, touching her now on the small of the back as he escorted her into that chamber.

The porch itself was covered with a painting of the Annunciation. Above it Tamara read the motto: "I have only what I have given." Just inside sat a bridge pylon crowned by *Victory,* a symbol of the Italian resistance on the River Piave in 1917. Further on she saw another motto, carved in cement and covered with cracks: "Remain calm in the face of danger." D'Annunzio pointed to an open area on the right and announced that here he intended to build a full-scale Greek theater. Beyond, through the cypresses, Tamara saw the gleaming waters of the lake.

He turned her round and led her to a rotunda filled with alternate niches and pilasters between two ocher walls covered with roses. In one of the niches sat his coffin, and above the coffin a small glass box, which he pulled down to show his visitors. "Here," he whispered, reaching over to touch lightly Tamara's ear, "my ears shall rest for eternity, separate from and above my dead body. Why? It is not so bizarre as you think. My ears have always been the most sensitive part of me— through them I hear such music! I have in my ears my nativity and my destiny! But come and see my relics. Now I live only through my dead."

He led them through a severe piazza paved with Dalmatian marble toward the house proper. In the middle of the piazza stood a flagpole embossed on its base with heroic masks, and, opposite it, a loggia from which, he said, he could harangue the crowds who visited him. Beneath one arch sat the V-type Fiat he had used in the advance on Fiume and, beneath another, his huge yellow limousine.

He called the house his "priory." Inside, the atmosphere was dark, claustrophobic, pervaded by perfumes. The rooms were hung with silk brocades or covered with rich book bindings, the ceilings were worked and inlaid, the narrow windows darkened by stained glass. Everything was padded, smothered, cluttered. The house was littered, too, with cushions of every possible fabric, made according to d'Annunzio's precise specifications and put here and there to break a fall, amorous or sleepy.

There were books everywhere. The library itself, called "The Map of the World

Room," had a refectory table swamped with documents and albums and surmounted by an Austrian machine gun. But there were also masses of books in the "Lily Room," whose principal ornament was an organ, and in the "Leda Room," or bedroom, dominated by a huge bedstead carved in the figure of Leda and the Swan. And in the narrow "Dalmatian Oratory," lit by oil lamp—where, dressed in monkish robes, d'Annunzio sometimes held brief audiences—Tamara saw rows of folio volumes in parchment bindings.

She also noticed gilded boxes containing splinters of shells and fragments of torn uniforms. She was intrigued by a silk handkerchief lying among them. "The Duchess of Aosta needed silk for her hospital," he explained. "So I had the idea of converting the trenches in which my company was under fire from the Austrians into a cocoonery. In this way I conquered something more powerful than death: boredom. When a shell burst, the soldiers would rush to save the worms, regardless of the danger. But who thinks of the dead in this rotten world?"

And so it went. He took them to the study, the only light room in the house, filled with encyclopedias, dictionaries, and volumes of the classics. The tall Tamara had to stoop to enter the doorway of this huge room, whose walls were covered with plaster casts of the Parthenon frieze, photos of the Sistine Chapel, and the frescoes of Mantegna. The music room was draped with silk, red or black, depending on the mood of the piece to be played. The bathroom's walls were covered with Persian tiles and dishes from Rhodes and had a dark-blue bath and bidet. The dining room, also lined with books, seemed to be a chest lacquered in red and gold, with black seats and a brocade tablecloth. There was a "Room of Relics," with statues reaching from floor to ceiling called the "Ladder of Religions" (Chinese dragons on the bottom, Buddhas in the middle, the Holy Virgin on top), and a "Leper's Room," to which the poet withdrew in hard times.

They came across casts of Michelangelo's "Dying Slave" and "Rebellious Slave," but *dressed* in purple figured velvet with jewels strung around their necks. "I hate imperfection," d'Annunzio explained. "It offends my eyesight. Their legs are too short, so I asked our friend Poiret for some dressing gowns." In front of a window stood a bronze statue of Saint Francis with arms outstretched—and wearing a belt with a pistol. "St. Francis is the first fascist," d'Annunzio told her, "and I am the last Franciscan." They passed through a boudoir with old gloves hanging on the wall, and he turned again to her. "The gloves forgotten by all those ladies who lost their heads," he smiled.

And then—at last—fresh air! How beautiful the gardens seemed to her when they emerged from the old poet's necropolis—still, it was fascinating.

Roses, wisteria, moss hung on the walls and some of the monuments. The gardens themselves lay on a green hillside with waterfalls, pools, a bridge decorated with artillery shells, and, under the magnolias, a field gun. Down a bit, between the tall cypresses, lay the prow of a cruiser with masts rising above the tops of the trees. It was the *Puglia,* d'Annunzio explained, which had once disobeyed orders and brought him reinforcements at Fiume. He had purchased it from the Admiralty when it was decommissioned.

Standing on the prow, Tamara felt as if she were sailing toward Lake Garda on a sea of olive and orange trees. She also liked the dozen sailors in impeccably white uniforms, especially the handsome petty officer who presented arms. D'Annunzio told her they were gifted, and asked if she would have them play ancient music or set off a few cannon salvos. She stared him squarely in the eyes and said: "The cannon." He ordered three salvos, one to Art, one to a now independent Poland, and a third to the France they both loved, taking hold of her hand as the cannonade echoed from mountain to mountain.

At dinner, he attended almost exclusively to her. He suggested that she return when she could stay longer and do one of her exquisite portraits of him. He was witty, brilliant, entertaining, and impatient with anyone who presumed to lead the conversation anywhere but where he wanted it to go. In a rare lull, one of the guests mentioned he had recently been to China, and d'Annunzio responded with a withering, "Oh, it does not show."

After dinner, he took them to an enormous sacristy cupboard containing dozens of cravats, gaudy dressing gowns, uniforms, yards of precious fabric, and semiprecious jewelry—theatrical mementos and costumes from the past. He dramatically threw open the doors to the cupboard and let its goods come tumbling out. With a grand, courtly gesture, he swept them up and placed them at Tamara's feet. "Choose," he declaimed. "Anything. It is my gift, my tribute to both beauty and talent—to perfection."

Her timing, at least, was perfect. She carefully collected only a pair of silk stockings. D'Annunzio had been upstaged. In contrast to his theatrics, Tamara's understated gesture was quite effective. One could read it as modest or sophisticated. Either way, the great seducer was hooked.

And so was Tamara, in her way. In the clutches of her hunger, having barely tasted of success and salivating for celebrity in her own right as an artist, she could hardly avoid wishing to paint the man whose personality had marked an epoch and whom everyone she knew admired and praised. A de Lempicka portrait of d'Annunzio would be something to see, a masterpiece well beyond anything Romaine Brooks, now a well-known lesbian, had ever done when she was having her ambiguous affair with the man. She was perfectly aware of his intentions, but all real men were like that—she was used to it. And she was also used to blending sensuality and art in her life. He was an old man and not physically attractive, but he had soul and an amazing force of personality that she would love to get close to, to capture on canvas. For her, painting had become a mediation of the hunger, both an expression of it and a control of it, a way to distance herself from it. At this point, she was more successful socially than artistically, and she knew it. But if others did not take her painting as seriously as she did, that was their problem—not hers. D'Annunzio seemed infatuated with her, and that flattered her. With her "killer instinct," she thought she could both enjoy his attention and use it in the service of her art.

She was back in Italy that winter, and from Florence she wrote d'Annunzio:

Photograph of Gabriele d'Annunzio, 1926. Inscribed to Tamara from "le flibustier de l'Adriatique"—the Adriatic freebooter, an allusion to d'Annunzio's unauthorized paramilitary occupation of the disputed Dalmatian port city of Fiume in defiance of the Treaty of Versailles, 1919.

"Dear Maestro and friend (I hope and pray), Here I am in Florence!!! Why Florence? To work, to study Pontormo's cartoons, to purify myself by contact with your great Art, to breathe the air of this delightful city, to dispel the blues, to have a change of scene—that's why I'm here. I'm staying in a 'casa per studentesse,' where I get up at 7:30 in the morning because at ten one has to be in bed, and in this atmosphere, along with my little companions—I'm fine and feel very pure! I'm sorry to be so bad at expressing my ideas. I would so have liked to talk to you and confide to you my thoughts, for I think you're the only one who understands everything and doesn't say I'm crazy, you who have seen everything, experienced everything, tried everything. . . . For the Christmas holidays I go back to Paris. I'll pass through Milan, where I'll probably stop for two days. Would you like me to pass your way too? (In the good sense of the word?) I'd like to—how about you? I send you, my brother, all my thoughts, the good ones and the bad ones, the mischievous ones and the ones that make me suffer."

D'Annunzio responded with the suggestion that she come directly to Gardone, and an ecstatic Tamara replied: "Thank you, I'm coming! I'm so glad—and afraid. What are you like? Who are you? And me, will you like me looking like a little student, without my Paris gowns, my make-up, etc., etc.? I know you're sometimes in the habit of inviting your women friends to the Gardone hotel—for a very simple reason, which I'd rather explain when I see you, I'd like to be received in the same way (at least for a few days) I look forward with joy to seeing you soon, thanks."

The simple reason was a jealous Tadeusz, waiting in Paris for his wife to come home for Christmas. Like everyone else, he knew d'Annunzio's reputation, and she wanted time to explain matters to him. Much better that he should be able to wire her at the Palace Hotel instead of Il Vittoriale. Not that it counted for much when, back home, she told him she was returning after the New Year, first to Milan to finish another portrait of the Marquis Sommi Picenardi and then to Gardone for an extended stay to do a portrait of d'Annunzio. The holiday turned into a huge row. She tried to tell Tadeusz that things were not as he thought, and she and d'Annunzio were fellow artists, soulmates, brothers, but he refused to listen. She was crazy, that's all, crazy. What did she expect him to think? She always slept with the people she painted, he said. Man or woman.

Angry and depressed by the worsening situation at home, she fled to Milan immediately after New Year's, writing to d'Annunzio that she was staying at the Grand Hotel, only to have him put her off for a few days. Though his reasons were not clear to her, the truth was that his wife was stopping just then at Il Vittoriale, and he did not want to complicate matters.

Instead, he sent her presents. "Dear Brother," she wrote. "I'm working here at the Brera and the short delay is perfectly all right. If possible, write me again before Monday, so that I can let you know if my work is finished. All my thoughts. P.S. The ivory brooch and pin—superb!" A week went by, and still the invitation failed to come. "Magnificent letter," she wrote. "Magnificent purse, dear brother! I'm still in Milan, Hotel Milan, you can write me—when you like." She was anxious. Already Tadeusz had begun to wire her, demanding to know when she planned to return, and

he would keep it up throughout her stay, a nagging, depressing background worry to add to all the others she would have to face in Gardone.

D'Annunzio, for his part, had no more illusions than Tadeusz about why Tamara was coming to visit—and he knew what he wanted out of it. He understood *the hunger* as well as anybody, that urge of the creative mind to mix life's sensual pleasure with the artist's need to dominate. He had once had the killer instinct himself, that tendency to transform all one's relationships to serve one's art and ego, to use people, even to use them up, in order to satisfy a craving for greatness.

People tried to use him to further their careers, just as he in his time had used others. That kind of thing came with renown. In fact, it was flattering in its way. The seventeen-year-old ballerina Carlotta Barra was there now, sometimes staying at the Palace Hotel, sometimes at Il Vittoriale, in hopes that he would introduce her to Ballets Russes director Diaghilev. And he might, depending.

Oh, yes, many women came to Il Vittoriale to plead for recommendations, usually in exchange for various *favors*. So let Tamara call him her brother and talk about his special understanding and imagine they were kindred souls—he would go along with it, so long as she recognized he was a man and she was a woman, so long as she continued to hint at her own desire for him, so long as she slept with him. Tamara may have planned to use his hankering for her to establish her reputation, or, as she would say, to serve her art. D'Annunzio surely intended to use her ambition to feed the only hunger he felt anymore: sexual lust.

For this man, d'Annunzio, who was both the John the Baptist of Fascism and its prisoner, whom Lenin had once called "the only true Italian revolutionary," was a man growing old in a gilded shell and without dignity. He told himself he lived in a world that was turning its back on poetry, when it was he who had done the turning. Though he mouthed the same words about art and literature as always, he no longer produced either. Corrupted by the failed quest for political power, he no longer much believed in the redemptive virtue of art. He did believe in orgasms.

He called them his "chapters."

D'Annunzio's harem, supervised by an official sultana—Luisa Baccarra, once a promising pianist who now devoted her life to making d'Annunzio "happy"—provided the insatiable old man with a variety of pleasures. He slept in turn with Baccarra, her younger sister, a housemaid named Emile, and a "housekeeper," Aelis Mazoyer, in addition to his frequent women guests and the prostitutes Aelis procured. Mazoyer, whom d'Annunzio's biographers call a charming woman utterly without pretensions, also supplied him with his daily doses of cocaine and pretty much ran the show, despite Baccarra's official status as "hostess."

It was to Aelis that d'Annunzio turned when the time had come to prepare for Tamara's arrival: "It's important that things shouldn't happen in the wrong way," he said. According to Mazoyer's diary, he told her to tend carefully to his wife's departure. "I do not want any awkward meetings." She pointed out to him how amusing it was that "the Polish woman," as she called her, should arrive just an hour after Donna Maria's departure. "I suppose the bed will still be warm," she offered dryly. He told

her that he had promised himself to act discreetly and not rush things, since he wanted to treat Tamara "like a real lady." "Besides," he went on. "It may just be one more delusion to add to the others. But if it all falls through, she can still paint my portrait, which will be good publicity for her."

He would call her his "Donna d'Oro," his "golden woman," and install her in the Leda Room.

This time there was nothing spontaneous about her trip to Il Vittoriale. This time she took a train from Milan to Brescia, after waiting days for d'Annunzio's summons. She saw the soldiers first—a delegation playing martial tunes celebrating her arrival, and behind them d'Annunzio himself dressed in full regalia. He had made an event of her coming, and, after the wait, the extravagance of it all thrilled her.

She played it from the beginning as if she and d'Annunzio were equals. She was there to plead for nothing, and she was not like the rest of the women attending to him, his harem. She treated Baccarra, as the official hostess, with respect, even friendliness, having met her and talked with her on previous visits. But with the others she was distant, and soon she had won their enmity. Aelis responded to her with disdain, thinking her pretentious and treating her as just another of d'Annunzio's conquests. Carlotta, who danced for the group on Tamara's first night there, became jealous and petulant, almost insulting. And soon even La Baccarra was longing for her to go.

D'Annunzio may have planned to be subtle. He may have planned not to rush things. But what he once had called his "inimitable life" had become simply a senile erotomania, and he could not control himself. He made his first pass that night in the Leda Room, and Tamara put him off. He reported to Aelis that things had gone very badly, that Tamara was a "blockhead, an opinionated woman who does nothing but argue and has no feeling."

The next attack came the following day, when she tried to begin her portrait of him. Tamara stood there ready to start, her paintbrush in hand, playing with the colors on her palette. In Tamara's account, d'Annunzio affected the air of an amused Zeus, sardonic and lascivious, before he grabbed her in an awkward parody of passion. She pushed him away and chattered about the business at hand, her precious painting. He was insistent. As d'Annunzio described it to Aelis, Tamara told him that she did not want to get syphilis. "I have a very young husband and wouldn't care to give him such a present. You always have such a great number of women that I wonder if it's possible to rely on you." Later, she would add that she was afraid of getting pregnant.

Aelis consoled the old poet by saying that only a "professional" would think of such a thing as syphilis, and the two of them made love in the doorway of the Leda Room that night—a gesture of contempt for Tamara. Yet again the next night d'Annunzio pressed his affections on Tamara, and she relented—but only to a degree. He talked to Aelis of her soulful kisses, of her desire to be kissed in the armpits, of how she had allowed him to feel her body with his hands. But when he asked if he could ejaculate, she told him: "Only with your clothes on."

The rain started in the middle of her ten-day stay. It never let up.

70

They mixed mystical talk of the Artist's Soul with d'Annunzio's racy accounts of previous conquests, which Tamara seemed to enjoy. She told him at first she did not sleep with other men, then admitted she had had several affairs. They engaged in a kind of nightly wrestling match, which he wanted to think of as passion and which she refused to consummate. D'Annunzio occasionally berated her, telling her that she had his whole household "hanging by a hair of her cunt."

Every other day, a telegram would arrive from Lempicki, demanding her return—or at least a response. Instead, she wrote notes to d'Annunzio, trying to keep things clear: "I adore your message that begins 'Darling child,' for the rest I close my eyes. You end with 'soon,' when for you is soon?" or "I beg you, if this is not 'blind resentment,' let us explain ourselves, let us speak out. Why make the moments that were beautiful and spontaneous ridiculous? I can't write these things. I speak to you in the name of 'clairvoyant love.' Come down, I beg you."

The Princess of Piedmont had once complained that Il Vittoriale's oppressive atmosphere prevented her from sleeping a wink, and the same became true for Tamara. The place was a dungeon. No formal meals were ever served—she simply pushed a button for a servant to appear when she wanted a meal, which grew rarer and rarer. Watches and clocks were taboo, and she had only darkness and light by which to judge time. As the days dragged out, d'Annunzio—deep into his cocaine—would alternately insult her and suggest she leave, or shower her with gifts and plead for her to stay. The strange hours she kept, the rich food she ate at odd moments, the irregular sleep, the constant tension between her and the master of the house, all took its toll. Still, several times she delayed her departure, which virtually everyone was looking forward to. Not surprisingly, when he took her for a ride in his airplane, she fell ill with the flu.

Mazoyer's diary describes how that night he offered her cocaine to ease her misery, and she accepted. Feverish and high, she half-consciously let him take advantage of her. He undressed her and ran his erection slowly over her body. As he was about to enter her, she asked him: "Why do you do such disgusting things to me?" He left, only to return the next afternoon in answer to a "very sweet letter" she sent to say she was expecting him. He was more determined than ever to have her.

D'Annunzio came in wearing his pajamas and carrying his "love satchel" with all of his "equipment." He offered her cocaine, which she refused, though she did spread a small amount on her gums. He took off his pajamas to show her "the beauty of [his] body," but she turned away, saying she had a horror of pornography. She brought up the portrait she was supposed to be painting of him. "Perhaps you've avoided mentioning it," she said, "because you did not know my prices."

It was the final insult. He fled the room. According to d'Annunzio, as he left he said: "What, Madame? Is that the way you talk to Gabriele d'Annunzio? Well, good-bye!" According to Tamara, he was weeping and shouting: "I am old, an old man! And that's why you don't want me!"

Whatever he actually said, he refused afterward to answer her note to him: "Since tomorrow, unfortunately, I must leave, it would be a very, very great pleasure to spend the evening in your company." He was ready for her to leave; that seemed

clear to her even through her fever. As if in a dream, she called a taxi and slipped out into the night to meet it. It was pitch black all around her and raining miserably. Over there, somewhere, she could hear dogs barking. She imagined d'Annunzio or, worse, Aelis jumping out of the darkness to stop her. The taxi, when it arrived, was old and rickety, too slow ever to kill a chicken or scare a child, but it took her to Brescia, where she found a room. Exhausted, frustrated, relieved, and miserable at the same time, she collapsed on the bed. Even with a clock in the room, she lost all sense of time.

After a few feverish days in the mountains, waiting to hear from d'Annunzio, she telephoned Il Vittoriale only to be treated curtly by the poet. She took to the museums, looking for peace in what she called her "aesthetic courses." Despite the rain, she wandered through the streets to regain her calm and felt a sudden need to work in the little city lost in the mountains. She made inquiries and got some information from the museums and the Moretto School. She visited the studio of "the painter Pasini," as she described him, and asked him to help her locate other artists, models, a studio to rent. He offered her his—in exchange for her "beautiful legs."

She had had enough. She left for Milan.

In Milan, Tamara planned to catch a wagon-lit to Paris, but the Pignatellis insisted that she stop a few days with them. She agreed to stay, but refused to answer their questions about what happened at Gardone and whether or not d'Annunzio had sat for his portrait. They could see she was ill, and they tried to distract her by taking her to the opera, to the ballet, and to a lavish party, where out of two hundred guests she managed to find a handsome young man to sleep with her.

Returning at dawn to her hotel, she fell exhausted into bed only to be awakened minutes later by an insistent knocking. Still in a fog, she called out, "Avanti!" But the knocking continued until she got up and answered the door. A bellhop, wearing an impudent smile, said: "Madame, there is a messenger for you downstairs."

"A messenger... what messenger... why a messenger?" She brought herself back to reality. "Have him come up."

"He cannot do that. He wants you to come downstairs."

Tamara grew angry, more so because the bellhop seemed to be enjoying himself.

"He comes from d'Annunzio," he said.

Downstairs, now fully awake, she saw a throng of people gathered around a man mounted on a large white horse. The man was having trouble restraining the animal, keeping it from trampling a few guests. As she approached, he leaned over toward her and said: "Il Commandante wishes you to have this."

He handed her a parchment scroll and a small jewel box. The scroll contained a poem by d'Annunzio to "La Donna d'Oro" and the box a huge topaz ring in a heavy silver mounting that fitted perfectly the middle finger of her left hand.

The d'Annunzio touch.

She wrote to him from Cannes on her way back to Paris: "Everything passes, everything fades . . . and the fire, so burning and painful, of these last few days, perhaps

it, too, will pass, like everything else. . . . Brescia, city of suffering! I had to stop there, but I knew it was only an excuse I was inventing to delay my departure—once again. . . . But what was I waiting for? A telephone call? You perhaps? Oh, how endless the hours seem when one is waiting! And that night when I heard a knocking at the door, I didn't have the courage to move. What was I waiting for? What did I want? I didn't even know myself. But my only wish was to see you again. Next day. . . I couldn't stand it anymore, between the four walls of that miserable hotel room. I was consumed by fever and anxiety. I was suffocating. I needed air, air. I got up and started running, straight ahead like a madwoman, with no destination in mind. For how long I kept running I don't know, but finally I regained my *sang-froid* and realized I was on the road to Gardone. . . . And I, who have never been yours! The sin of my betrayal has never felt so heavy. The interminable hours of the journey. The haunting idea that I'm going away, at each bend in the road a little farther, always farther, forever. . . . Still I've found the courage to write you this letter of confession!" She ended by reminding him that he told her one morning, " 'I've spent a night of sadness. Thank you.' " In response, she could now say, "I've known hours of suffering. Thank you."

D'Annunzio, ever subtle, wired in reply: "Received your letter which rends me so sweetly. Stop. Misunderstanding continues. Stop. You had only to return to Vittoriale. Stop. Please tell me where I can write you." And on the heels of that, another telegram: "Have written you a letter too long but so disturbing that I keep it in memory of the secret tragedy. Stop. Like a good soldier I detest neutral ground. Stop. Letter departs with this telegram. Wire me after you read it. Stop. Leda is impatient."

She wrote him back that he must not rush her: "Why these ultimatums? I beg you, in the name of your 'clairvoyant love,' do not destroy this wonderful state of semi-poisoning, semi-Louis Philippe in which you have immersed me! You say: 'I know that the thought of me burns you.' Yes, I burn, I burn, I burn. . . ." But for now, she told him, she could not return to Vittoriale. The "laws of nature" prevented her. "So I'm going to Paris with your very dear letter. . . . Perhaps one day, one evening, one night, you'll feel an irresistible urge to speak to me—and then you'll write me again. I wait. I hope. I want." And she gave him her address.

D'Annunzio wired her in Paris that he *wanted*, too, and that he expected her. He asked her to wire him and tell him the day, the hour, the station, so he could send a car. But it was no use. His efforts to recreate for her the "inimitable life" had fallen prey to the jaded old voluptuary's crude attempts to revive his blunted senses, and he had been unable to sustain the effort necessary to dazzle his visitor. Later, in self-defense, she would call him an "ugly old dwarf in uniform" and say that she—as a beautiful young woman—was simply used to better. But, in truth, she was much more ambivalent about him than that. Perhaps she always regretted not painting his portrait. But in 1927 her career took off, and she no longer needed d'Annunzio.

Like d'Annunzio, Tamara had always a sense of herself playing to a wider audience. She never answered his last telegram, never even saw him again. But she wore the topaz ring he gave her till the day she died.

THE LIFE OF GESTURE
(PARIS, 1927-1930)

The *Années Folles*, the Jazz Age, the Roaring Twenties—whatever one calls the decade between the last machine gun burst in the trenches on the Marne and the first splat of bone and blood on the sidewalks of Wall Street—were dominated by rich, ruthless, merger-mad businessmen. They set the tone of the times, and in order to survive, artists had to come to terms with them. Unlike the prewar avant-garde, the artists of the "mad years" did not try to reject the ethos of capitalism altogether by creating difficult or obscure or even revolutionary works. Instead, they compromised and enshrined success as the great god of their art. They became the spokesmen for a "lost generation," and they made their fortunes in the late 1920s in Paris.

The lost generation had been created by the rapid rise of monopoly capital, the jolting displacements of social revolution, and the unimaginable destruction of world war. Its artists fled from the past, embraced the present, and refused to think about the future. For them significance and meaning existed, if at all, in the here and now. Their goal was to make something new, something for their times, something—to use one of their favorite words—"modern." It is hardly surprising that they became obsessed with living well and with making a name for themselves. Nor is it surprising that the tycoon and the gangster often appeared in their novels, screenplays, and paintings. F. Scott Fitzgerald gave the generation the images by which it recognized itself: the Flapper, the Great Gatsby, Dick and Nicole Diver's all-night parties. He and Zelda swore to live as if they did not give a damn.

Since they aimed to be understood, appreciated, and admired, these artists defined the modern not as an experiment with form but as the creation of a new elegance and grace. And here ended their great postwar compromise. Fame and enjoyment were the businessman's only aesthetic values, and artists always want to be more than simple celebrities who provide mere entertainment. So, like Tamara de Lempicka, they based their aesthetics on the code of behavior of the prewar social elites, even when they did not, like she, belong to them. Hemingway was a prime example. His lean, stark, stiff prose was almost synonymous with the modern style in contemporary fiction, and the values he expressed through it were those of the laconic, self-controlled—usually British—upper-class males he had met during the war.

The conflict between the artists' aesthetic code and their mode of living seems obvious. For all Fitzgerald's careless carousing, he maintained that "character was the only thing that did not wear out." And Hemingway's insistence on grace under pressure never stopped him from being a drunken boor and a bully. The artists of the lost generation tried to resolve the conflict by creating works that claimed "today" would last forever and by living as if each day were the last. In other words, they lived as if they were in a work of art and created works of art about the way they lived. The result was a life of gesture, a life in which they played the forms, upped the ante with each gesture, each set of clothes they bought, each party they gave, each affair they had, each book they wrote, each portrait they painted, running on sheer energy and defying time and history by trying to use their art to make their moment, their experience, so much an expression of the times that it transcended them.

In short, they lived dangerously—just as everyone imagined the woman lived in Tamara de Lempicka's famous portrait of herself, variously known as the *Auto-portrait* or *Tamara in the Green Bugatti*. Of course, she never owned a green Bugatti. . . .

"But this is unimportant," as she would say years later. "One day in Monte Carlo—it must have been 1927, or 1928, no matter [it was actually 1925]—I left my car to go into Chanel. It was my little Renault, not green, but bright yellow and black. When I drove in it, I wore a pullover of the same bright yellow, always with a black skirt and hat. I was dressed like the car and the car like me.

"When I *retourne* I find a note on the windscreen. No name, a message only. It says: 'You look so wonderful in the car I would like to meet you.' It was signed with a woman's name and the address of Nice's fashionable Hotel Ruhl.

"Later, when I am in Nice, I think of the note and say, 'Why not?' I go into the hotel and send my card with a message to say this is about the car in Monte Carlo. A fashionable woman greets me with enthusiasm. She says, 'I did not know before—before I thought only this woman and her car make such a vision. But now, are you not Lempicka the painter?' 'Yes, Madame, I am.' 'Well,' she says, 'I am the fashion *directrice* for *Die Dame*.' This was a chic women's magazine in Germany. 'Before I was interested in your look, but now . . . would you consent to do a painting of yourself in your yellow car for the cover of *Die Dame*?'

"I am a young painter. I am not so wealthy. I think quickly, 'yes,' and I say, and yes again, because for this work I will be paid twice. First by the magazine for the reproduction, and then I will be able to sell the painting itself. And so I did. This is how I began with this magazine. I did many covers for them."

Immediately the painting was hailed as a perfect image of the modern woman. Over time it would come to be considered a perfect image of the period. And from the beginning, everyone assumed it was a perfect image of the artist herself. It stood as the centerpiece of the 1972 retrospective and the 1966 exhibit in Paris celebrating the fiftieth anniversary of the Années Folles. Franco Maria Ricci would use it as the cover of his book. The play in Hollywood reproduced it on a poster advertising *Tamara: A Living Movie*. *Das Magazin*, in 1932, said that "Lempicka, a beautiful

Brunhilde, has made her self-portrait as she is in reality—an intelligent and very talented artist, but also a voluptuous woman." *Le Monde* called it in 1972 "a superb work typical of the 'mad years.' " And *Auto-Journal* in 1974 said: "The self-portrait of Tamara de Lempicka is the real image of the independent woman who asserts herself. Her hands are gloved, she is helmeted, and inaccessible; a cold and disturbing Beauty [through which] pierces a formidable being—*this woman is free!*"

All of which is appropriate enough for what the *New York Times* called in 1978 a "steely-eyed goddess of the auto age." For by 1925, Tamara had already adopted her motto: "There are no miracles. There is only what you make." And in the life of gesture, what you make best is yourself. How did the painting become known as *Tamara in the Green Bugatti*? "Later," Tamara claimed, "people said that my car was a big Bugatti, that I was very wealthy. At this time this was *not* so. On the contrary, I was very *poor*." This despite the fact that by her own account she was dressed to the nines and color-coordinated with her car, vacationing in Monte Carlo, going to Chanel's, traveling to Nice, and was already so well known as a painter that *Die Dame*'s editor recognized her name.

And why didn't she do as the fashion director of *Die Dame* asked? Why didn't she paint herself as she was: dressed in yellow, driving a yellow car? "I painted the car green because I prefer it so," she said with characteristic mischievousness.

That gesture was important. It's the way an artist acts.

"Hers is an art of defiant gestures," wrote the *Pittsburgh Sun and Telegraph* of *Kizette on the Balcony*, which in 1927 won Tamara her first major award: First Prize at the Exposition Internationale des Beaux Arts in Bordeaux. She painted Kizette often that year and the next, but otherwise she did not spend much time with her. She kept her from her friends and her parties, which she gave regularly now in her new— and larger—apartment, foisting the child off on Malvina. *Le Carillon* in 1927 called *Kizette in Pink*—purchased by the Musée des Beaux-Arts de Nantes—"outstanding," and *Populaire* said it was "a masterpiece of expression, sincerity, and grace" of the "style Arts Décoratifs": "Madame de Lempicka is a great artist." A third painting, *La Communiante (Kizette, First Communion)*, won her the bronze medal at the Exposition Internationale in Posnan, Poland, in 1929.

By this time, she had placed Kizette in the care of the "dames de Saint Maure," the nuns who ran Cour Dupanloup of Paris, a most snobbish school for young ladies of good family, and Tamara hoped by sending Kizette to them that she could protect her daughter from some of the excesses of her life in the margin. The few weeks she did spend with Kizette each year, she spent *intensely* with her, and Kizette came to long for those times on the Italian lakes, or in Spain or Greece, when her mother was hers alone. At the same time, Tamara tended to show her affection in the one way she knew best—painting—and she often used Kizette as a model, pouring her motherly love into the portraits for the world to see. Sometimes, when she exhibited the paintings, she called them by other names: *Girl on the Balcony* or *Young Girl Reading*. Most of her friends did not know she even had a daughter, and Tamara never rushed to enlighten them.

Kizette on the
Balcony, *1927.*
Musée Georges
Pompidou, Paris.

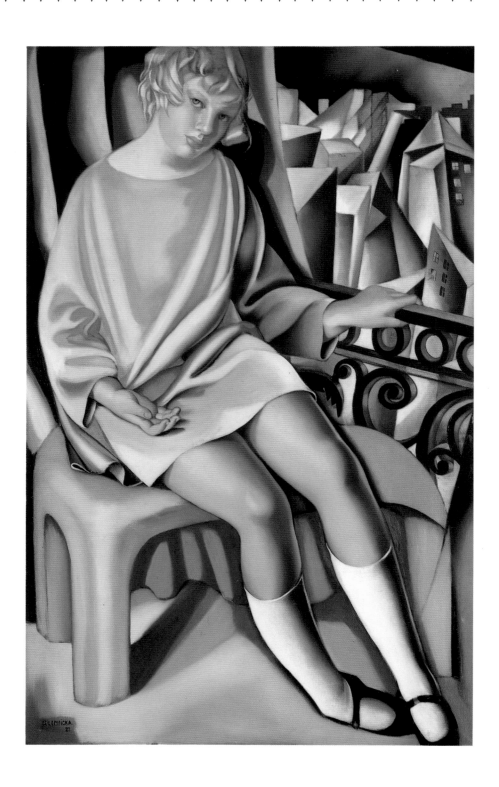

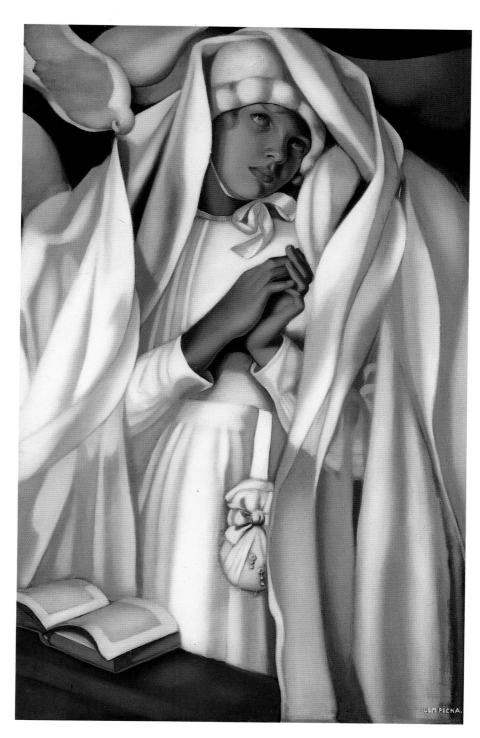

La Communiante
(Kizette, First
Communion), *1929.*
Musée Georges
Pompidou, Paris.

In 1927, she was at the height of her powers, and she could hardly control her longing to capture the moment. She would begin to paint at first light and continue through the day till the light was gone, though sometimes she would come back to work in her studio late at night. At ten-thirty each morning she would take the air in the Bois de Boulogne. It was not a fashionable hour, and especially in winter there were very few people in the park to distract her from thinking about her work.

"Suddenly," Tamara would say, "I become aware of a woman walking some distance in front of me. As she walks, everyone coming in the opposite direction stops and looks at her. They turn their heads as she passes by. I am curious. What is so extraordinary that they are doing this? I walk very quickly until I pass her, then I turn around and come back down the path in the opposite direction. Then I see why everyone stops. She is the most beautiful woman I have ever seen—huge black eyes, beautiful sensuous mouth, beautiful body. I stop her and say to her, 'Mademoiselle, I'm a painter, and I would like you to pose for me. Would you do this?' She says, 'Yes, why not?' And I say, 'Yes, come. My car is here.'

"I took her home in my car, we had lunch, and after lunch, in my studio, I said, 'Undress, I want to paint you.' She undressed without any shame. I said, 'Lay down on this sofa here.' She lay. Every position was art—perfection, and I started to paint her, and I painted her for over a year. We talk, and she tells me many sad stories of her life—her father was a count and her mother was a countess. Finally, I say to her, 'I do not care what you are or what you do, but finish all the lies and speak to me frankly.' And she says, 'When I'm alone at night, I get crazy. I go out into the street and look for men. I need a man. I cannot live without a man.' And she did it not for money. She did it because she needed a man. She had to be with a man, a different man, all the time. Fantastic girl.

"There was a boy who lived in the same building and whose apartment windows were opposite the windows of my studio. He watched her every day, and she knew it. He fell in love with her through the window. Finally she married him, and I lost my model."

Her name was Rafaela, and she became the model for *La Belle Rafaela*, which the *Sunday Times Magazine* (London) has called "one of the most remarkable nudes of the century." It is as quintessential de Lempicka as her *Auto-portrait,* and one of the reasons surely lies in Tamara's lust for her subject, because here the hunger comes as close as it ever does to breaking through the iron bonds of her technique. The desire is palpable. She wants this woman.

Sometimes Tamara's gestures bordered on the indiscreet. She had gone one night with "two good-looking young men" to the Théâtre de Paris, where she saw a pair of bare shoulders she admired on a woman she did not know seated before her in the audience. "When the lights came up," she later told a Japanese writer, "she turned her profile, and I looked at her and I thought—I was painting in my studio a big painting of five women and I could not find the model for the fifth woman. Nobody was fitting—'This is the face. This is what I need.'

80

"I talked to my two boys: 'Look, I want to speak with this lady.' I explained to them what I wanted and said, 'You better get out because I don't know how she will react.' And they said, 'No, you cannot do this. How can you ask? She's a lady. You won't ask her to sit for a nude, you can't.' I said, 'Look, this is my business. Leave me alone. Wait for me at the door.' They both went. I looked at them. They were at the door, standing there, thinking: 'What will she do?' And I touched the woman on her shoulder. I said, 'Madame, my name is Tamara de Lempicka. I'm a painter. I'm doing now a big work. Five personalities. One is missing, and that one is you. Would you sit for my painting—' And my heart was beating. (What would she say? What could she say? 'You take me for a model? What's wrong with you—you are impertinent! How can you ask me to sit?') And I told her—'nude?'

"She looked at me with level eyes. And she said, 'I will sit for your painting.'

"The next day, I went into my studio two hours before to prepare the big canvas, finished all but for one woman. And my heart was beating. Will she come or not? No, she will not. Why should she come? She doesn't know me. At eleven o'clock to the minute . . . knock, knock, knock. I invited her in. 'You can change yourself upstairs, it's the little bedroom on the first floor.' A few minutes later she came back. She had on a little nightgown, no bigger than that, from here to here, a little gown, green, pale green in mousseline. Perfection of body, beautiful color of skin, light and gold."

It went on every day for three weeks, three hours a day. The elegant lady with whom Tamara was infatuated would ask at the end of each session, "I'm coming tomorrow?" And she would answer, "Yes, please." They never talked. Tamara never asked for the woman's name, and the woman never volunteered. On the day she finally brought herself to complete the painting, Tamara said, "Well, that's it. I've finished. And thanks to you, I did the painting just the way I wanted to do it. I would like to thank you. I don't know how. Could I send you perfume?"

"Oh, no," the woman said. "Thank you, no. I don't use perfume."

"Flowers?"

"No, I think flowers should remain in the garden."

She was already at the door, wrapped in her expensive fur coat. Tamara said quickly: "Chocolate?"

"No."

"Money?"

The woman smiled. "No, thank you."

"Then why did you sit for me for three weeks? You gave me all your time."

"I knew and admired your paintings," the woman said. "Goodbye."

She was gone. "I never knew who she was," Tamara told the Japanese writer. "All she said was: 'I knew and I admired your painting and that's why I came.' And disappeared. Forever."

She nurtured her own spontaneity. Inspiration for her was a kind of passion by design. For example, in one of her favorite stories, she was working on a nude in her studio with a professional model she often employed. The model had held her pose for some time and asked for a break. In the corner of the studio Tamara was

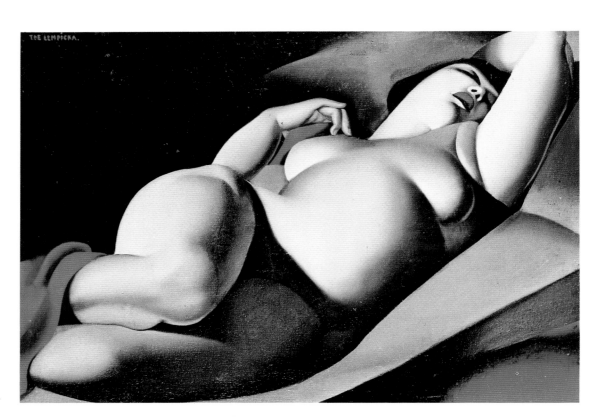

82

La Belle Rafaela,
1927. Private collec-
tion, California.

also working on a still life of a basket of fruit, and the model, claiming she was famished, asked if she could have one of the fruits. When Tamara replied "but certainly," she walked across the room, still naked, and took an apple from the bowl. While she was standing there, something caught her attention and she suddenly stopped with the apple held near her shoulder.

"I had an inspiration," Tamara said. "I called quickly: 'Stop! You must hold that pose exactly as it is. Do not move'" And I sketched *furiously*. I knew that in that moment that what I saw was Eve, and that I must find my Adam.

"When I finished the sketch, I went out into the streets. This was the artist's quarter. I had before me the vision of the Adam and Eve. In the street nearby I saw a *gendarme*, a policeman on his beat. He was young, he was handsome. I said to him: 'Monsieur, I am an artist and I need a model for my painting. Would you pose for me?' And he said, 'Of course, Madame. I am myself an artist. At what time do you require me?' We made arrangements. He came to my studio after work and said: 'How shall I pose?' 'In the nude.' He took off his things and folded them neatly on the chair, placing his big revolver on the top. I set him on the podium and then called my model. 'You are Adam, and here is your Eve,' " I said."

It was one of her more successful works.

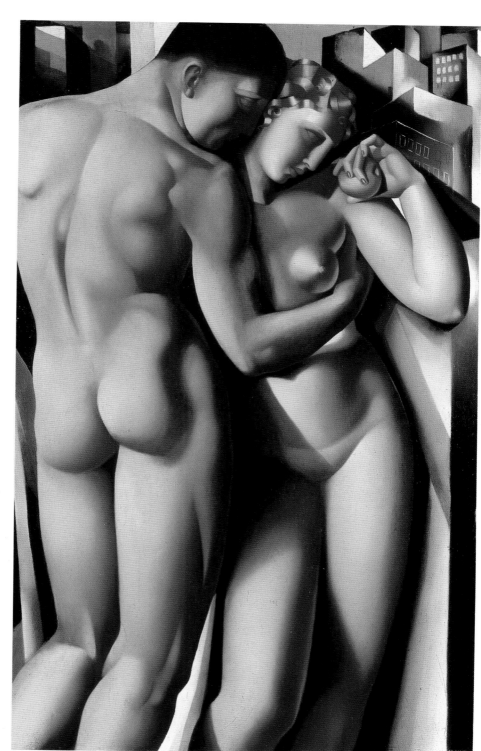

Adam and Eve,
ca. 1932.
Petit Palais, Geneva.

They were stories she told often, vignettes from a life of an artist of the "mad years," an artist who was fast becoming the most sought-after portrait painter in Europe. She asked a starting price of about 50,000 francs, or around $2,000, and in 1927 and 1928 she could do a portrait in three weeks. And whatever she did, people noticed. With the money she bought clothes, especially hats, dozens and dozens of hats, under which she could strike elegant poses in the nightclub La Vie Parisienne, or out shopping with Ira Ponte, or out dining with the brothers d'Afflitto.

One reporter after another fell under her spell and took to hyperbole in describing her long, elegant hands, her thick, reddish-blonde hair, her extravagant wardrobe. Fernand Vallon visited her in 1927, when she was painting the painfully seductive chained captive *Andromeda*. He found her in "cardinal's purple, wearing emeralds as deep as lakes." She was "splendidly blonde," with "delicate hands [and] blood-red fingernails." For one, she was "a slender little thing," for another, tall, slender, and "round in the right places." She was "tall, soft, harmonious in her movements," said Luigi Chiarelli, "glowing with life, her face illuminated by large, rather artificial eyes, and with an easily smiling mouth reddened by costly Parisian lip-rouge." Others concentrated on her clothes, on a "white satin evening gown with a dark red sash and short sable jacket" or "a beige yellow whipcord coat, trimmed in black, designed by Creed." As late as 1951, Vittorio Foschini was captivated by her "slowly gesticulating" hands. They gave the impression that they were "always caressing," and he fantasized that the caresses would feel "very sweet and numbing."

The hunger fueled the gestures of the 1920s. What she painted had a smooth polish, an icy perfection that detached her subjects from reality, that made them archetypal. The elegant poses, the clothes, the hats did the same for her in private life. Beneath the paintings' satin and porcelain surfaces, beneath the icing, passion smoldered, hinted at by the fullness of her volumes, by the violent outbursts of reds, blues, greens. Beneath the outlandish velvet berets, the towering black-and-lace concoctions, or the flop of a huge brim—all her hats threw a dramatic shadow on the right side of her face—was a woman who wanted to touch, who yearned to possess everything beautiful. The style that glossed over the hunger was meant less to hide desire than to make one notice it. The chill was part of the seduction.

Tamara's appeal was not unlike that of Greta Garbo. Tamara, indeed, was well aware of the similarities and took care to cultivate the comparison. "I will tell you what happened when I was in Salsomaggiore in Italy," she would say years later. "I was staying in the best hotel, one of those places you go to make a cure. And then one day, the director of the hotel came to me, and he said, 'Madame de Lempicka, it was in the newspaper that Greta Garbo is here in Salsomaggiore. And people are in front of the hotel waiting for Greta Garbo. And they think that you are Greta Garbo.' I said, 'But you know that I am not.' He said, 'No, we know that you are a great painter. But would you do a favor for our hotel? It will be good publicity.' I say, 'What do you mean?' 'Well,' he said, 'we will say that you are Greta Garbo.' I said, 'If it's good for your hotel, you can do whatever you want.' 'But,' he said, 'they will ask you for your autograph. What will you do?' I said, 'I will sign "Greta Garbo," of course.' And so I did."

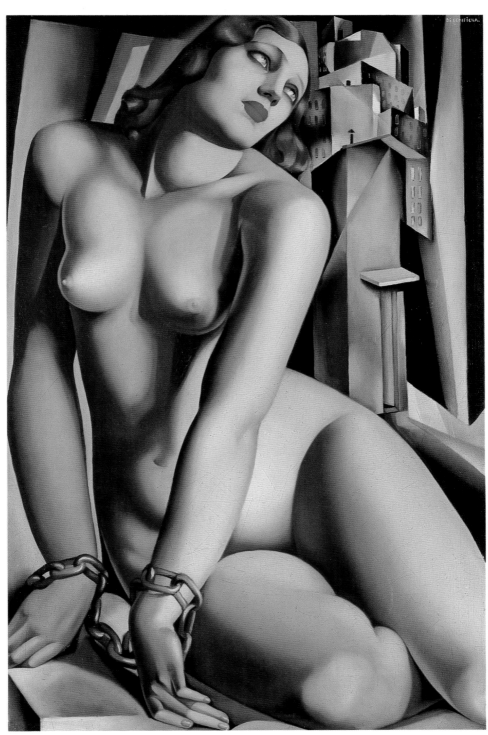

Andromeda,
1927–28.
Private collection.

85

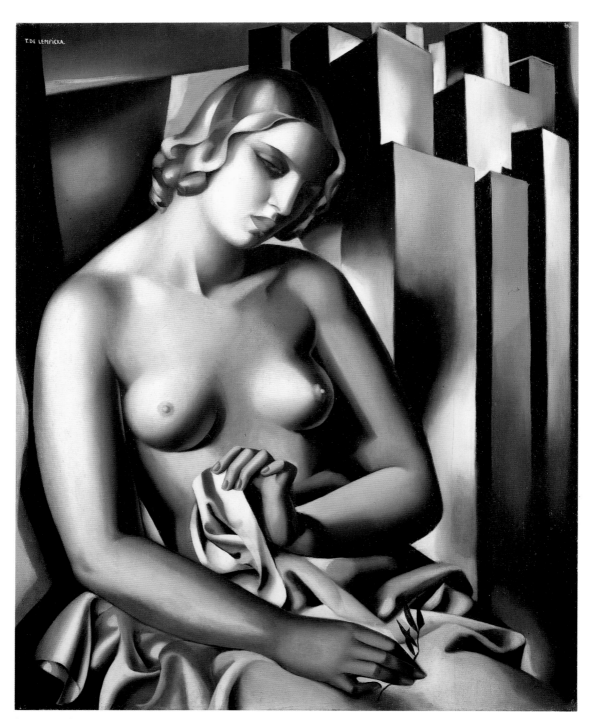

Nu aux buildings, *ca.*
1930. Private
collection.

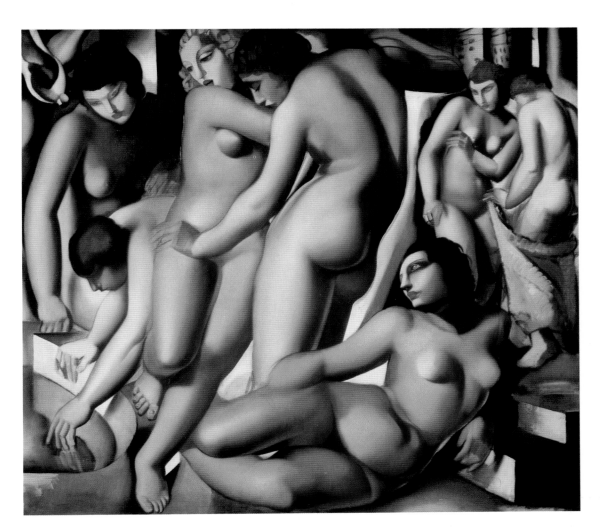

Women Bathing,
ca. 1929.
Private collection.

The de Lempickis had by then moved from rue Montparnasse to a more pretentious house on rue Martin, containing a lovely garden. But the serenity of the surroundings failed to mask the deterioration of the marriage. Tamara was receiving the notice she so craved, and nobody paid her more notice than Tadeusz de Lempicki.

He noticed that she never spent time with her family. He noticed that every second of her life had something to do with her painting. He noticed that she never ate a meal without inviting an art critic, or a fellow artist, or a rich patron, that she never made a friend these days who could not help her with her career, that she never talked about anything but herself, that she spent every franc she made on herself, that in private and in public she was someone he had never met before. And he told her so.

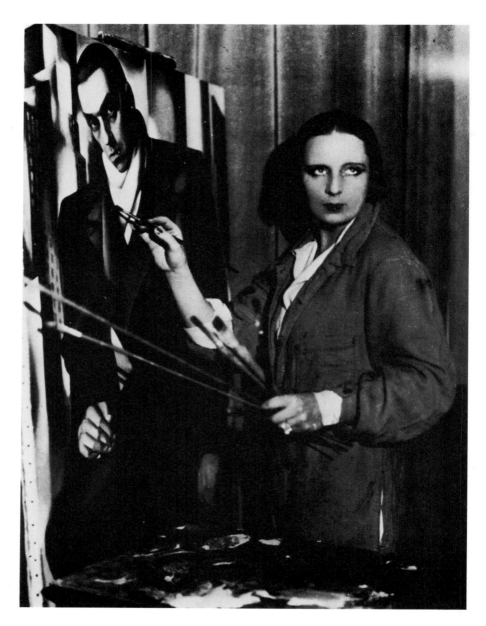

The artist at work on Portrait d'homme, inachevé *(Unfinished portrait of Tadeusz de Lempicki).*

She responded by suggesting that she do a painting of *him*. The resulting portrait captured better than any words the years of resentment, jealousy, pain, and hatred he felt for Tamara. It was the picture of a man who intended to make her pay for what she had done and was doing to him. She began painting it late in 1927, shortly before he left for Warsaw on business for her uncle. In the Polish capital, on a visit to the dentist, he bumped into a woman named Irena Spiess, whose prosperous

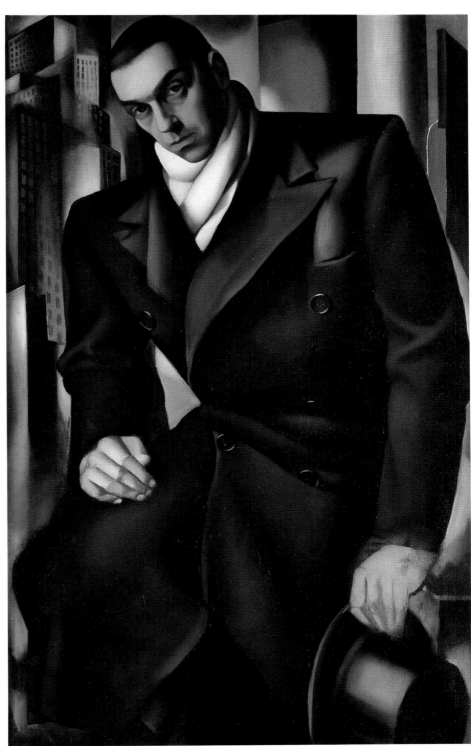

Portrait d'homme,
inachevé *(Unfinished
portrait of Tadeusz de
Lempicki),* 1928.
*Musée Georges
Pompidou, Paris.*

family owned a pharmaceutical company. They met on the staircase leading from the dentist's office and walked to the ground floor together. By that time—according to the story he told Tamara—Irena had fallen in love with him, and told him so. Right there. On the spot. Ridiculous, really.

They had an affair, and he left Tamara for her.

Tamara was at first outraged, then devastated. She took Kizette out of school, kept her at home, and in front of the child cried night after night. The truth of the matter, Kizette always maintained, was that Tamara's anger and her bitterness grew out of her need to control everyone around her, everyone in her life. De Lempicki may not have been the kind of man she needed, but he was her husband, her retainer, part of her court. When he ran away—*for another woman*—that left a gap in her existence, like a gnawing in her stomach she could not ignore.

Tamara made three trips to Poland to plead with Lempicki to come back. On the first two, she went alone. Having failed twice, she took Kizette with her on the third. It worked. Tadeusz agreed to accompany the two of them to Monte Carlo. He would make an effort to patch things up if Tamara would too.

Instead, Monte Carlo's Grand Hotel became the setting against which they played out the last scenes from their marriage. She began again to work on the painting. It was the only way she knew to show she loved someone. Kizette recalls that the fight in Monte Carlo was incredibly brutal. Neither of them pulled any punches. At first, Tadeusz lashed out. No one Tamara knew, even casually, escaped his abuse. He catalogued for her ten solid years of selfish acts, this time in front of the child. Finally, Tamara struck back, as only she could. She admitted to all the affairs he had ever accused her of, even affairs she had not had. And why shouldn't she have affairs when she had such a husband: weak, a failure, and a fool.

When he left for Poland, swearing to marry Irene, Tamara turned on Kizette. She was always her father's daughter. She always took his side. She had been no help at all. "Oh, God, how I love him."

At length she found a more appropriate way to express her rage than by attacking Kizette. She refused to complete Tadeusz's portrait. She always painted life-sized portraits by first finishing the underpaint, then the face, then the hands, one arm and then the other, one leg then the other, and, finally, she filled in the background. With Tadeusz, she skipped the left hand—the one on which she would have painted a wedding ring.

She called it *Portrait d'homme, inachevé*—picture of a man, unfinished—and she finished it in 1928, the year they were divorced.

The life of gesture cost Tamara a husband, but by 1928 it had brought her the success by which she justified living it. That year she graduated from painting the likes of H.I.H. Grand Duke Gabriel Constantinovich, who had no money, and the Duchess de La Salle, who was her friend, to painting for the wealthiest of the bourgeoisie and big landowners in Europe and America.

That year Baron Raoul Kuffner visited her studio; he held title to the largest single estate in the Austro-Hungarian Empire and was extremely well known in

Les Jeunes Filles,
1928. Private
collection.

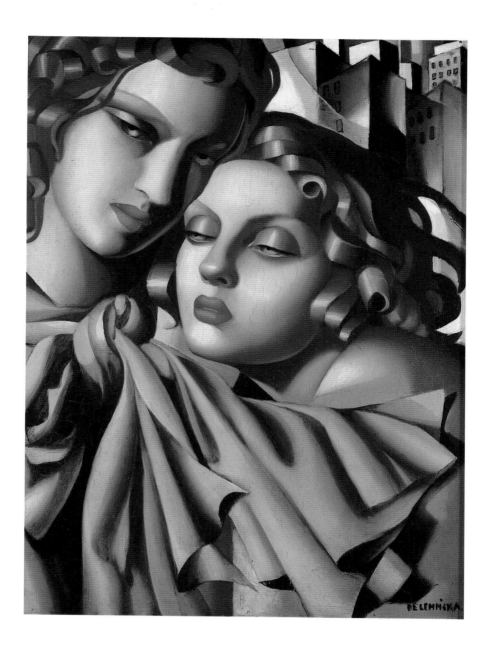

91

cosmopolitan art circles. He had been interested in Tamara for nearly five years, since the time she had sent him, at the request of his art dealer, a number of photographs of her work—all of which he bought.

He was one of her earliest patrons, purchasing literally dozens of her paintings over the years, and now he wanted to commission her directly to paint a portrait of his mistress, the famous Andalusian dancer Nana de Herrera.

Study for Portrait of
the Grand Duke
Gabriel, *ca. 1927.*
Private collection,
California.

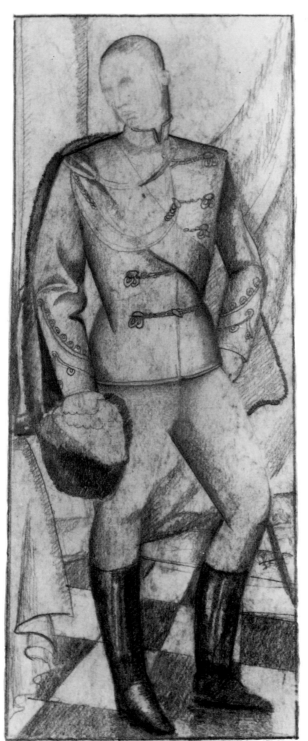

LEMPICKA.

Portrait of the Grand
Duke Gabriel, *ca.*
1927.
Private collection.

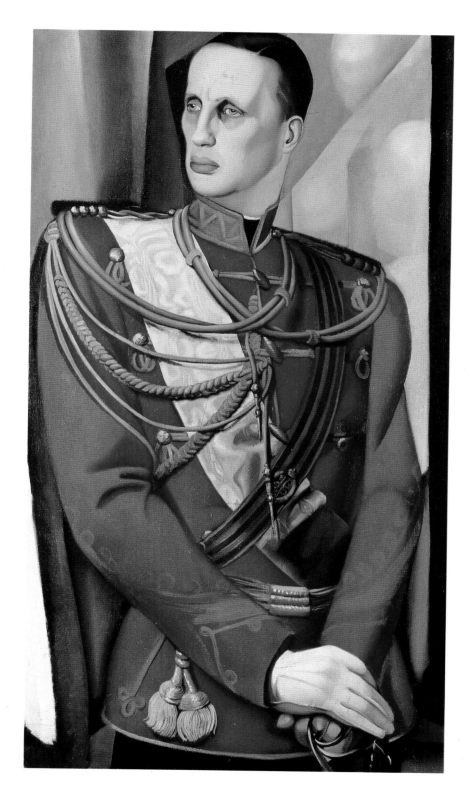

94

"I told him," Tamara said, "that I had heard of her and that she must be very beautiful, if she was a dancer. He said, 'I will call her and tell her to come to see you.' I was very surprised. When she came to my studio, she was badly dressed, she was not elegant, she was not chic. I thought, 'Oh no, I don't want to paint her. I cannot believe that's the famous Nana de Herrera. Well,' I thought, 'let's try.' So, in my studio, I said, 'Sit down.' She sits down. I don't like it. And I said, 'Take this off.' So she takes it off. I don't like it. 'The hair,' I said. 'How do you have your hair done?' 'Oh,' she said, 'just with a flower.' 'So, where is the flower?'

"Finally, I took everything off, until she was nude. Then I added lace here, there. I said, 'Cover up a little bit here, here, and here. As long as she was dressed, it was impossible. So ugly. I couldn't believe it. And I thought, 'This man has very bad taste.' But when she was nude, then she was a little more interesting. Still, as long as she sat there, she was nobody. And I said, 'No, no, no.' And I was about to give up the portrait, not do it at all, until I said, 'When you dance, how do you look?' And she did this expression. And I said, 'That's all right,' and then I painted her."

The portrait—completed in 1929—was something of an assassination, and before long de Lempicka had replaced de Herrera as the mistress of the sophisticated Baron Kuffner.

Portrait of Nana de
Herrera, *1929. Private
collection.*

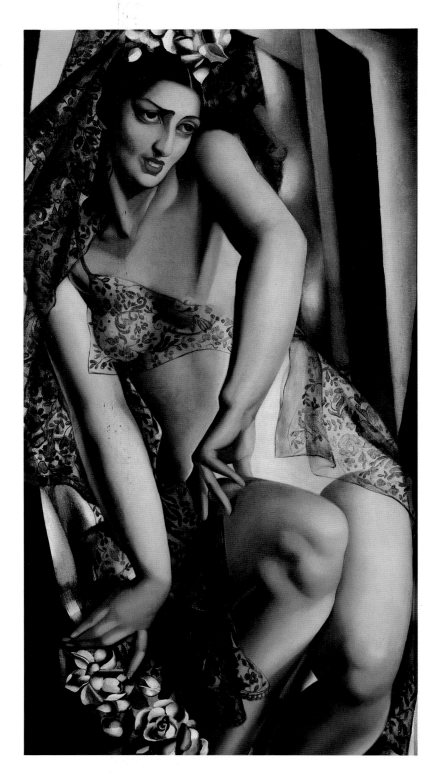

Portrait of Arlette
Boucard, *1928. Private
collection.*

Also, by 1928, Dr. Boucard, a scientist who made millions off his invention of the patent medicine Lacteol, had been buying paintings from her for a year, including the most overtly lesbian of them all: *Myrto, Two Women on a Couch.* Now he invited her to spend the next year working on portraits of his daughter Arlette, himself, and his wife. At the time, Tamara was in a position to turn down portraits when she wanted, and she drove a hard bargain. She sucked the marrow from his bones and came away, if not exactly rich, at least with the freedom of the woman she imagined herself in the *Auto-portrait.*

In 1929, she bought the huge apartment with studio in the rue Méchain on the Rive Gauche and contracted with Mallet-Stevens to design it. Art Deco architecture tends toward the theatrical, and Mallet-Stevens made for her a stage on which to perform her life and create her art. Tamara wanted every detail worked out, down to the material for upholstering the furniture, which she ordered with her initials woven into the fabric. She asked her sister Adrienne, now a noted architect and decorator, to do the entrance hall for her in chrome and glass.

Yes, it would provide just the right backdrop, stark and sleek. Here she would throw the grand parties she had always dreamed of. Here she was sure she would talk to the best minds of her generation, sleep with the most stunning women and the handsomest men in Europe, paint the greatest paintings Paris had ever seen. It was as perfect for her as Il Vittoriale had been for d'Annunzio, and in no time at all it was featured in the right magazines on both sides of the Atlantic.

Late in the spring of 1929, Tamara was on her way to dinner when she received a phone call from a young man who asked if he could see her immediately.

"But, I'm on my way out," she explained.

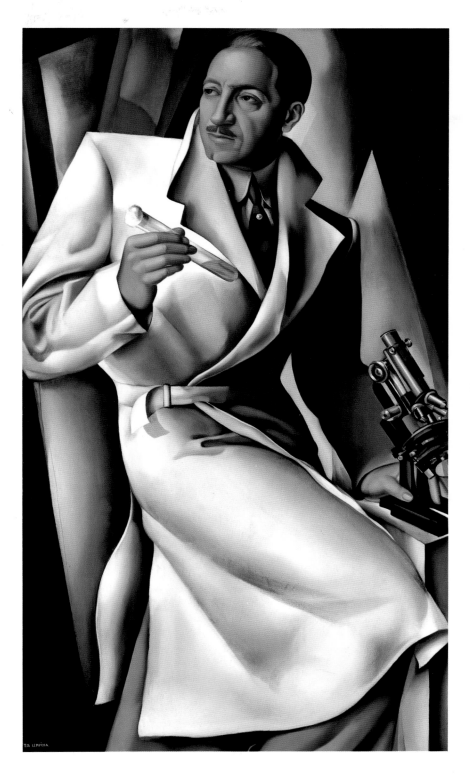

Portrait of Dr.
Boucard, 1929.
Private collection.

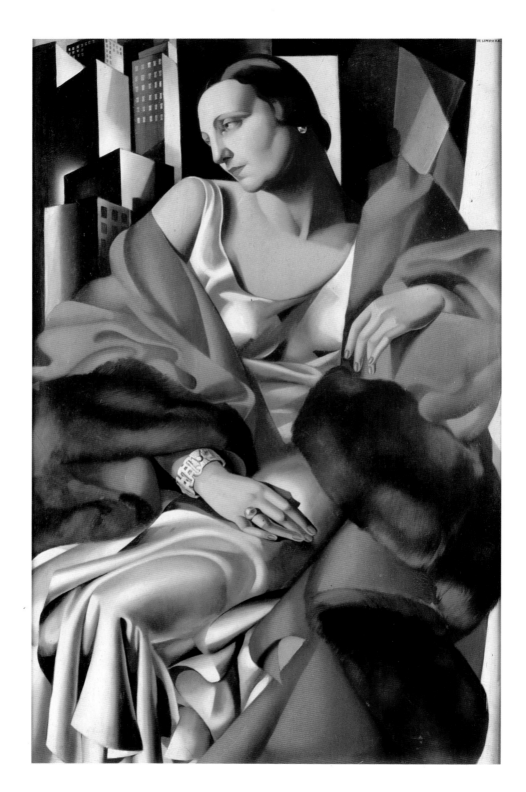

The artist's rue Méchain studio. Paris, early 1930s.

"Please, Madame de Lempicka, I'm from America, and I have been over here attending Oxford University. I am going home to be married. I would like you to come to America to do a portrait of my fiancée."

Something in the casualness of his proposal caused her to pause. His tone carried the sound of money. "Well, then," she said, "come right away because I have a rendezvous at eight o'clock for dinner."

"We'll be there in fifteen minutes."

Fifteen minutes later, a not very good looking but very distinguished young man walked into her studio with a stunningly beautiful young woman on his arm. Without much ado, he said: "Could you do a portrait of my fiancée?"

"Yes," she said, just as directly. "I can do it right away."

"No," he said. "You don't understand. She is going back to America. Could you come to America?"

She said that she could go in four months, and gave the young man her standard rate. Without pause, he suggested they sign a contract right then and there, and sat down to write out: "Tamara de Lempicka, painter, will come to America the 14th of October, to paint the portrait of my wife, life-size" for the sum she had named. He signed it: "Rufus Bush."

Portrait of Madame Boucard, 1931. Collection Boucard, Paris.

*Untitled drawings
(Studies of heads,
Florence), 1929.
Collection of Christie
Tamara Foxhall.*

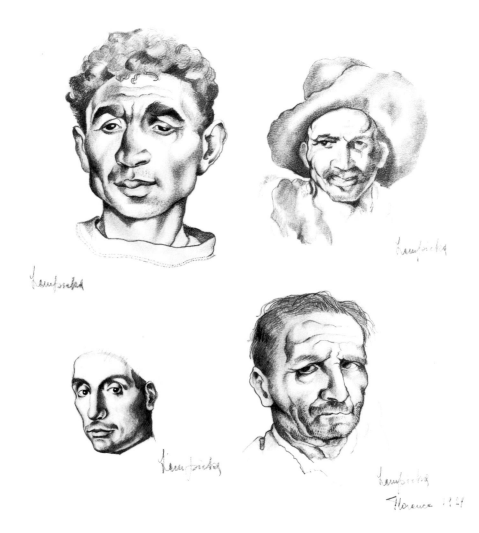

100

The whole thing took a matter of minutes, and she was off to dinner, where she told the story. Her dinner companion was aghast at the price she had charged, told her she would not be able even to survive in New York for that amount, and suggested she write to this Rufus Bush at Oxford to explain that she had made a mistake, that she could not do it for so little money.

She wrote to Bush, and two weeks later he was back in Paris, back at her studio, and asking her just what she thought she needed for the portrait. She named a sum four times the price she had originally given him, and again he sat down, wrote out a contract that read just the same as before, except for the higher commission. She found his behavior remarkable, and it was not till she reached America in the fall that she discovered he was an established young millionaire whose family owned New York's Bush Terminal.

She left France in September of 1929 on the pleasure ship *Paris* after she had finished her portraits of Arlette Boucard and her father, but before she started work on one of Madame Boucard. She planned to stay in New York for only three weeks, and she told Kizette that she would be home soon, before Christmas, and they would spend the holidays together. The Boucards weren't the type to wait. But when things turned out differently, they—like Kizette—waited.

Kizette stayed with her grandmother at Tamara's new apartment. All autumn long, the two of them shared Tamara's letters, which at first came frequently. She described for them the two Rolls-Royces waiting for her when she docked, and the elegant Hotel Savoy to which they had transported her. She told them about New York's skyscrapers, how she had fallen in love with them and planned to use them as background in all her paintings. She wrote that she had wanted to begin painting the same day, but the Bushes told her no, first she had to go with them to order the dress for the painting.

They took off for Hatie Carnegie's, she said, who was the best dressmaker in New York. She objected that there was no time to make a dress, but they said Carnegie would do it for them in a single day. All day long, models would come out wearing elegant gowns, and Tamara would say, "That dress is nice, but the color is a little too strong," and the future Mrs. Rufus Bush would turn to Hatie Carnegie and say, "That dress is nice, but the color is too strong." Tamara would say, "I don't like the color," and the young bride-to-be would say, "I don't like the color." Finally, Tamara wrote, they had settled on a dress, which she described for Kizette and her mother: "It was a red jacket, tailored, with a black skirt. . . ."

She complained to her correspondents about how difficult it was to paint Americans. The first day she had been at work in her studio, a young man had come to visit her richly clad subject—and the woman had invited him right into the studio. "Oh, darling," she said. "This is the painter, you know, from Paris. Oh, she is so lovely. Oh, I just love her. What is your name?" They began to drink champagne, and Tamara could not hold her concentration. "How can I paint?" she said. "I have to have peace. I will go back to Paris. I will not paint." But they looked at her so contritely that she couldn't resist them, and she said, "I will try the American way." Every day now, she wrote, people came, and they all sat around and drank and talked while she painted away. When the painting was done, she wrote that she thought it one of her best portraits.

During all of this, Tamara somehow managed to schedule an exhibition for the end of October at the Carnegie Institute in Pittsburgh. In her letters now, she said she was busy preparing for the show. That was the first time she told them she planned to stay longer than the three weeks. Then, for a while, Malvina and Kizette did not hear much from her, until, early in November, she wrote that the exhibition had gone very well indeed, but that she had lost all the money she had made in America because the bank where she kept it had collapsed after the catastrophe on Wall Street the month before. She had gotten other commissions. She needed to stay for a while yet. She wanted to try to recoup some of her losses. Then they heard nothing at all.

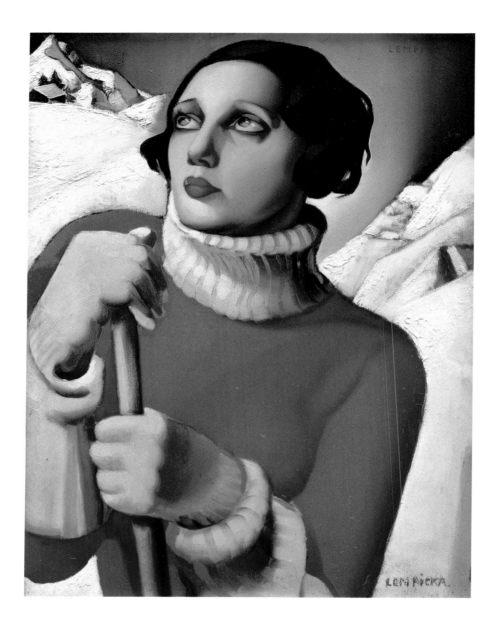

Saint-Moritz, 1929.
Private collection.

Finally, she wrote in mid December to say she had the most wonderful news. She had met a man—he was very rich and very handsome, and he had invited her out to his ranch in New Mexico for Christmas. She was going to spend a month in the Wild West! They would be going together by train, and it was a very famous train, but she could not remember its name. She never mentioned his.

When Malvina received Tamara's letter announcing that she would not be home for Christmas, Kizette was already back from school for the holidays. They were alone

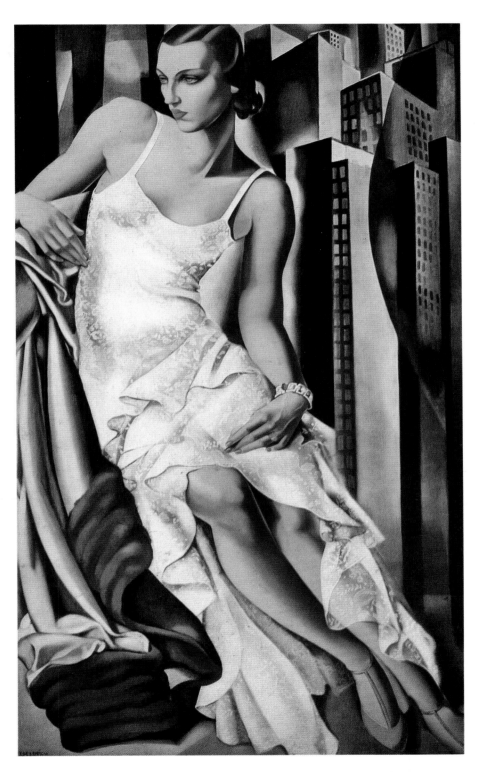

Portrait of Mrs. Alan
Bott, *as reproduced in*
Die Dame, *1930.*

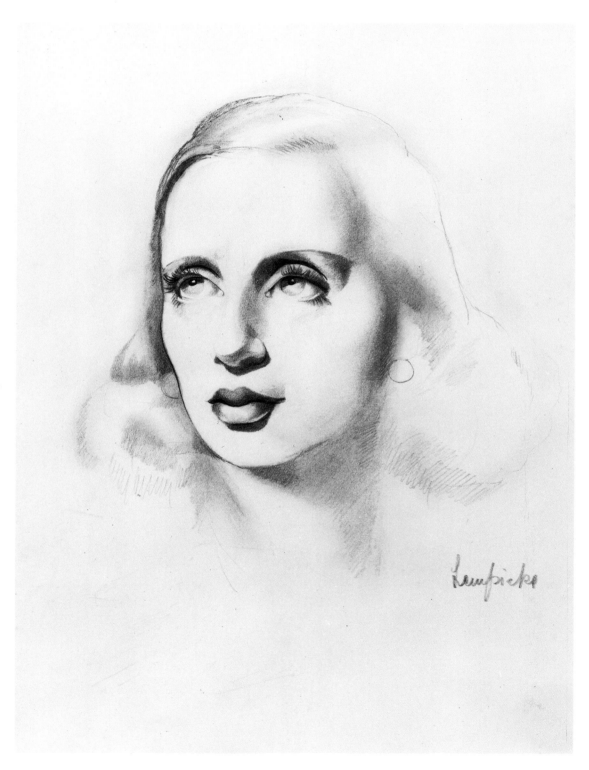

*Untitled drawing
(Self-portrait), n.d.
Collection of Christie
Tamara Foxhall.*

in the cold-gray, antiseptic apartment. It was late afternoon. It was raining. As she read the letter aloud to Kizette, she watched her granddaughter's face, expecting some reaction. She saw none. When she finished, she took the letter, crumpled it, and walked into the back rooms to find the incinerator. She stopped, threw the letter inside, and watched it burn.

She looked at the flames for a time, too long a time. Kizette said, "Grandmother, what is the matter?"

"I hate her... *hats*," the dignified old woman replied.

She turned and headed upstairs toward Tamara's bedroom. Kizette followed. Once they arrived, Malvina went straight for the closet. She opened it and pulled down a hat, a feather and veil concoction, and dropped it on the bed. Then she pulled down another. Then several at once. "Here," she said. "Take these downstairs."

Soon they had every hat in the house—all Tamara owned that she had not taken with her to America, all bearing the names of expensive Paris designers, all assembled in a pile before the incinerator. Without a word, Malvina began pitching them one by one into the flames. In total silence, Kizette, fascinated, followed each movement her grandmother made. Malvina would let one burn, look at the fire for a few minutes, reach back, pick up another, hold it in front of her face as if to imagine a special time when she remembered Tamara wearing that particular hat, then toss it into the fire.

They stood there, not speaking, watching the hats go up in flames, until there was nothing left to burn.

105

DEJA VU
(PARIS, 1931-1939)

Tamara did not know it yet, but by the time she got back from America the party was over. The lost generation had lost its energy—and its money. It had been living on borrowed time, which it called trading on margin, and now it had to cut expenses, head for home, settle down. Depression set in.

While she was still in America, the average value of stock on the New York exchange had dropped 40 percent in a single month. Between 1929 and 1932, the average value of fifty industrials fell from 252 to 61, and in those same three years five thousand American banks followed the one Tamara wrote home about and closed their doors. In 1931 the failure of the *Kreditanstalt,* a leading bank in Vienna, sent a wave of shivers, bankruptcies, and business calamities over all of Europe. By 1932 world production had fallen 38 percent below its 1929 level, and international trade had been cut by two-thirds.

Before long a strange little man who looked remarkably like Charlie Chaplin would play on the turmoil of worldwide depression to get himself elected ruler of Germany. He would become the last chancellor of a Weimar Republic tottering under the combined weight of its massive war debt, its drastic unemployment, its ruinous inflation, its excessive hedonism, and its complete political impotence. Eventually he would make the whole of Europe the stage for his own peculiar—and political—version of the life of gesture. As surely as Lenin had taken St. Petersburg, Hitler would take Paris away from Tamara.

But just then, in the early 1930s, she was more famous than she had ever been. She still had her vignettes, the stories that she lived and then told over and over again. She still painted mostly the rich and famous, among them Queen Elizabeth of Greece, King Alfonso of Spain, and her friend Suzy Solidor. The portrait she executed of the lesbian nightclub owner, perhaps by then the most painted woman in the world, was Suzy's thirtieth and maybe her favorite. The one she did of King Alfonso was his first since the Republican forces had chased him off the Iberian peninsula in 1931, and he did not like the painting—at least he did not like sitting for her. She treated him too high-handedly. "We are not accustomed to being addressed in such a manner," His Highness told Tamara. "And we are not used to models who talk so much," she snapped in reply.

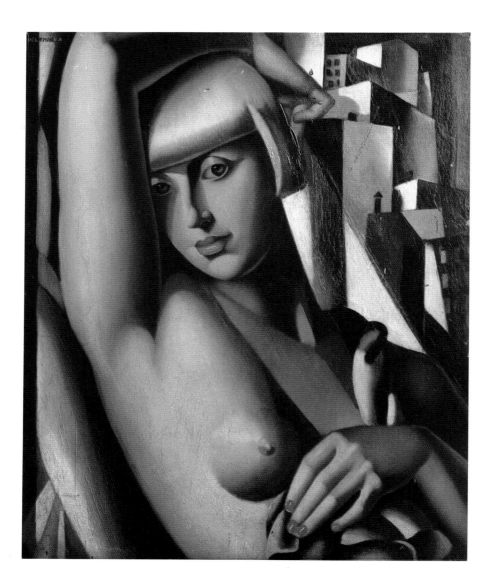

Portrait of Suzy
Solidor, *1933.*
Musée de Cagnes
sur Mer, France.

108

The painting progressed and so did their relationship. His Majesty invited her
one afternoon for a ride in the country. Somewhere outside Paris, they had a flat
tire. As the king's chauffeur worked to repair it, several mill hands from a nearby
village passed by, and the two stranded motorists struck up a conversation with
them. Like all kings, Alfonso imagined he got along well with "the people." He asked
them what they did for a living, and one of them explained that the mill had closed
down, and they at present were out of work. They asked in return what he did. "I
am king of Spain," His Majesty replied, "and I, too, am unemployed."

By 1932, so were 30,000,000 others.

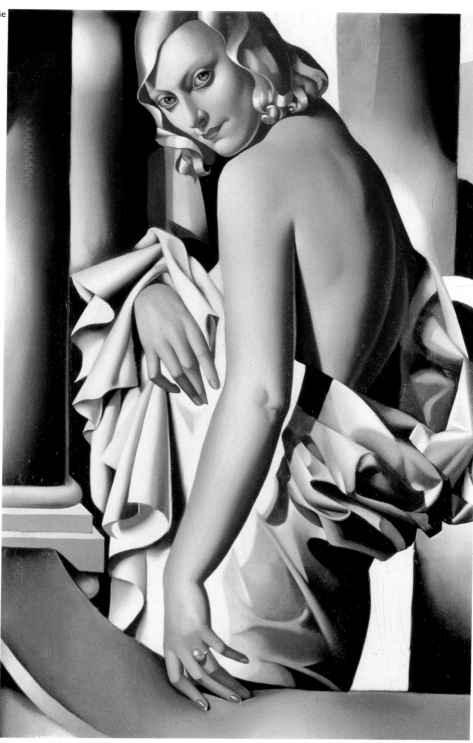

Portrait of Marjorie
Ferry, *ca. 1932.*
Private collection.

La Chemise rose,
*1933. Private
collection, Paris.*

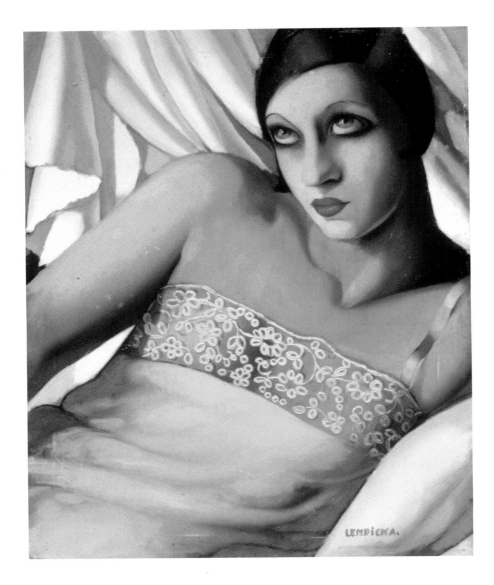

With signs all around her of a world in trouble, Tamara seemed anxious to expand her repertoire, and occasionally throughout the thirties, now an old man, now a peasant mother and child, now a saint or two appeared in her paintings. She toned down her neo-Cubism a bit and indulged more her infatuation with the classics. But even so, her paintings still had to feed her narrative: "I wished to paint an old man. It was a very strong desire. I *must* find the old man. So I went to the Académie de la Grande Chaumière to search for a model. There I found the face. An old man in rags. I said he must sit dressed exactly as he is. He came back to my studio. He sat for some days, always looking so sad. Then one day, before we began, he takes

Portrait of
Madame M., *1933.*
Private collection,
Paris.

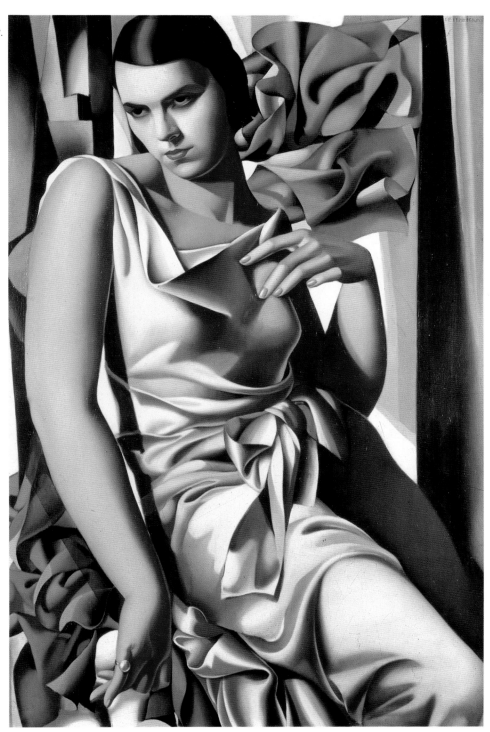

from his pocket a wallet from which he takes a very old, very yellow cutting from the newspaper. It was folded one hundred times. He gives it to me and says, 'I was not always as you see me.' The cutting tells of Rodin's lovers [*The Kiss*]. It tells the model's name. 'I am that man,' he says.''

Even her models seemed to be warning her.

At first she was too busy to pay attention. She kept up her painfully productive professional pace and stuck to her insanely active social schedule, and both still yielded a few dividends. In addition to the commissions she commanded, a couple of museums (the Musée des Beaux-Arts de Nantes, the Musée National d'Art Moderne) began to acquire her work. Of course, she continued to exhibit, now at the Galerie Zak, the Galerie Colette Weill, the Galerie du Cygne. By the end of the decade she had added the Musée du Jeu de Paume, the Pavillion on the Espalanade des Invalides, and the Galerie Charpentier, all in Paris.

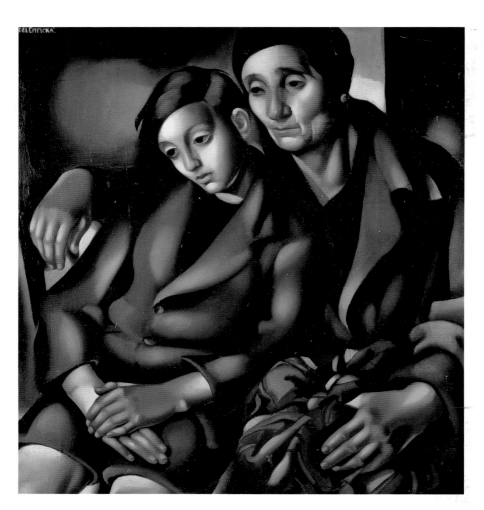

The Refugees, *1937.*
Musée d'Art et
d'Histoire, Saint-Denis,
France.

112

Old Man with Guitar,
*1935. Musée
Departemental de
L'Oise, Beauvais.*

113

And soon she had garnered her first proposal of marriage. It came from Dr. Sergei Voronoff, whom she had seduced at a health spa on Lake Como. Voronoff was the first of those physicians to peddle to an aging European aristocracy a solution made from the glands of monkeys as a cure for flagging virility. Naturally, he made a fortune. Completely enamored of Tamara, Voronoff offered her anything she wanted. But he was a Russian, and she had just gotten free of one jealous, possessive Slavic male. Before she gave him an answer, she said, she wanted him to describe for her a day in the future life of Madame Voronoff.

Nude with Sails
(L'Heure bleue), *1931.*
Private collection.

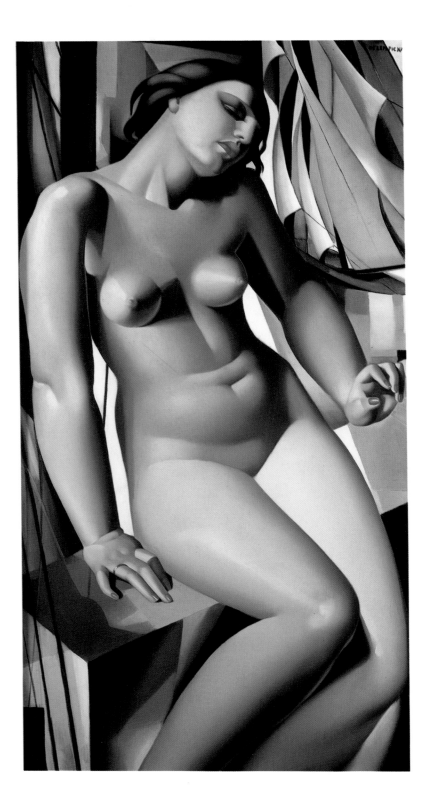

"We would travel," he said, "and stay in the best hotels, of course. Each morning, I would take you to the *couturier*, and we would look at clothes together, and you would choose whatever you wanted. Then lunch. Afterward, every afternoon, we would stop by the jeweler's—by Cartier's or Tiffany's or whomsoever you wish—and I would buy you diamonds, emeralds. And each evening, you would wear what you had purchased that day to accompany me to the finest restaurants in Europe. You would have to do nothing. I would take care of everything."

"When would I paint during such a day?" she asked.

"But there would be no need for you to paint at all," Voronoff told her. He was puzzled. "I have all the money we would ever need."

Voronoff did not understand her peculiar hunger, and she rejected him for it. Afterwards, she always laughed as she told how he had gone on to marry an eighteen-year-old Rumanian beauty and bought her a huge castle in Spain. When Tamara saw the couple two years after their marriage, she failed to recognize his bride because she had grown so fat. "She did nothing but eat chocolates all day," Tamara said, "and lie around in bed making love. As I looked at her, I knew I looked at my own fate—one I had escaped."

By then, too, Tamara had a better offer.

Tamara's affair with the Baron Raoul Kuffner may have begun as early as 1928, the year he asked her to paint his mistress, Nana de Herrera. In 1929, Tamara did a remarkable pen-and-ink portrait of the Baron himself, which she carefully hid away

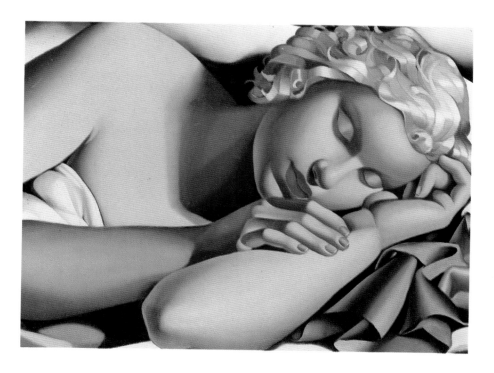

Girl Sleeping, 1935.
Private collection.

and which was not discovered for almost sixty years. Given her penchant for trying to capture her emotional life on canvas, it was a telltale sign. Without a doubt, however, she took up with him after her return from America. By the time she finished a full-scale portrait of him in 1932, she had completely replaced Herrera as the other woman. Then, in 1933, the Baroness Kuffner died of leukemia on his estate, "Dioszegh," in Hungary, and the Baron wrote Tamara a number of letters informing her of the event and proposing marriage upon his return to Paris. At the time, though, she was out of the country, and it was not until she returned to France that she discovered the turn her private life had taken.

Back in Paris, the Baron's proposal took her by surprise. She could not take his offer as lightly as she had Voronoff's. In the first place, she felt genuine affection for "Rollie," as she called him. In the second, he, unlike Voronoff, was at the center of her social world: he ran with the same crowd she did; he was admired by almost everyone who knew him for his worldly ways and his gentlemanly manners; and by that time he was her best patron. Lastly, his offer was very attractive. He would give her two things she had always longed for: more money and a *title*. For someone with her background, they were the two things that, along with her accomplishments as an artist, spelled "success." Bohemian notoriety was all well and good when it was the best she could hope for, but the Baron could take her out of life in the margin and give her life at the top. He had placed before her at last the dish that could satisfy her hunger.

But for all of that, she did not love him as she had loved Tadeusz—and she did love the life she was leading. She wanted what she wanted when she wanted it, not when some man told her she could have it. She had done pretty well for herself, thank you. She had her pride. It was very difficult for her to drop the mask she had painted for herself in the *Auto-portrait,* even when Rollie returned to Paris and assured her that she would not have to change either her public or her private life. He was a man of the world, he said. He had his life to lead, she had hers. He expected neither to change. He would stick to his big game hunting, the care of his guns, and his land. She could keep her friends, her lovers, her studio, her career, and her own hours—in short, she could have her freedom along with the title and the money. He preferred it so.

Still, she hesitated, until her mother intervened. A revolution, a world war, and life as a destitute refugee had made the once fun-loving Malvina a very practical woman. "Tamara, you are a fool," she said. "Stop acting like a spoiled child. Do you think you are going to get a better offer? You will not always be so young. You will not always be so attractive. Marry Rollie. He will be a good husband. He is wealthy. You will not have to work so hard."

For once, she listened to her mother. She married the Baron in 1933 in a sedate civil ceremony. They spent their honeymoon in Egypt, then traveled overland to Hungary, where they inspected his estates, about which one day he would write a book. Kuffner's family had raised beef and made beer for the Austro-Hungarian Emperor Franz Joseph, for which the family had been ennobled, and Rollie still had holdings throughout Central Europe. During a quiet stay in the Austrian Alps, while

Portraits of the artist.
Paris and Milan, 1930s.
Also pages 118, 120.

117

In the rue Méchain studio: the bar designed by Tamara's sister, Adrienne de Montaut, architect D.E.S.A. Paris, early 1930s.

they breakfasted outside in a quaint cafe attached to the hotel, Tamara noticed a group of Hitler Youth marching by, singing.

"Déjà vu," she said, more or less to herself.

"What is that, Tamara?" Kuffner asked of his new wife.

"Rollie," she said, dramatically. "You must sell your estates—everything. Sell it now. Move whatever you do not wish to sell out of the country, to Paris or Switzerland. Switzerland will be better. We will go to America."

He thought she was joking, and when she insisted that she wasn't, that she had been through all of this before, that she knew a revolution brewing when she saw one, he told her they would talk about it later. For the time being, they would simply go back to Paris and live just as they had been living. Stop worrying. Nothing could harm her now. He would see to that. She was a baroness, the Baroness Kuffner, and he was her husband. He knew exactly what she needed. He knew exactly how to provide it.

And he was as good as his word. They bought a third floor for him in her studio/apartment on rue Méchain, but he preferred to stay at the Westminster Hotel. They sent Kizette away to school in England, first to the Convent of St. Maure in Weybridge, Surrey (she had earlier attended the Cour Dupanloup in Paris, run by the same order

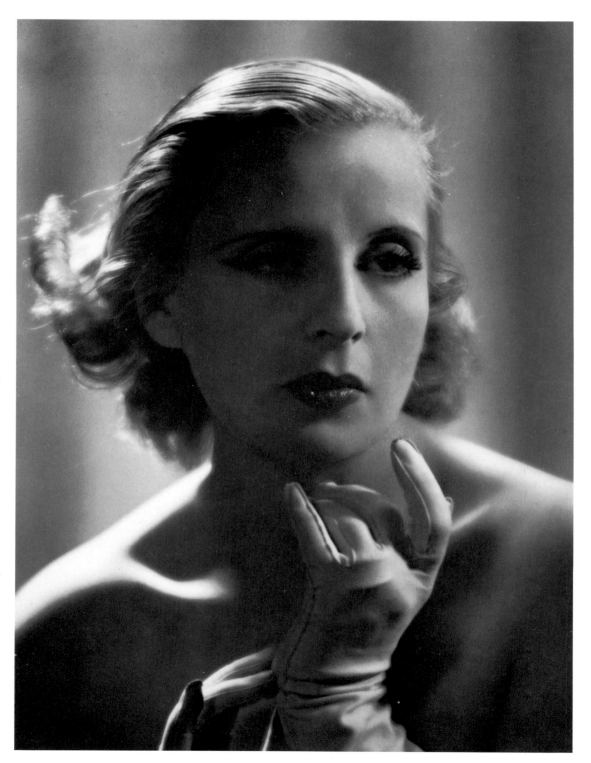

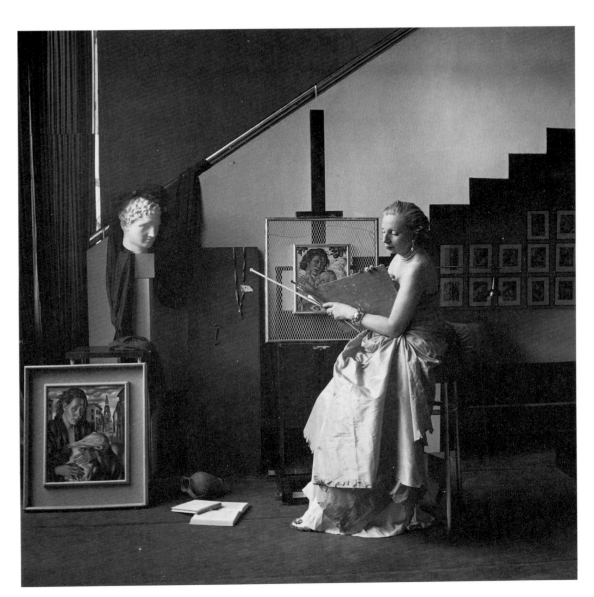

121

The artist in her rue Méchain studio. Paris, about 1937.

of nuns), and then to Oxford. They hired a man to cook and take care of Tamara's place, an Oriental named Lai. Life did go on as before, only better.

It was as if she had undone history. She was back to the kind of life she had once expected to live in St. Petersburg, the kind of life that had been taken away from her by a bunch of power-mad hooligans in the cold winter of 1917. And because it was so good, she could not get rid of the haunting image she had had in the Austrian Alps—of beautiful blond children marching in time and singing in tune the mindless songs of the Nazis. She had seen that day the one thing in her life that always made her feel insecure: people who were both poor and fanatical.

Nude, *1936. Private collection, Houston.*

In 1933, the Nazis burned the Reichstag, the German parliament. They framed a hapless communist for the deed, and he was duly executed. A week later, Hitler was legally elected Chancellor of Germany, and the National Socialist Party's revolution was under way. He called his new order the Third Reich and claimed it would last a thousand years. On June 30, 1934, Hitler purged the Nazi party of the old Brownshirts, or S.A., the social revolutionary faction of his movement, which had served him as a private army on his rise to power, but whose leader Röhm had turned from a one-time friend to a sometime rival. Hitler took the opportunity to murder in a single night a thousand or so others who had offended him in some way. He established a secret police, the Gestapo, called himself "Der Fuehrer," and began to take away the rest of Europe piece by piece from its rightful owners.

Tamara passed through Hitler's new Germany for the first time in 1934, on her way back to Paris from Poland. The train stopped in Berlin early in the morning, and she decided on the spur of the moment to hop off and visit some friends.

"I thought," she said later, "I will ring them, we will lunch, and I will take the evening train to Paris. And so I did.

Lady in Blue, 1939.
The Metropolitan
Museum of Art.

123

"Hitler was not long in power at this time, but already the streets were filled with Nazi uniforms and the people were afraid. At lunch in the hotel my friend says to me, 'I am so happy to see you, but how did you get a permit to come?' And I say: 'Permit, what permit?' She becomes terribly upset. 'This is terrible,' she says. 'We must go to the police at once.' We leave the hotel. We go to the police. They are rude. They take away my passport. They ask my friend many questions. Finally they take me to the chief authority. He is sitting behind a big desk in a big room. He is wearing the Nazi uniform and the red band on his arm. He had my papers. He looks at them and frowns. 'Madame Lempicka, you are a French citizen?' 'Yes I am.' 'And you live in Paris?' 'Yes I do.' 'And why do you stop in Berlin with no permit?' He looks at me. I am afraid, but I do not show this. I tell him. He looks again at my papers, then he asks, 'Are you the same Mme. Lempicka who paints the covers of *Die Dame?*' 'Yes, I am.' 'Ah,' he says, coming around the desk to shake my hand. 'I am so pleased to meet you. My wife is most fond of your paintings; in fact, we have collected all your covers from the magazine. I will let you pay the fine, the lightest punishment, and you may go. But you must *never* come back to Germany.' "

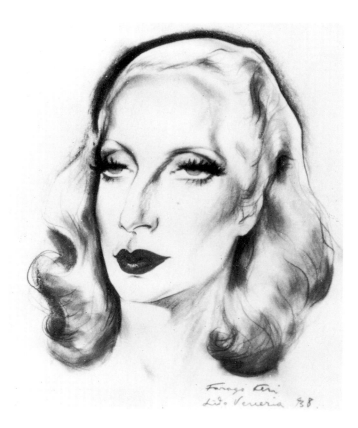

Pencil sketch of Tamara de Lempicka. Lido, Venice, 1938.

124

And she never did.

In Paris, she began to harp on Kuffner to sell his property. And she talked about America, how she loved it. She sensed that history had started up again, somehow, and it made her uneasy. But it was more than Herr Hitler and the German drive for *Lebensraum* that made her uncomfortable. By the late 1930s time had conspired against her in a number of ways, as it had against everyone who lived the life of gesture. Marriage to Kuffner had taken the edge off her hunger. At thirty-seven and thirty-eight and thirty-nine and forty, she was losing some of her energy. She had tied herself so closely to her "look," to her times, that she found it extremely difficult to loosen the stranglehold of style. For, by then, like Art Deco itself, she was already becoming a little passé. Franzi Hohenlohe remembers the first time he met her, when she visited Kizette at Oxford, that he found her striking, yes, and theatrical, yes, but beautiful, no. Instead, he thought, "This woman must have really been something when she was younger."

During the last half of the decade of the 1930s, Kuffner moved permanently into a suite at the Westminster Hotel. Tamara stayed at the studio in rue Méchain, where she continued—however fitfully—to paint in between the parties that she threw more and more frequently. She spent much of her time at the Boeuf sur le Toit, a

*The Baroness Kuffner—
Tamara with her
second husband, Raoul
Kuffner. Venice.*

fashionable nightclub, or at Maxim's, where both she and Kuffner enjoyed dining. Kuffner liked to beat the crowd, eat early, and move on. She joined him late, at a fashionable 9:00 or 9:30, when she could be seen. And, in this as in all things, he catered to her whims.

The two of them traveled often to Venice, where she stayed at the Excelsior, he at the Danieli. Once while they were there, Hohenlohe—on holiday in Venice himself—politely looked up his friend's mother, with whom he had only recently become acquainted, hoping to meet her husband as well. Like Kuffner, Hohenlohe's father had known the Emperor Franz Joseph and known him quite well. Hohenlohe was promptly dubbed Tamara's escort for the evening. He was to take her to the opera. "As we left the hotel," Hohenlohe said, "this kindly old gentleman kept patting my hand and smiling. 'Now take care of our little treasure. Don't keep her out too late' and all that. She was precious to him, my God, as if she were his daughter, rather than this mature woman who certainly knew her way around as well as I did— better!"

Soon, even her everyday life seemed to be going sour. She lost her cook and major-domo, Lai, to an ambassador who attended one of her dinners. She caught her decades-long friend Ira Ponte stealing money from her and severed their relationship immediately and forever. And Kizette, who graduated from Oxford, seemed to be going nowhere in her life. She moved about Europe from one pleasure spot to another with her young friends and did not try to develop her talent for writing. She was lazy, Tamara said, and overeducated.

On one of Tamara's extended stays at the Bircher-Benner spa in Zurich in 1936, she began to see a psychiatrist, whom she promptly painted in the guise of St.

125

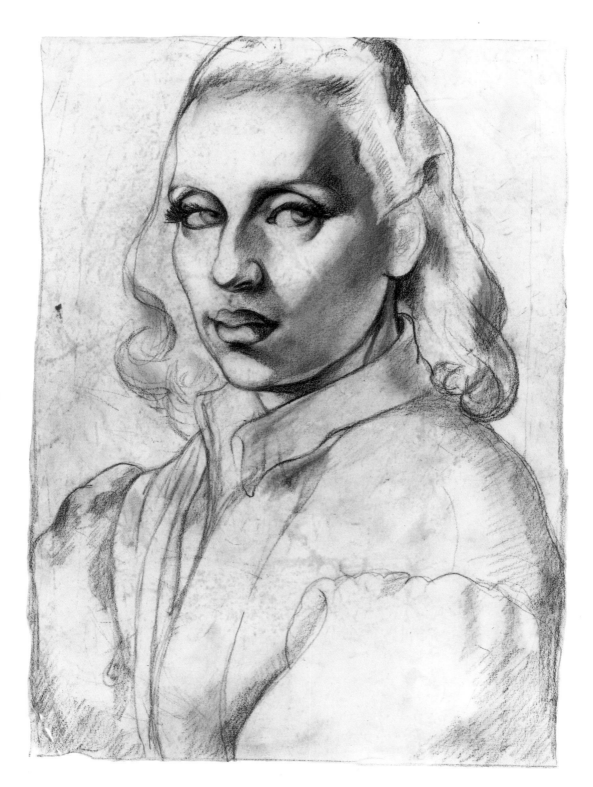

Anthony. The gesture was appropriate: Tamara had begun to look for salvation, somewhere, anywhere.

In 1937, Nazi agitation flared up in the free city of Danzig. In March of 1938, Hitler overran Austria and established his much longed-for *Anschluss* with the country of his birth. Later that year he moved on Czechoslovakia, and the French, like the rest of the world, held their breath as their leaders bought peace in their time with the souls of a few million Slavs.

Finally Kuffner listened to Tamara. He sold off a considerable number of his holdings, keeping enough land to maintain his children by his first marriage. He salvaged from those estates that he did sell many of the family heirlooms and treasures, which he stored in Switzerland to be retrieved later. By 1939, with the threat of war hanging over Europe, he agreed to take an extended vacation with Tamara to America.

Though she was Polish, Tamara was not a Jew. She had blonde hair and blue eyes. She was rich, titled, talented, and decadent. She loved the music of Richard Wagner. Her paintings had nothing in them to offend Der Fuehrer's aesthetics. She was probably in no great danger if she controlled her natural bluntness and her disdain for Herr Hitler and his ilk. She had nothing to fear but history itself. And there was nothing she feared more.

The summer Tamara and Baron Kuffner booked passage for America, Kizette traveled to Poland with her Aunt Adrienne and Adrienne's architect husband, Pierre de Montaut. Husband and wife were working as a team in Adrienne's native country designing newsreel theaters for Pathé Nathan. Tamara wanted Kizette to come with her to America, but her daughter refused, calling it a "barbarian country." She did not care if there was a war. She would rather live in a civilized country at war than in a primitive one like the United States during peacetime. It was safer, she said.

On August 31, 1939, the de Montauts and Kizette were ready to return to Paris, and they left Warsaw by motorcar. They drove west toward the Maginot Line, the barrier that was supposed to protect French soil from invasion, and almost collided head-on with Panzer tanks and armored trucks. The next day at dawn, Hitler attacked Poland. By then Kizette's mother was already in America.

Tamara herself had spent her last season in Europe, before the "great European debacle," wondering where things had gone wrong. "I was in an artist's depression," she said later. "When you create, create, create and put out so much of yourself, you become drained and depressed. I had gone to Italy to deal with the depression, and there I suddenly decided to give it all up, to enter a convent and just paint simple things. I went to a convent near Parma and rang the bell. A lovely nun answered, and I asked to see the Mother Superior. 'Sit down, my child,' she says. I sit on the hard bench and wait. I do not know how long. Then I go into a wonderful Renaissance room with the ceiling and the columns and there was the Mother Superior, and on her face was the suffering of the world, so terrible to look at, so sad, and I rushed out of the room. I forgot for what I came there. I knew only that I must have canvas and brush and paint her, this face.

"But already we are packing to leave for America, my second husband, the

Portrait of Pierre de Montaut, *1931. Private collection, Paris.*

128

Baron, and I. So I must wait. We arrived in New York. We are staying at the [Savoy Plaza], but I have a studio in another place, an old, dirty studio with a cat just like in Europe.

"I take from my hotel black cloth and white cloth and in the studio I put them on an old armchair that is on the podium in the good light and then I see her, the Mother Superior. It was as if I was in a trance, a fever. I talked to her and told her to turn more to the left and so on and so on. After three weeks, I worked and worked and worked and it was finally finished. It is small, no bigger than a magazine page. My husband put it on the mantel in the hotel. He looks at it for a very long time in silence. Then he says, 'This is the best, I think.' "

Many critics disagreed. Though *Mother Superior* was acquired by the French government in 1976 and now hangs in the Musée des Beaux-Arts de Nantes, to this day a number of them think it one of her worst, her phoniest paintings, with cheap

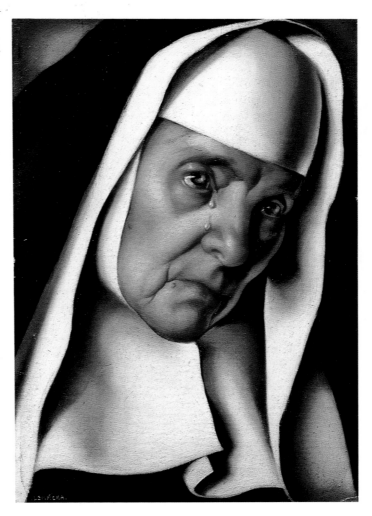

Mother Superior,
1939. Musée des
Beaux-Arts de Nantes,
France.

129

emotionalism and "unpardonable" glycerine tears. It is what happens when a style no longer serves its artist, when technique begins to substitute for vision.

But the story itself is telling. It is Tamara de Lempicka's last vignette from the "mad years." Time had caught up with her, and just as Cocteau had predicted, her social life had begun to erode her art.

In the summer of 1939, Tamara de Lempicka, the Grande Dame of Art Deco, Siren of the Silent Era, left a Europe headed straight for a second world war to sail for America, trying to escape her own history, looking for personal salvation and a renewal of her powers. But she would discover, like many emigrés before her, that you cannot simply sail away from your own past, your own character.

The trip became just another gesture. On the voyage over, she suffered a sea change. When she stepped off the boat in New York, Tamara de Lempicka had vanished. All that was left was a chic curiosity named the Baroness Kuffner.

9

THE BARONESS
(HOLLYWOOD AND NEW YORK, 1940-1962)

In Hollywood, everybody lives by gestures. It's expected. And it has been, ever since the turn of the century, when a few street-wise New York Jews—attracted to the little backwater suburb of L.A. by its cheap real estate and its cloud-free sky—opened up their shops selling dreams to the poor and the lonely. They called those dreams "the movies" and made a mint off them. In the process they also created something called the "star system," a peculiarly American version of aristocracy, based on an actor's ability to project on film not just the character he or she happens to be playing at the moment, but some ineffable essence made up of looks, manner, presence, style. If one had *It*, one did not need much else, at least not for the moment.

After she held a one-woman show at Paul Reinhart's gallery in 1939, the Baroness Kuffner and her husband took up residence at American director King Vidor's former house in Beverly Hills. She hired a Russian couple as butler and housekeeper and began immediately to throw parties with such guests as the Conrad Veidts, Vicki Baum and Juan Romero, Luigi Filasi and Theda Bara, Conchita Pignatelli and Lorna Hearst, Princess Ghika, Charles Babin, all duly recorded by the gossip columns, those bibles of the life of gesture.

Later, she told the Ortiz-Monasterios that Alex and Nina, the Russian couple she had hired, were deposed aristocrats she had known well from her St. Petersburg days who made her swear never to reveal their true identities. But that sounds like something one of her new scriptwriter friends would have made up. Again, the story is telling. She had a natural sense of the role publicity played in a city where appearance is everything, and she hired an agent to keep track of her clippings. Here she is on the set with Walter Pidgeon and George Sanders. There she is walking on the arm of Charles Boyer. Who's that she's talking to? Director Mitchell Leisen.

Soon she was "The Baroness with a Brush," the "Favorite Artist of the Hollywood Stars." And why not? Who better could understand her particular genius, the ability to suggest overwhelming passion or immense sensuality through a lacquered, tightly controlled, highly polished exterior than a Greta Garbo, a Dolores del Rio, a Tyrone Power, all of whom visited her studio. It is no accident that even today Tamara plays

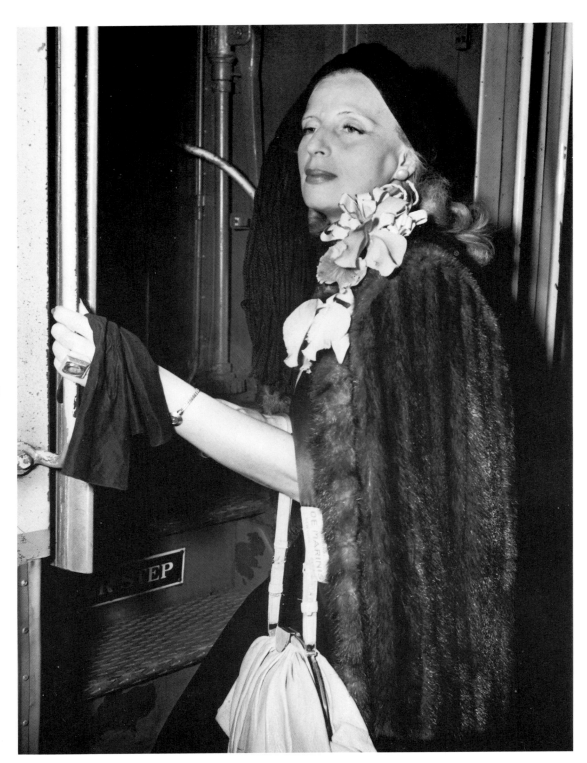

Boarding the Union Pacific, bound for Hollywood, 1940.

best in Hollywood, that the drama bearing her name opened there, that the most avid collector of her works currently is Jack Nicholson.

In Hollywood gestures are sometimes known as "publicity stunts." The year the Kuffners moved to California, Tamara pulled just such a stunt. She had exhibited in New York one of her better-received paintings, *Susannah at the Baths*, and she wanted to finish a contrasting biblical painting, *Susannah and the Elders*, which she had begun in Paris. The trouble, of course, was that "Susannah" was in war-torn Europe and the Baroness in Beverly Hills. Tamara needed a double, and she decided to hold a contest. Playing on her title and name, she announced to the student body of U.C.L.A. that she was looking for a twin for one of her famous paintings. She had over a hundred coeds—called variously "contestants" or "applicants" in the newspapers—come to her place and pose nude in front of the painting before she finally found one who closely resembled her original in the curve of her body and the shape of her face. It was a classic man-bites-dog story ("Titled Artist Reverses Procedure"), and it made the national press.

Like her fellow celebrities, Tamara became involved in well-publicized war-relief work, donating her time, money, and a painting or two, especially for Polish causes. She helped found the Women's Emergency Corps, worked with British Relief, the Paderewski Fund, and France Forever. She designed uniforms and drilled the ladies, for which she was given the rank of "sergeant." She was also anxious to get Kizette out of Europe and wrote Eleanor Roosevelt to request aid. By 1941 she had succeeded. Despite Kizette's initial reluctance to come to America, she accepted the wisdom of leaving a Paris run by Nazi puppets, especially since she had been working for the Polish government-in-exile, which by then had moved to London. She left from Lisbon on a Greek banana boat, the *Nea Hellas*, made it safely across heavily mined stretches of the Atlantic, and docked in New York. She reached California by car. She enrolled in Stanford University, where she ran into her old friend from Oxford, Franzi Hohenlohe. That same year, the Baron and Baroness Kuffner announced their intention to apply for American citizenship.

133

"I have traveled many places all over the world," said Baron Kuffner, who was fast coming to resemble the monocled and moustached logo of the old *Esquire* magazine, "but in your Southern California only do I want to live forever."

He spoke precipitously. Hardly a year would go by before he grew to hate the place. He took off for the wilds of Montana to shoot elk and grumble about the shallowness of Hollywood people in general and Tamara's "fairy friends" in particular. And, by then, the sea change that had taken place in her when she abandoned Paris was becoming evident even to the Baroness herself.

She continued her one-woman shows—at Julian Levy's in New York, at the Courvoisier Galleries in San Francisco, at the Milwaukee Institute of Art—and Atwater Kent so fell in love with her works that he filled his Beverly Hills mansion with them. But she painted less now than she had even during her depression in Europe. Once so closely attuned to her times, she now began to feel vaguely remote from them. She worried constantly: What is wrong with me?

134

*With George Sanders
and Walter Pidgeon on
the set of* Man Hunt.
*Twentieth Century-Fox
Studios, Hollywood,
1941.*

At one of the Kuffners' first huge Beverly Hills dinner parties, they had entertained their guests with a program of antiquated newsreels, the first all-color cartoon, and ancient motion pictures starring Mary Pickford and Owen Moore, Mabel Normand and "Fatty" Arbuckle. The idea was to make people laugh, as one columnist noted, at the "ridiculous contrast" between images from "the nickelodeon days" and the "Baroness' own sublime paintings." And her guests laughed loud and long.

But what happened to a Mary Pickford or a Gloria Swanson offers good parallels to what was happening to Tamara de Lempicka. Pickford had been the first "star" ever, the first woman to make a million dollars, and the first widely publicized rags-to-riches Hollywood story, in which a girl from humble beginnings comes to live like royalty. Swanson, who quipped that, while Pickford "may have been the first woman to make a million, I am the first woman to spend one," actually married a marquis. Their stories (and a few like them) prompted young women to leave home and head for Hollywood. Some 200,000 of them between the ages of nineteen and twenty-five came to Tinsel Town during the decade from 1919 to 1929. A desperate Hollywood chamber of commerce posted notices in railway stations as far away as Calcutta,

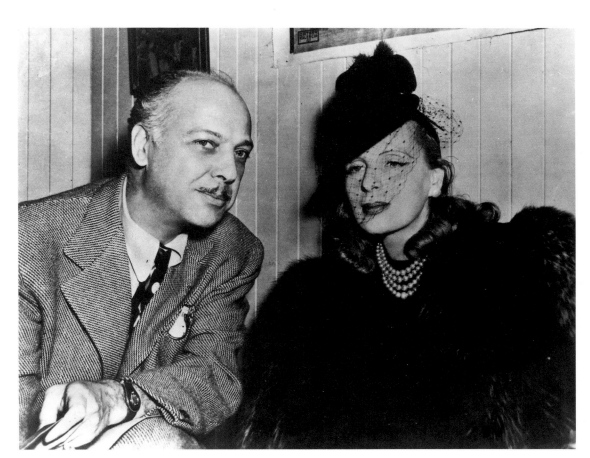

*With director Mitchell
Leisen. Hollywood,
early 1940s.*

India, warning young women that there was no work in the movies. Pickford and Swanson were as successful as any women in history.

Their success, however, was based entirely on their box-office draw, and that was based on the Mary Pickford or the Gloria Swanson fans came to see—a little, curly-haired, prepubescent, innocent (but still sexy) waif, and a slinky, sophisticated, licentious, silent vamp. The public would not tolerate them in any other guise. As Pickford grew older, she became more and more trapped by the little-girl image. At sixteen, she was playing a girl of sixteen. By the time she was thirty, she was playing a girl of twelve. Finally, she could not stand it. She bobbed her hair and gave a single, quite excellent performance in one of the new talkies as a mature woman. Her fans summarily abandoned her. For Swanson it was even worse, because she did not struggle with her image for fifteen years first. The talkies made the exaggerated gestures and seductive silence of her vampishness obsolete, but it took her almost a decade of frustration and sporadic employment to realize what had happened.

Pickford retired from the silver screen. She founded United Artists with Charlie Chaplin and Douglas Fairbanks, used the money she made as a producer to buy up

Key and Hand, *1941.*
Private collection,
Buenos Aires.

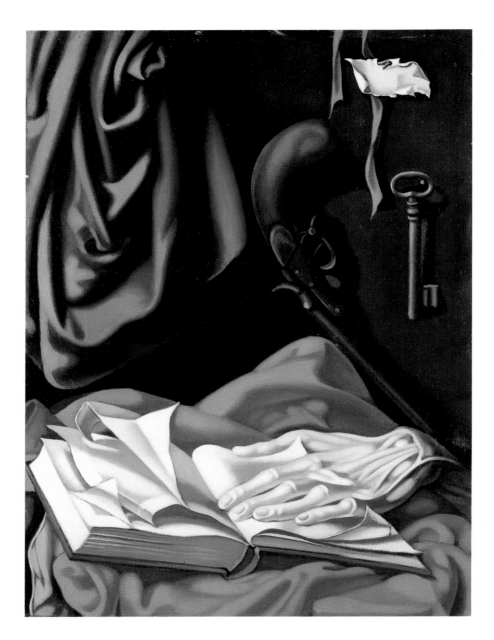

the rights to all her old movies, and withdrew from public life. For decades she never left her bedroom or let anyone show her films. Swanson kept chasing roles no one would hire her for, escaped into a hedonistic abandon, and wound up playing a parody of herself, Pickford, and others like them in her last film, *Sunset Boulevard.*

The refugees and orphans and humble folks Tamara now painted, often brilliantly, are in fact at variance with the meaning her style and reputation had come to have

for her public, just as Pickford's screen image and actual age had been. And the style itself, like Swanson's silent sophistication, became dated precisely because it was so striking and so perfect for its day. Abstraction was in the air, the times were changing, and like many a silent screen star twenty years earlier, Tamara fell victim to the art world's "talkies"—nonrepresentational painting.

One can see it reflected in the clippings her press agency saved for her. More and more, the papers play on the novelty of a Baroness who just happens to make a career of painting, and soon even that becomes a "tag-line," a catchy lead for the real story: the Baroness Kuffner talks about how a woman should wear her hair, or how she should use her makeup to advantage, or how to enthrall—and keep—a man. America has never been kind to its artists, and in Hollywood it had devised the ultimate torture—there everything fell prey to image. Tamara's "image" as an artist became passé; her "image" as a socialite held its cachet: She was reduced to a name on an invitation list.

In her gushing reminiscence, *Once Upon a Time*, Gloria Vanderbilt describes

Key, Egg, and Jug, 1945. Collection of Kizette de Lempicka-Foxhall.

137

322 East 57th Street, New York City. The artist lived here from 1942 to 1962.

planning a Hollywood party with her mother: "Oh, and don't forget the Baroness Tamara de Lempicka Kuffner, Mummy was saying. She's fun and she does those amusing paintings."

She's fun and she does those amusing paintings. It's the worst epitaph a serious artist can imagine.

When the Baron came back from one of his extended hunting trips and insisted they move to New York, Tamara went along with him. They purchased a stunning apartment at 322 East 57th Street, with a two-story-high studio offering good north light. In 1943, she still worked in her old, familiar style and would continue to do so for another year or two. But already she complained that she could not find the right sable brushes or the kind of paints she needed for her work. Soon she would abandon representational art altogether to take up a reluctant abstractionism that she would practice with precision and persistence, if without love, for nearly a decade.

The change in her style of art may well have been the result of a physical collapse Tamara suffered shortly after she and Kuffner moved to New York. In the city, she

138

liked much more to entertain than to go out. Increasingly, she seemed to feel that her world was growing hostile around her, and, increasingly, she distrusted situations, even social situations, that she did not control. In old age, such distrust would become almost a paranoia, and she would, for example, at times refuse even to discuss Russia because "they" might assassinate her. But for now she merely threw huge parties, inviting two hundred people or more.

On those evenings when she did not entertain, she worked compulsively. She and Kuffner had separate bedrooms, and when he went to bed early, which was most

A l'Opera, 1941.
Private collection.

Amethyste, *1946*.
Private collection.

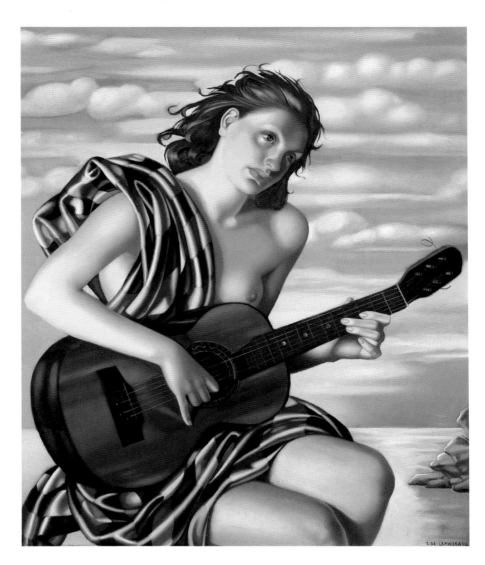

nights, she would repair to her studio, put up her night lamps, and work the whole evening away with Wagner playing constantly on the phonograph.

One morning, the butler came in to find her sprawled on the floor of her studio. Kuffner called in the doctors, and they rushed her to the hospital, where she remained unconscious for nearly five days. The stroke may have been the first attack of the arteriosclerosis that finally would kill her, but the doctors diagnosed the collapse as exhaustion due to overwork.

"I don't understand," she said. "Am I ill?"

"No, not ill," her doctor said. "Nervous. You are all right now, very healthy, but you have to stop work completely. If you go on like this, you will lose your mind."

"But what will I do?"

142

Untitled drawing, n.d.
Collection of Christie
Tamara Foxhall.

"Do what other people do," the doctor said. "Go out. Go to the theater, to the opera."

"No, no. I hate——I don't want that."

"What do you want?"

"I have to work."

"So go find work," he said. "Something else. Something that won't kill you."

As Tamara told the story: "So I went to Elizabeth Arden, whom I knew personally. And I told her, 'Look, I'm ill. The doctor told me I have to work. Could you give me work in your place? So many women are working.' Elizabeth was laughing. 'Yes,' she said, 'there are women working, but not women with your talent.' I said, 'Forget my talent. I cannot paint. I have to stop.' 'No,' she said. 'I cannot forget. Every minute that you have free, you should be painting, you should produce.' She didn't want to take me."

In the newspapers, Tamara came across an ad calling for window dressers—"decorators," the ad called them. She took a taxi to the Fifth Avenue address listed in the advertisement, and when she walked in there were already a dozen or so women waiting to be interviewed. She, too, waited for a while, but then became impatient with it all and demanded to see "the boss."

"Mister," she said to the hapless fellow who finally came out to talk to her, "I've been here for an hour now. Could you tell me if you are looking for somebody to work?"

The man allowed as how he was, indeed, looking to fill a position and that he had been the one to place the ad, but when he decribed the job and mentioned that it included cleaning the windows and sweeping the floor as well as designing displays, Tamara exploded.

"So I turned to the other girls, and I said, 'You all came to look for a job like I came. The job here is to clean the floors, clean the windows. It's not what is written in the advertisement—to prepare the windows or to sell. It's not that. It's to clean the shop.' And I said, 'Girls, if you want this kind of job, you wait. If not, I'm leaving and everybody who wants can leave with me.' We all got up, and I took them to my house, and I gave them a very good lunch. . . ."

Tamara never took a job. She did something much more appropriate for an artist: she went into a deep, thoroughly devastating depression.

Twenty years she would live in New York with Kuffner, each year retreating further into her social life and a kind of burning hatred of "the times," of Existentialism and the average man, of the entire postwar quotidian world, built as it was on consensus and conformity. Like most people of accomplishment who find themselves consigned by history to the dustbin, she thought that "living well is the best revenge," though—like them, too—she never made it clear precisely against what she avenged herself.

She decorated the apartment on 57th Street with the antiques she and the Baron had rescued from his Hungarian estate, and when the war in Europe ended, she reopened and redecorated the studio in rue Méchain in rococo style. Friends, such as Helena Rubinstein's sister Muzka Bernard, called on her to decorate their

143

The Orange Turban,
*1945. Musée des
Beaux-Arts, Le Havre.*

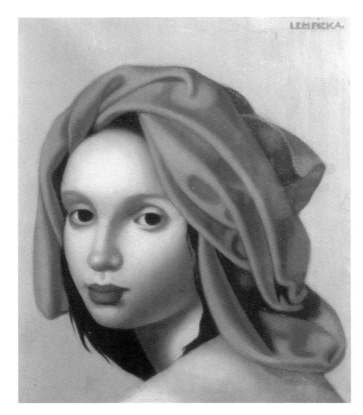

144

La Madonne Ronde,
*1948. Musée
Departemental de
l'Oise, Beauvais.*

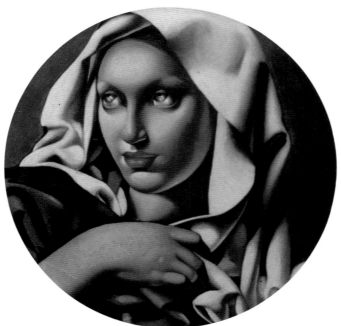

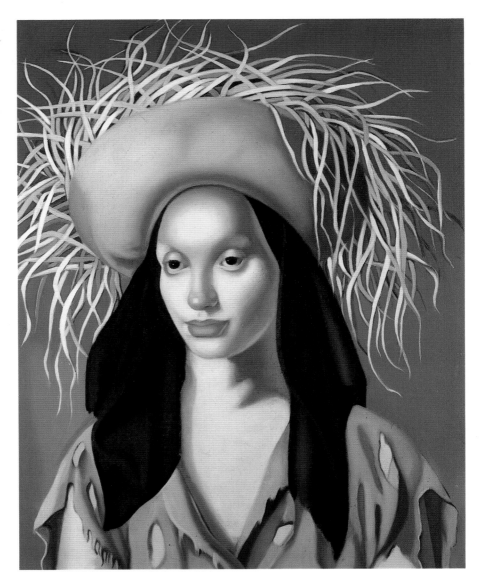

Mexican Girl, *1948.*
Musée des Beaux-Arts,
Nice.

New York apartments, and she did so, as always, with style. She drove about town in a white Chrysler convertible with wine-colored interior, which matched not only the chauffeur's uniform but also her luggage done in soft, white leather. The Kuffners socialized continuously with the likes of Lily Pons, Oleg Cassini, the Bulovas, the Vanderbilts. Both considered themselves gourmets and loved to talk about food, as well as eat it, and they made many an urban safari in search of new restaurants. The Baron still always arrived early, always discussed the menu with the owner, and always slipped money to the chef. And always, for lunch or dinner, the Baroness came late.

Abstract, *1957.*
Collection van den
Abbeele, Belgium.

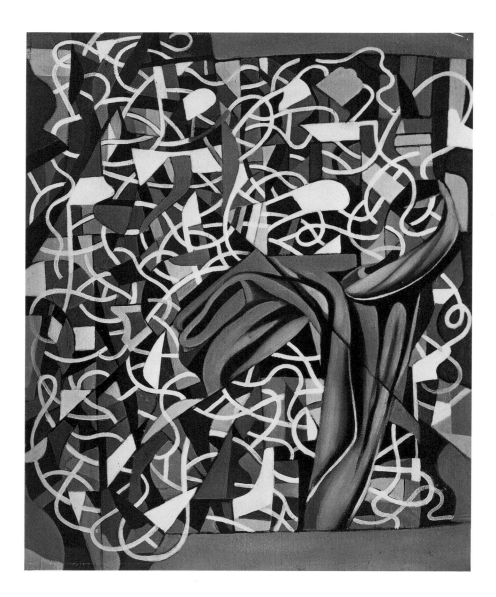

They traveled to Europe often and spent several weeks each year at the Bircher clinic in Switzerland, where they gave up their indulgences for a diet of something called "muesli," a concoction of Quaker Oats, apples, and yogurt. As the years went by, Kuffner began to spend more and more time with Hungarian refugee groups. He got up each morning and left the house at ten, wearing a bowler and carrying an umbrella, regardless of the weather, to go talk hopeless politics with ex-countrymen from a vanished past. He worked with two professors from New York University on a scholarly book about his family's estate entitled *Plenomania,* which described how his grandfather and father before him had transformed barren acres into productive

farm land that they used to raise beef, to grow beets, asparagus, and potatoes, and to make beer.

Tamara worked—or tried to work—at her painting.

Meanwhile, Kizette, at Stanford, had met and fallen in love with a young north Texas geologist named Harold Foxhall. She married him, and they moved to Alexandria, Virginia. Two children later, they moved to Little Rock, Arkansas, where he became state geologist. In 1953, he accepted a position as chief geologist at Dow Chemical and moved to Houston with Kizette and their two daughters: Victoria, nicknamed "Putti" by her grandmother because the curly-haired blonde baby looked to Tamara like the *putti*, or angels, of Correggio; and Christie Tamara, nicknamed "Chacha."

Occasionally Tamara would visit. She liked "Foxy," as it seems everyone did, but she made crystal clear her disdain for the bourgeois life Kizette had chosen. Nor was Tamara a woman to coddle her grandchildren. She was rich; she knew it, and she used it. Both Putti and Chacha had every advantage she could give them, just as she had had as a girl, but the advantages came with her own demands—they dressed as she commanded, went to the schools she approved, comported themselves according to her rules. Foxy was perhaps too tolerant of and Kizette too cowed by Tamara to prevent the emotional disaster between grandmother and granddaughters that, clearly, was brewing.

In 1961, the well-known French art critic Michel Georges-Michel received an invitation from Tamara de Lempicka when she was on a visit to Paris.

Georges-Michel remembered her well from the days before the war, when he had met her at cosmopolitan *salons* given by the Marquesa Casati, who received her

147

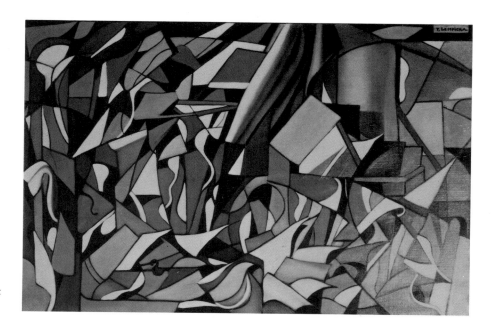

Blue Abstract, 1955.
Musée National d'Art
Moderne, Paris.

guests in the nude, waving a peacock feather and ignoring the embassy attaché, who begged her to show a little decorum. He remembered seeing her with the Contessa Picenardi on the eve of the fascist revolution when the Contessa (who used skull and crossbones makeup under her tricorn hat) paraded in front of a hundred angry workingmen wearing a live falcon on her wrist and a dozen stunning necklaces round her throat.

But he remembered most fondly the day he walked into a sordid little bar in one of the dirtiest streets in Cannes where one encountered only the tough faces of sailors, women with a look in their eyes wilder than the men, and pale young homosexuals dressed in pink shirts and exchanging acid glances. The owner of the place, whose red and purple face matched his wines, sat at the door like a prison guard. In the darkest corner reclined a barefoot, nearly bare-breasted woman, betopped by an outrageous donkey hat. Her hair was pulled through the holes reserved for the donkey's ears, and her huge eyes glimmered in the dimness. He stared at her. She shrugged her shoulders and turned her back, a magnificent back, naked to the loins. That night he was invited to a plush and elegant party at one of Cannes's more respectable addresses. As he amused himself with private observations about the lavish display of food and the decorous behavior of the guests, he felt a slap on his

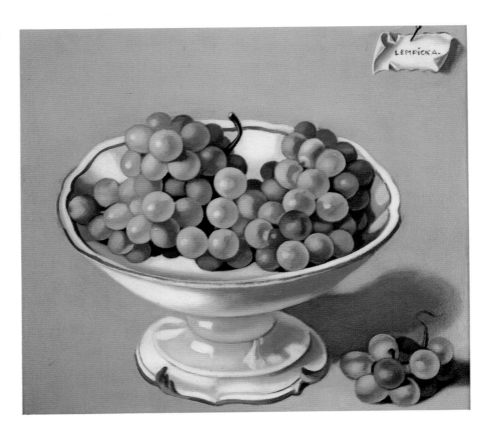

Bowl of Grapes, *1949.*
Musée Georges
Pompidou, Paris.

shoulder and heard a woman say in a husky voice: "Well, you certainly were in a strange place this morning." He turned around to see the woman from the bar, this time sparkling with jewelry from the tip of her shoes to the top of her tiara, which sat like a halo on her golden head.

That was the day he met Tamara de Lempicka.

Today's invitation read: "I am receiving a few guests tomorrow. Do come. You will see your friend Lily Pons and a few ex-grand dukes. . . ." He was intrigued. It had been more than a decade, almost two, since he had last talked to her. He went to her studio in the rue Méchain.

Covering the walls of her apartment were reproductions of all the portraits she had painted between the wars. "My victims," she called them. "But I am now entirely into Abstraction," she added. And she showed him her new work.

"Indeed," he wrote later. "She had reversed her palette, and lived [for] years studying, looking for new values, discovering unknown depths, and now it had happened, after so many years of hard work, an unexpected reaction from this artist who had lived by her violent impulses: side by side with her older works, so brutal in their contours, Tamara is showing today the most delicate, most subtle emotions of her 'soul today.' In contrast with the rude precision of her portraits, the unshakable

Pink Drapery, 1950.
Private Collection,
Buenos Aires.

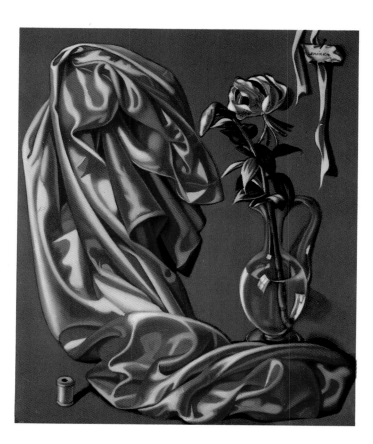

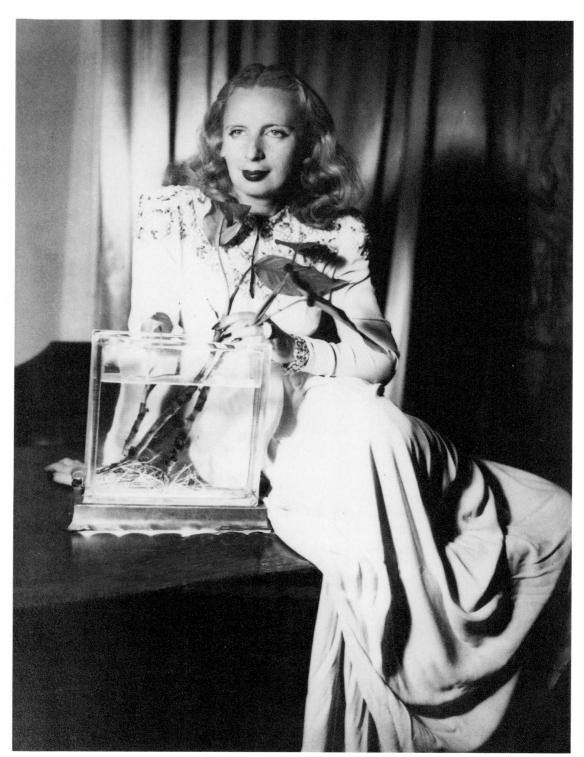

Tamara in her studio. New York, probably 1954.

logic of her abstractions, Tamara de Lempicka has reversed to barely a suggestion of line, a smudged contour, barely a color. Those paintings are almost pastel in color and remind one of the partially erased and yet so intense frescoes on the walls of Pompeii."

By the 1960s, the Baroness Kuffner saw her world in ruins about her and painted it that way.

And she had hopes for these palette-knife paintings, high hopes. But when she exhibited them at the Iolas Gallery in New York in 1962, the critics were indifferent and the buyers cautious. She sold embarrassingly few paintings.

She was not the woman Georges-Michel had known in Paris between the wars. The Baroness Kuffner gave up; she swore to herself she would never exhibit again. She was, however, still Madame Decler's spoiled little grandchild. Tamara took her toys and went home.

151

10

HEARTBREAK TANGO
(HOUSTON, 1963-1978)

At the time, it seemed the final blow.

On November 3, 1962, on what was to be the last voyage of the French ship *Liberté* to New York Harbor, Baron Raoul Kuffner died of a heart attack.

Once again history had betrayed Tamara. Never mind that this time it was not the history of a huge country like Russia nor of a political movement that came close to destroying Europe like Nazism, but merely her own personal history. The refugee in her responded as always: she sold off everything and fled New York for three trips around the world on three different boats until—unable to work, alienated wherever she traveled—she fell into the arms of her family in Houston, Texas.

Once again, she seemed to flourish in exile, despite the genuine despair she felt at the death of a man to whom she had been married for thirty years.

And once again, it seems, she felt compelled to live as unfettered as possible at the expense of those closest to her. When Kizette had visited the Baroness over the years in New York, Tamara had always introduced her as her sister, but in Houston that pretense was no longer possible. Instead, Tamara decided to play the matriarch, the Grande Dame, and to do so with a vengeance. She took Houston and Kizette's social circle by storm. Soon Kizette's friends and acquaintances found themselves a captive audience to some fifteen years of Tamara's life-long love-hate tango with her daughter.

Tamara set herself up in Houston's elegant Warwick. She early on mismanaged some of her funds, though she never directly admitted to doing so, and now she expected Kizette to spend all her time handling her mother's affairs. Kizette served as Tamara's business manager, her social secretary, and her general factotum. For years, Kizette got up each day, saw to the needs of her family, and, after Foxy had left for work and Putti and Chacha for school, headed off to the Warwick to open mail, balance accounts, and write letters for Tamara. If Tamara traveled to Paris, Kizette went along to take care of business—to inventory paintings, contact museums, finally to see to the sale of Tamara's studio in the rue Méchain. When Tamara vacationed, Kizette handled hotel reservations and made the travel arrangements. In

short, Kizette was expected to submerge her life completely to cater to the needs of her famous mother.

And precisely because she now needed Kizette, Tamara treated her badly. Their old-time friend Franzi Hohenlohe says Tamara acted as if Kizette were one of her staff—secretary, accountant, chauffeur, and cook—ordering her about constantly, dismissing her with a wave of her hand. Jane Owen, an oil-rich Houston socialite whose husband's great-grandfather Robert Owen founded New Harmony, Indiana (now being restored by Jane), admired Tamara the artist and cherishes a small painting called *La Bretonne*, which Tamara gave her and which now hangs in one of the guest rooms at New Harmony. But though she admired the artist's style, flamboyance, and unflagging energy, she privately condemned Tamara for the way she treated her family. Even Victor Contreras, the boon companion of Tamara's last years, for whom she could do no wrong, admits that she was hard on her only child.

"Anything Tamara did not like," he says, "she would change. Even her daughter. 'I don't like your hair. Do your hair this way. Here, change that dress. You must wear this. If you don't, I don't take you out.' She would not allow anyone to be themselves, unless they were perfectly elegant, looked the best they could, or at least had great respect for themselves."

There is no doubt that Tamara's need to control extended beyond Kizette. Franzi Hohenlohe remembers how, on one of his visits to Cuernavaca to see the vacationing Foxhalls, Tamara became so upset with a shirt Franzi was wearing that she marched him off to a store to buy another. Once there, she tried to bargain with the sales clerk for two—the second shirt was for her son-in-law, whether he wanted it or not. Contreras tells of a time when, having no one to shop with in Cuernavaca, she decided to remake one of her servant girls into a worthy companion. She designed a dress for the little Indian girl in a color carefully contrasting with the one she planned to wear and concocted a floppy-brimmed hat that she plopped on the girl's unruly hair. The two of them set off for a day-long spree, so striking a pair that they actually drew crowds.

But for Kizette and her family, Tamara's need to control, to dominate, could seem almost pathological. When Kizette's oldest daughter Putti announced to Tamara her intention to marry a well-to-do Argentinian, the grandmother was furious that the young man had approached her son-in-law for permission rather than coming to her. She took her revenge on the day of the reception. Kizette had invited dozens of guests to her house in River Oaks after the ceremony. At ten o'clock that morning, the doorbell rang and Kizette answered—to find the wife of the curator of Rice University's museum standing there with her two daughters and a number of grocery shopping carts. Tamara had donated to the museum all her antique serving pieces and silver, which Kizette already had properly in place, on the condition that the university pick them up that morning and at no other time. Kizette had to call the caterer and tell him to bring all the necessary dishes and silver.

Kizette remembers, too, how the need to dominate began to manifest itself as a mania for order and cleanliness, and how devastating that mania was for the family at Christmas. Tamara would move about the room on Christmas Eve, grabbing up

wrappings and string and tossing it all into the fireplace, even when the tissue paper still contained a pair of gloves or a silk scarf from Italy. She made sure the tree itself was at the curb by 8:00 P.M. on the twenty-fourth and that all traces of the Christmas "mess," as she called it, had disappeared by midnight.

Such behavior became almost routine, and, not surprisingly, Tamara's relationship with her family grew strained. But her family was not Tamara's only unappreciative audience.

Tamara's friends and publicists, Wade and Gene Barnes, gave a dinner party for Tamara in New York in the late sixties. The Baroness, who now complained that she could eat almost nothing and could drink only orange juice, began clearing plates from the table during the middle of the meal.

"You Americans eat too much," she said, as she whisked plate after plate out from under the noses of embarrassed guests.

Finally, one of the women caught her by the arm, stared steely eyed at her, then said calmly in the tones of politeness: "Baroness, if you touch my plate, I will break your arm."

The dramatic gesture had become habitual for her, and she made it commonplace. Tamara would often accompany Kizette in the afternoon on trips to the Houston racquet club, where her daughter loved to play tennis. While Kizette played, the Baroness presided in the clubhouse. When she grew bored, or became fatigued, or simply thought of something else she wished to do, she would tromp out to Kizette in the middle of a volley and demand that her daughter take her away immediately.

"She would say, 'Write it down,' " says Contreras. " 'Move that chair. It is not in its place.' Always fighting for things and places and people to put them in their right place. Everything has a place and so we must give it the right place, people and things. And she walked very straight. She never gave the idea of being an old lady."

She cultivated both her domineering manners and her impulsiveness in order to give precisely that impression. The problem, though, is that she *was* an old lady. In the twenties, such gestures had worked well for her. Now fewer and fewer people each year cared for her extravagant ways or appreciated them as the mannerisms natural to a great artist. She still played the Siren of the Silent Era whenever she had an audience, but the audiences had changed. To them she seemed a parody of herself.

Behind it all, somewhere, lay her painting. She had lost the work that once sustained her and the name that once defined her, and now she had nothing by which to prove to herself that she was different from anyone else except for the biological working through of her life, the decaying of her specific, individual body, and that she could not accept.

When she first got to Houston, she had commandeered her son-in-law, the scientist, into helping mix paints. Day after day, month after month, she worked to get colors that were hard and firm like those she had used in the twenties and thirties. But it was no use. She complained that the paint, the brushes, the canvases she bought weren't of the same quality she had once found in Paris, just as she claimed the people she met these days lacked the special qualities, the breeding, the joie de vivre of those she once knew. She refused to admit to herself, or to anyone

The Lovers, *1961.*
Private collection,
California.

else, that her eyes had gone bad, that her hands were no longer as steady, as trustworthy as they had been when her husband called them golden, or that her art no longer seemed to her the sharp, protective weapon she had once forged.

Though publicly she remained aloof, putting it about that she had no desire to exhibit in so unworthy a world as the one in which she lived out her exile, privately she tried to manipulate the Houston art dealers into taking an interest in her work. To their discredit, they snubbed her.

Kizette remembers the afternoon the owner of a local gallery came by Tamara's suite in the Warwick to look over her latest palette-knife paintings. As she had when her sister Adrienne's Beaux-Arts professor first visited her modest apartment on Montparnasse, Tamara appeared indifferent to, if not disdainful of, his opinions. He told her, politely, that the paintings left him cold. He simply could not see his way clear to purchase any, to exhibit them in his gallery. After he left, Tamara sat quietly for a while, staring at her latest work, which lay propped on an easel in the middle of the room. Then she walked over to the desk where Kizette, avoiding her mother's eyes, had been carefully opening mail. Tamara picked up the letter opener and, in a frenzy, attacked the canvas, ripping it into long, thin shreds. She never said a word, then or ever, about the incident.

Venice in the Rain,
1960. Private
collection, California.

The retrospective in 1973 almost saved her, but there, too, her pride got in the

Flower Vase, 1961.
Collection of Kizette de
Lempicka-Foxhall.

158

way. Following the successful opening at Paris's Galerie du Luxembourg, Wade and
Gene Barnes arranged for a show of Tamara's current work at the Knoedler Gallery
in New York. She owned very few of her paintings herself, and the gallery needed
some assurance that what it exhibited would sell, so the arrangements took time
and trouble, but at length the Knoedler agreed to go ahead with the exhibition.
Wade Barnes took Tamara to the gallery and introduced her to the curator. Immediately,
Tamara told the curator he would have to paint the walls in a certain shade of gray

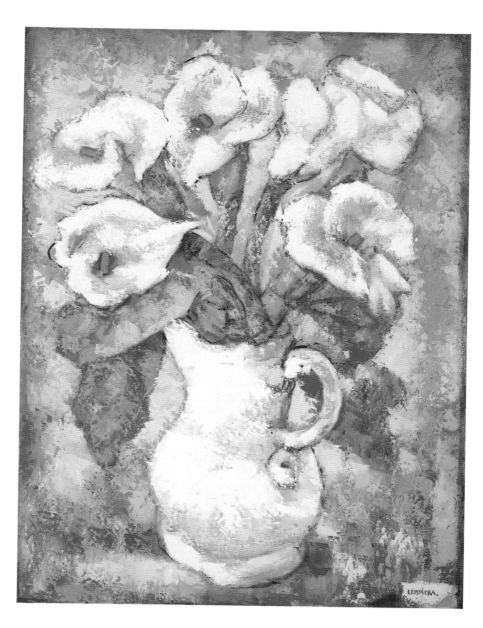

Calla Lilies, *1961.*
Private collection.

because they were not right as background for her work. They would also have to change the lighting, she said, and place an additional *window* at the end of a long hall. Barnes never heard from the curator again. Whenever he called, the man was out.

And so was Tamara.

Her pride forced her to turn on the young friends who had created that opportunity for her in the first place by opening their gallery in Paris with her show. No matter how loath she was to admit it, the truth is that Blondel and Plantin had

*Girl with Guitar,
1963. Collection
of Kizette de
Lempicka-Foxhall.*

rediscovered her. And just how badly she wanted to be rediscovered, just how badly she wanted to be once again in the public eye, she proved when she now gave up her palette-knife paintings, even though a year after the Knoedler spurned them, the French government acquired all twenty-one of the paintings to have been exhibited and placed them in the prestigious Musée Georges Pompidou in Paris. Now she began again to try to paint in the style that had made her famous forty years earlier. It was the saddest thing she ever did.

Ortiz-Monasterio once made the mistake of calling those paintings Tamara did in the last few years of her life "copies" of her earlier work. She gave him a withering stare and said: "When a great artist does what I am doing, one does not call them 'copies.' They are both—the early one and the late one—versions of the same work." Still, those late paintings look not only like copies, but like poor copies as well. They have lost the hard lines, the enamel-like color, and the intangible insight of the originals.

For all that, Tamara de Lempicka was indeed an artist, and like all artists, she had the ego to say to the world what Nietzsche claims Napoleon said to Josephine when she discovered his infidelities: "That is me. I'm different. I'm apart from the rest of the world. No one shall dictate anything to me. In fact, I demand that you give yourself up to me, give yourself over to my whim. You should find it natural when I yield to this or that distraction."

When an artist no longer has the works to justify such a claim, it becomes just a bunch of desperate words from a desperate individual, one who is trapped, caught out, on the defensive. At that point, all the artist has left is *time*. Like d'Annunzio, Tamara found herself growing old in a world that wanted to deny her her due. The need to dominate the world around her grew ever more obsessive as she more and more lost control of her ability to paint.

In 1978, Tamara moved to Cuernavaca permanently, buying a beautiful place designed by the same Japanese architect who built Barbara Hutton's mansion. Tres Bambus was located in a chic neighborhood on a *privada*, where the Shah of Iran's mother and sister also spent time before his exile. Kizette's husband had fallen terminally ill with lung cancer, and Kizette could no longer afford to give priority to her mother's demands, which grew more and more unreasonable. Tamara let Kizette know she had rewritten her will to say that Kizette must be with her during her last moments in order to receive anything at all from her estate. She began to call Kizette from Mexico, demanding to know why her only daughter neglected her. If Kizette was at the hospital, Tamara would call Foxy's room there. She did not understand, she said. She was ill, too. She needed care, too. "So your husband is in the hospital," Tamara said. "You get a nurse to take care of him and come to see me for three days." Soon Kizette heard from friends in Mexico that Tamara planned to give away Tres Bambus to her new-found friend, the young Mexican sculptor Victor Manuel Contreras.

Tamara never let up.

161

11

UNDER THE VOLCANO
(CUERNAVACA, 1978-1980)

In Victor Contreras, Tamara had found someone with whom to share the life of gesture.

Contreras, a Mexican artist of some note, who has placed his monumental works along the outside walls of municipal buildings and in the squares of a number of cities in Mexico, including Guadalajara and Cuernavaca, as well as in Chattanooga, Denver, Miami, and New York, first met an artist named Tamara de Lempicka in Paris in 1958.

From a humble Mexican family, he was in the City of Light on a scholarship to study at the Paris School of Fine Arts when he was befriended by the ubiquitous Prince Yusupov and his wife, Princess Irina. The Yusupovs more or less adopted the handsome young Latin, and they took pains to introduce their charge to Russian emigré intellectuals, artists, and writers, as well as the Parisian social circles in which they frolicked.

The night they invited Tamara de Lempicka to meet him at their lavish apartment in Montparnasse, she of course arrived late. She made a grand entrance in a stunning sequined dress, a strikingly cocked hat, and white silk gloves that reached to her elbows. She had tossed a long white coat carelessly around her shoulders, and it flapped freely about her as she crossed the room. To the nineteen-year-old Contreras, she seemed the definition of elegance as she slowly removed her gloves and stared searchingly at his dark-skinned face. Yusupov slid across the room, draped a tender arm around his special ward, and said, "Tamara, this is the son that has fallen from the sky to me, that I always wanted to have, an artist—and, therefore, I invited him to come get acquainted with you and your magnificent work."

Tamara at that time was making the transition from her abstract pieces to her work with the palette knife, and Contreras visited her with the Yusupovs at her rue Mechain studio three or four times before he left to travel and study first in Germany and then in Italy. After that he received his first professional commission from International Planners, Inc., and then went on to a commissioned piece for McIvers in Florida.

Two decades later, the locals in downtown Cuernavaca called him *Maestro* when

he strolled about his city. The Yusupovs were gone, having left him their private papers, some of their personal belongings, a number of their paintings and miniatures, and memories of tender nights in a Paris they had always delighted, if not scandalized. Though he hardly seemed the type, he had in fact been married briefly and produced a daughter, who died while still a baby in Germany. Now he lived in an ancient and utterly charming house on a quiet street in downtown Cuernavaca, where he supported his beloved mother and her husband, his stepfather.

Sometime in 1974, a septuagenarian German silent-film actress named Canta Maia, who had been known in the Berlin of the twenties as the "flesh Venus," called her friend Victor Contreras to say she would like to drop by with an acquaintance of hers from the old days.

"Victor," she rasped, "I have a very interesting woman with me. She is Polish, and she used to be a great artist, has paintings in many museums, and is very much interested in meeting with you. I told her: But wait, I know that you are a very difficult and strange person, and so I have decided to call you first."

"I am not strange and difficult for an artist," Victor replied. "And I would be more than pleased to let you come. Who is she?"

"The Baroness Kuffner."

"Ah," Victor said. "As a matter of fact, I have a baron here who comes from France and is writing a book on the 'Sacred Places' of Mexico. So you give me a baroness, and I give you a baron."

The difference was, Victor would say years later, "my baron has forty years, very good looking, a Victor Mature type, and she gave me a baroness that was...well, a different woman." He did not recognize her, nor she him. Tamara came with Foxy and the five of them made a day of it. That afternoon, back at Victor's for tea, Tamara took him aside and said: "There is no way to fool one another, is there? We both speak the same language, don't we?"

"I hope so," Victor said, looking into her startlingly clear blue eyes. "Because I like you very much. It seems we know each other. Yes, there is no question about it, we speak the same language."

She always went by the title "baroness," and, as Victor tells it, they did not recognize each other until two years later, when, after a morning together of shopping and talking about art and Europe's vanishing aristocrats, they went to pick up Kizette for lunch at the racquet club, where she was, as usual, playing tennis. While they waited, they ordered vodka tonics, and the taste of the drink recalled for Victor Paris, the Yusupovs, and that morning's conversation.

"This vodka makes me remember, too, my Russian friends in Paris. Cheers!"

"What Russian friends?" the Baroness asked.

"Well, maybe you know them, I don't know. It was Prince and Princess Yusupov, the one who killed Rasputin?"

Tamara seemed lost in thought. When she spoke again, it was as if she had been the one to recall their names. "Oh, yes, the Yusupovs. So you knew Felix and Irina. They were my dearest friends. The most beautiful couple I ever met in my life."

"Yes, they were beautiful," said Victor, distracted, thinking about the nights he

and the Yusupovs dressed in special costumes and chased one another about the huge apartment, like children during carnival.

The Baroness was staring at him—no, *through* him, into the past.

"Now I know who you are!" she shouted, oblivious of the heads turned their way. "You are 'the son that has fallen from the sky, that heaven has given them.' "

"It was a very generous way to call me. Yes, you are right. How did you know that—"

"He told me," she snapped. "Listen, did you meet a painter called de Lempicka, who like you lived on Montparnasse? Yes? Yes! I'm telling you, idiot, that was me!"

After that, she never let him go.

Tamara knew others in Cuernavaca, rich Americans, the famous and once famous, remnants of an aging international set, and the younger "jet set," many of whom were her neighbors in the town's most fashionable neighborhood.

"The only qualifications she had for people she associated with," laughs Victor, "was that they had to have good taste and a lot of money. Aristocrats and artists could be poor."

These days, though, Tamara's own cachet was not what it had once been. As Felipe Ortiz-Monasterio explains, "Cuernavaca is socially a very curious place. I wouldn't say it is dominated by them, but there is a very strong group of Americans and Canadians who spend their time here during the winter, which is one of the 'social scenes,' and when Tamara came here, she sort of . . . not being a part of that scene, she rented some of the houses that these people used to rent out. She knew some of the people they knew, and I understand there was a certain amount of friction, of overlap."

165

She was attracted especially to young people, who responded well to her extravagant manners and to the risqué stories about her youth. Felipe's wife, Gaby, remembers a large party her parents threw for a hundred or so guests, twenty of whom were young people. Her parents had made special arrangements for Tamara, since she was "somewhat of an elder statesman," and had seated her at the main table. "She wouldn't do it," Gaby says. "She refused. She flatly refused, without being rude. And she came and sat with the young people. She said: 'I don't like to sit around with old people. I like to be with young people so I too am young. I am going to sit with the young ones.' "

The Ortiz-Monasterios were just such young people—both from families of prominent Spanish descent. Tamara first met Felipe through his parents in the summer of 1976. At dinner that night, she insisted on sitting next to him and told him that she had decided he should marry her niece. "I don't know if she was a real niece," Ortiz-Monasterio says, "or if she just called her a niece. But she said: 'I have a niece who has lived in Mexico for some years, and you should marry her. She is beautiful. A blonde. You must write her a love letter.' 'But, Baroness,' I said, 'I can hardly think of anything to say.' 'Well,' she said, 'I'll do it for you. I am very good at these things.' So she wrote the letter right there, would not let me read it, and forced me to sign it. And she put it in an envelope and had it sent right away." Actually the niece's

name was Arielle Dombasle. Born in the United States, she grew up in Mexico, and now lives in Paris, where she is becoming well known as an actress.

"Tamara was a woman of this type," Felipe continues. "Impulsive. I guess she had people in the world she liked, and I was lucky to be one of them. And this girl was one of them, and she said, 'You two have to get together.' And it has to happen, period. It has to happen right now, her way." She called him her Mexican banker, because his family runs one of the larger banks in Mexico City, and she came more and more to rely on him to handle her finances, especially the wills she began to write and rewrite in the last few months of her life.

Tamara liked Gaby and approved of Felipe's plan to marry her, despite her "niece."

"She had this thing about touching people," says Felipe. "I remember her feeling Gaby very much and saying, 'Oh, how beautiful you are.' And when she said hello or goodbye to you, she wouldn't hold you by the elbow, she would hold you by the face. A very interesting experience."

She took Gaby under her wing and inserted herself into the wedding arrangements. She wanted to reproduce the effects of her own wedding in St. Petersburg and before she died had started to work on a design for the dress, which would stretch from altar to church door, naturally.

Despite their fondness for her, however, the Ortiz-Monasterios recognized that Tamara was having the effect on some in Cuernavaca that she had had on those in New York and Houston. Some found her overbearing, pretentious.

Says Felipe: "Now, I can't recall anybody saying openly: 'I don't like Tamara,' but there was this, that, or the other. Somebody would comment on her capricious nature or other things, but I never recall anyone openly disliking her."

"Some Americans," adds Gaby, "thought her odd. They called her spoiled, and she *was* spoiled. When she wanted to scream, she would scream, and when she wanted to be nice, she was nice. They didn't like that. They would think she was a little bit too tough and a little bit too hard."

They, like Victor, became fiercely loyal to Tamara.

Tamara saw Victor Contreras often during her last three years. They were not lovers in the usual sense, not simply because he was forty years her junior, but also because they were not so inclined. Nevertheless, there was much of the sensual about their relationship, a mutual aesthetic appreciation of each other not just as artists, but as physical beings, too. They were aware of each other's poise and grace: the effect each made on an always wider audience. They recognized in each other the attempt to be dancers of life as well as masters of a craft.

She would call almost daily and invite him to tea or to one of her soirees. He claimed her socializing was a "biological need," and if he begged off because he was compelled to work, she would invite herself to his studio, where she sat high on a chair, drinking coffee, puffing constantly on one of her ever-present cigarettes, and offering him diffident but insightful and supportive criticism of his work, which she professed to admire greatly. The skylights poured sunshine on her wrinkled but still-elegant face, dramatically emphasizing her huge, strange, glowing, Pacific-blue eyes,

"their basilisk expression" underscored by the dark lines with which she defined the edges. Wisps of gray cigarette smoke snaked upward as she would reach out with her left hand to tap ashes into a beaten tin cup he had once used for brushes, and somehow the gesture seemed elegant. The sunlight glinted off the huge square-cut topaz—d'Annunzio's gift—on the middle finger of her left hand, and the thick gold bracelet studded with a thousand tiny rubies matched the vermillion lacquer of her nails. Then, suddenly, with a flourish she would be gone.

She was off on one of her strolls through town, where the locals watched her as if she were some kind of amazing creature from another planet; or to visit with old friends, many of whom now found themselves confined to what would soon be their deathbeds; or back to Tres Bambus to bully her seven servants in an Italian that they almost but not quite understood, having them prepare for that evening's doings, either a party at her place or one of her young friends', an evening at Las Mañanitas, or dinner with Victor.

She talked to Victor about her past, her art, her philosophy of life, her family, everything.

"The only people who have class, Victor," she would say, "are the little innocent Mexican people. Not us, not the artists, not the intellectuals, not the *nuevos ricos*, certainly not the rich Americans. I hate them. They have only cocktails. They are empty. I have to go back soon from where I came, and every second here is ticking, ticking, and I know I'm reaching the end of my existence, and I don't want to waste time with empty people, Victor."

She would upbraid him for complimenting her clothes: "But I don't like people to flatter my clothes. Why? I tell you. When I was very young, people would say, 'Tamara, you are gorgeous, what beautiful eyes you have, what beautiful hair—oh, you are beautiful.' Now, they say, 'What a beautiful hat, what a beautiful dress, what a beautiful ring,' but they never say, 'How beautiful you are.' The world changes. First they notice you, then they notice your things. So you had better have beautiful things when you grow old."

Occasionally, he would stay the night at Tres Bambus. He remembers the first night in particular, when he could not sleep because he was in a strange place, and he got up very late to take a walk about the grounds. Stars spewed themselves across an indigo sky, and he could see black, black clouds edging the dark mass he knew was the volcano Popocatepetl on the far horizon. The veranda lay in darkness, and the lighted swimming pool winked and glimmered aquamarine in the jasmine-scented night. Over here paper lanterns swung slightly in the breath of wind that rustled the bamboo. Over there they glowed yellow in the pine trees at the border of the garden. And then he saw it.

Around the far corner of the house, a jarring light spilled out from a sliding glass door ten feet high. It was Tamara's bedroom. She moved about, adjusting the canvas slightly on her easel, till she seemed satisfied with the way the light struck her work-in-progress. She paused. In one hand she held a slender, long-handled sable brush, in the other dangled the omnipresent cigarette. She applied a touch of paint, then stepped back, striking a pose in the lighted doorway. It was a soft, black night, Victor

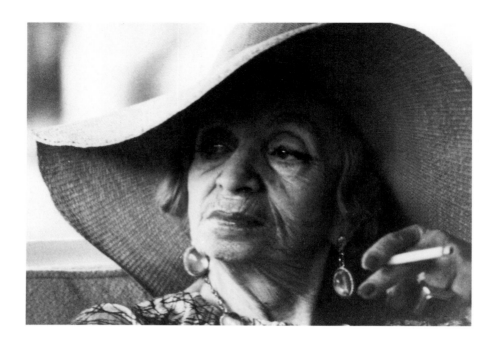

thought, and she is over eighty years old, and it is two o'clock in the morning.

The next morning she seemed reflective, but not tired. Looking out at the volcano, called Popo for short, she smiled and said, "Victor, will you do something for me?"

"What would you like me to do?"

"Say yes or no."

"Okay. Yes."

"I want to ask you something that is very important to me and very serious."

"But go ahead," Victor said. "Ask me. What is it?"

"I am nervous, very nervous. If I die, I want to be cremated, and I want my ashes to be scattered on the Popocatepetl. Would you do that?"

Victor paused, then at length said: "Would you do that for me? I tell you, my dear Tamara, age is not a barrier to death. Death can come for me first, and then what will happen? If I become a little angel with wings, how could I do what you ask?"

She smiled: "What do you say?"

"Listen, change positions. Would you do the same for me?"

"Of course," she said somberly.

In her last year especially, she worried constantly about Kizette. She felt her daughter's loyalty to her husband and her family as a betrayal. She constantly came back to Kizette, how she used to paint her when Kizette was little, when she was sleeping, so enchantingly.

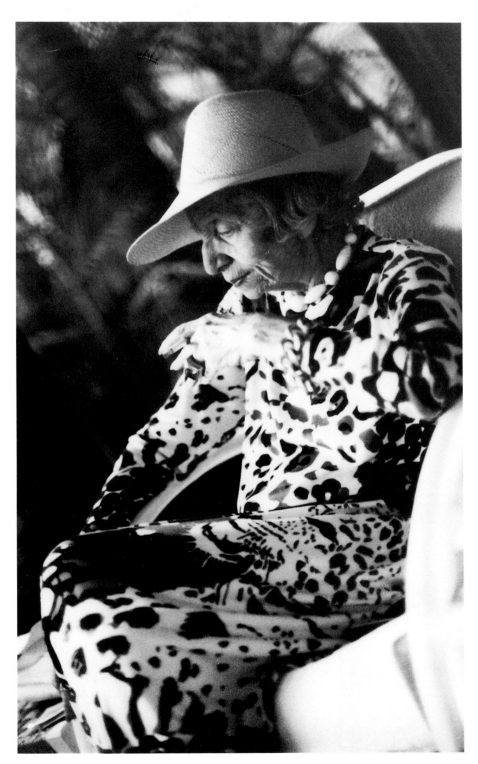

*Tamara at
Tres Bambus.
Cuernavaca,
1979 or 1980.*

"And, Tamara," Victor said, "what about your granddaughters?"

"Well, they are the daughters of my daughter. I only have one daughter. I *did* want to have a son. I wanted it, but life gives me a daughter, and I wanted her to be a writer, and I don't know—"

One day, she turned to him suddenly and said, "You know, Victor Manuel, Kizette is not well."

"Tamara," he said.

"No," she insisted. "She is cuckoo mentally, and I need to find a good psychiatras."

She harped at him until he invited a friend of his to meet them for coffee in a Viennese cafe downtown.

"So," she said, "you are a psychiatras?"

"Yes," Victor's friend smiled, and corrected her pronunciation. "I am a psychiatrist."

She ignored the correction. "Are you a good one?"

"Well, I think so," he said.

"How do you know that?" she asked drolly. "How do you know you are a good psychia*tras?*"

"You can ask my patients."

"Where are your patients?"

"Well, they are not my patients anymore because they are healed."

Tamara laughed. "You are funny. I like you already. My daughter is coming, and I don't want to tell her anything, but I do want you to see how she is because I don't believe she is well mentally."

"Why?" the doctor asked.

"I don't know," she snapped. "You must tell me."

Victor's friend looked at him, and Contreras shrugged his shoulders. Tamara began to explain about Kizette, how bourgeois, how complacent she had become, how she was doing nothing with her life. She mentioned Foxy's illness, and she told him that she had been coming to Cuernavaca with her family for many years. Finally, things had become so strained that she had decided to buy a place in the city and to stay here where she had true friends, like Victor. She complained that her daughter spent all her time with her family, and that, really, Kizette could not cope with the situation, and that she was extremely depressed. Kizette needed to get away, to do something on her own, something worthwhile.

"But it is not you who should worry," the doctor said quietly. "If she is happy with her family, especially in these difficult times, let her be."

"But you don't understand," Tamara insisted. "This is my daughter."

"But what do you want me to do?" the doctor asked.

"Talk to her and find out if she is cuckoo or not cuckoo. Oh, you are not a good psychia*tras,*" she said, dismissing him with a wave of her big hands.

"Baroness Kuffner," he said, "why do you say that?"

"Because you do not understand what I want. You should have known by now. You should understand: I have my reasons."

Soon, Tamara began to talk to Victor about selling Tres Bambus and moving back to Houston.

Victor introduced her to some friends of his who happened to be looking for a place in Cuernavaca, an elegant French diplomat and his rich American wife. He tried to impress on them the fact that they would be meeting a great artist and personality who expected a certain deference and formality, including a formality of dress. Presuming to put Tamara in her place, but—to spite him—the American wife came dressed in blue jeans and high heels, wearing very expensive jewelry. Tamara hated her on sight. As soon as they were introduced, she talked only to the French diplomat, and only in French.

"What an agreeable opportunity to speak good French with someone who really speaks French well," she said. "So, you are the ones who wish to buy my house?"

"Yes, Baroness," said the diplomat, looking at his wife.

Tamara turned to Victor. "Why don't you show the house to Madame," she said. Then to the diplomat: "And you sit here. Would you like a drink? What would you like?" She was oblivious of Victor and the wife, even after they had finished their inspection and returned. She did not offer the woman a drink, but finally asked her:

"Do you like the house?"

"Oh, yes, it is a beautiful house."

"Do you have enough money to buy it?"

"Yes, of course," the wife said, insulted, eyeing Tamara up and down. "But you simply do not have enough bedrooms. I need *six* bedrooms, you see, and you have only *four*."

"No," Tamara said, "you need a hotel. This is just a house. Let's have a drink."

And the subject was closed.

After they left, Tamara announced to Victor that she had changed her plans. She wished to sell the house to him because he was the only one who would appreciate it, and for that reason she would give it to him extremely cheaply. He told her he could not afford it at any price. "Then I will give it to you," she said.

When he objected, she launched a campaign to persuade him to accept. "You are closer to me than my granddaughters, and you need such a place as this. The world will not understand another language. They will give when they know that you have, they will take from you when they know you don't. They will destroy you if they know you don't have anything to give them, but if you do and you do not need them, they will fall at your feet. You need a place such as this, like you need a friend. It will make you seem substantial." In the end, he paid her a nominal price and accepted her gift.

She had sent just the message she wanted to Kizette.

But that was not enough. As her arteries hardened and she lost the energy to command, she began to tinker with her will as a way of exercising control. "In the end," says Ortiz-Monasterio, "she went through several distinct phases, all more or less based on how well things were going with Kizette. One thermometer for her state of mind is that she had this thing about changing wills all the time. She asked me to help, to get all the different wills together in one place, and get a notary to

171

come to the house to witness her signature. She basically did all the wording of the wills, and you can sort of see what her state of mind was by the contents of the will. If Chacha divorced Alexander and ran off to join a sect, and she liked Alexander, out the one went, in with the other. It was her way of controlling reality. I don't know, I must have witnessed at least five or six wills in three years.

"And I don't know how much of her illness was a screen for not facing things, how much of it was real. She would be crying, for instance, and saying that nobody around her loved her and she wanted to die and then in the same breath that the painters had not come and therefore her place was a mess and that the gardener... I mean, complaining and crying and all of that and all of a sudden she would say: 'I have to change the will. Felipe, come to my safe, help me open it, let's get the papers out and let's look at them, because I want to change it and it's got to be done tomorrow. I want this and that changed tomorrow.' And here is this supposedly very ill Tamara walking around with more energy than any common businessman, walking out of her room with all the decisiveness in the world, and there I am in the back, carrying a bunch of documents.

"And it was very depressing. I remember this so distinctly. Here was a woman like Tamara, a great woman, and she was crying, but with no tears. I mean she was literally crying, there was no other way to describe it, but there just were no tears."

The dry tears indicated just how close Tamara was to despair. When a writer and a photographer came to interview her for a book the Japanese publisher Parco planned about her paintings, she told them: "My idea was always the best of the best. Work was not enough. You had to have success. Then you have money. Then you have the best exhibitions, then they get the best newspaper reviews, then you get everything that goes with the best of the best. And that is what we all wanted. I wanted to have the best husband, the nicest house, the best dresses. And in my life I achieved that. Started from nothing, and did everything myself. It gives me satisfaction, you know?

"Now you see me in the most dramatic days of my life. I was never worse than I am now. God was always on my side. God always helped me. But now that I have so many tragic things, I'm thinking, 'Why did God forget me? What did I do that he's punishing me? Why doesn't he help me?' And I don't understand why he is . . . why I am so unhappy now. Alone, here, without my daughter. The husband dying. Everything is bad. Why, why? I'm thinking all the time, 'Why has God . . . abandoned me? What did I do?' He gave me success, he gave me talent, he gave me so many more things than he gave to other people. Why? What did I do, what did I do? I don't understand—why, why? I would like to die—"

As she got worse, she grew suspicious of everyone. She would not discuss Russia with the two women from Parco for fear of reprisals. When Victor introduced her to Mexican president Portillo's sister, she refused to believe him and demanded that the woman prove who she was. Kizette had been shuffling between Cuernavaca and Houston, trying to care for a mother who had suddenly grown desperately ill and a husband who could die any day, when finally she hired a professional nurse to provide twenty-four-hour-a-day care for Tamara.

When Harold Foxhall died in November, Kizette was free to move to Cuernavaca to be with her mother. Tamara lasted three months, three months that Kizette spent sitting next to her in the living room or on the veranda of Tres Bambus, watching the oxygen tanks Tamara used almost constantly now in order to breathe, numbly trying to come to terms with her grief over the loss of her husband and now the imminent threat of losing a mother she had—in spite of everything—adored all her life. Victor came by often, and the two grew close in a somber sort of way. He brought a friend of his, Count Giovanni Agusta, who was young, attractive, and something of a mystic. They prayed with Tamara. That evening she got up for the first time in weeks and sat near the pool between the two young men, talking, joking, laughing. The next night an exhausted Victor left to go home sometime after midnight. When he walked into his house the telephone was ringing. It was Kizette.

"Victor," she said, "come right away."

When Kizette opened the gates of Tres Bambus to admit him, she said with flat despair: "Well, it's finished."

It was March 18, 1980, and Tamara de Lempicka, the Baroness Kuffner, had died in her sleep.

EPILOGUE

"And Kizette said: 'Well, it's finished.' "

Victor Manuel Contreras is talking about the night Tamara de Lempicka died. It is late on a Sunday six years later, and he sits after siesta in the living room of his house, on the grounds of the oldest cathedral in the Americas, a place surrounded by charming gardens walled off from view of the narrow hidden little street he calls home. He designed and built the upper stories himself, but the ground floor has been around since the Spanish first conquered the Aztecs. On the coffee table in front of him sits a magnificent display of calla lilies, arranged just as they appear in a de Lempicka still life.

As he talks, the wind whips up outside and begins to blow through the gardens. The heavy iron handle on the latticed door opening into the living room from the front garden drops down of its own accord, and the door swings back, allowing the wind to flow freely for a while through the room. Contreras smiles. "You know, my house, it is known since the sixteenth century as the haunted house," he says. "I don't know why, but they said there were ghosts. I don't know why, but there are legends about this place because it is of the sixteenth century."

The afternoon has grown dark from the storm, and one of the servants comes in, offers drinks, and switches on a single lamp. No one moves to close the door. Victor continues: "*That* night I embrace Kizette. To my surprise, Kizette was stronger than I thought. I was thinking that I was giving some energy to support Kizette, but I was the one who was morose, no? She was the one that night who handled things in the natural, the logical, the correct way. Later, it will hit her, but now she says: 'Well, it's finished.' And the nurse said, 'Oh, she liked you so much,' and then runs away from Kizette and myself to call the United States.

"I want to see if my parents had already left the house to get to Tres Bambus. It was already late, it was the middle of the night, and I was very anxious, so I go to the phone, and pick it up, and hear the nurse talking to her husband in the United States, and I put the phone down, but I can still hear her in the next room. I listened to the conversation of the nurse. 'Yes. Yes. A few hours ago. I don't know, they have not read the will yet. It will be a few days. I will be there in a few days.' And I hate her, hate the fact of her sitting there beside the body of Tamara, having this conversation,

when she could have it any day after. I could not stand the cold calculation of it. So I ask her to leave the room. I got very angry.

"So my parents arrive, and we are Catholics, and my mother started to pray in front of Tamara's body, and it gets later, later, and the servants come, and Kizette says, 'Well, I am tired. I'm going to bed.' The nurse as well. But I say, 'Who are these gentlemen?' 'Oh, they are the men from the funeral home, who are coming to get the body, because they are going to burn it and give the ashes to Dr. Elizondo,' who used to take care of Tamara. 'But she asked for a Catholic service,' I say. 'And she wanted to have it. And we have to choose a coffin. I don't care if she is going to be cremated. While the ceremony and everything happens in the church and all, she must be in a coffin. I don't want the ushers and all to be there. *She* must be present.'

"And I stayed very strong on that point, and Kizette—she understood. After all this suffering together, we communicate, we agreed in everything. She was very willing to follow everything, probably more or less in some kind of shock, I think. I said, 'This is what your mother wanted, and I want this, and we will do this.' And Kizette said, 'Yes, okay, Victor. Take the body. I let you be in charge.'

"And there we are, my parents and me and the ambulance, how do you say, the station wagon of the funeral area—"

A hearse?

"*Sí*. And there we are with the body. And we go to the place where there is a chapel, where you rent the rooms to give the ceremony, and as we are driving I am looking in front of me at what is left of this great woman, great in so many ways, in so many senses, and I was there, and she was very humble lying on—you know, those . . ." Victor waves his hands. "Like the Red Cross, where you get those—"

A stretcher?

"*Sí*. That was the thing on the floor of the station wagon, and we sit on the floor, too, like little children, and then left this mansion, this Tres Bambus, behind, and there are my parents and myself and the body there. And everything she had now was all she had, like her pajamas, and something like a cover to cover the body, that's all, that's all she took with her. And finally we got to that *place*, not far, maybe three or four blocks—"

The lattice-work door slams shut. "She's gone," Victor says. The wind dies down. As the threat of a storm passes, Victor continues.

"I didn't sleep that night. Neither did my parents. But I send them back here. I said, 'You go, please, and I have to arrange everything here.' So there was Tamara in her coffin. They fix her a little bit. And me alone in the room. With so many souvenirs of Tamara. So many thoughts of my own. Lost in that world of endless confusions. So many questions come into your mind. I am honest with you—I was really very moved. I will be completely honest with you—I could not stop my tears.

"I went out of the chapel to breathe a little bit of air of that night. It was already four or five o'clock that morning. And there I saw a beautiful magnolia tree, that is there like a prisoner. The chapel has enclosed itself around this space where this magnolia has grown so beautifully. There was only one flower. And I had it in my mind to take that flower for Tamara. And then I realize there was somebody watching

me. I felt there was a person. And, when I turned to look, there was the woman who cleaned the place, a humble woman, Indian type, those types that Tamara respected and loved so much, because she used to say they are real people, they are not bourgeois, so they are not *damaged*. So I saw her, and I said: 'I was looking at this beautiful flower. It is beautiful, isn't it?'

" 'Oh, yes. It is the first one, you know. Don't you want a coffee?'

"She wanted to give me something. She was very sorry, felt pity for me: Look at him, he so lonely with his death. I was moved by her tenderness, but I felt the need to be away. I said, 'No, no thank you,' and I went back into the room, thinking, 'Tomorrow, I will try to get that magnolia for her, for my friend who is dead.' And just as I was thinking that, just as I have this in my mind, I saw this little Indian with the magnolia in her hand, saying to me, 'You like it. You can offer it to her.'

"I said, 'Thank you very much.' I did not offer her money, because poor people have something many rich people do not have—dignity. That is more important than money, and you cannot hurt this dignity. I felt great respect for the dignity and kindness and love expressed by this little woman, so I put the magnolia on top of the coffin."

According to Victor, when Kizette arrived at the chapel at noon that next day, the two of them discovered that Tamara had previously made all the arrangements. She had already paid for the church services, the coffin itself, the funeral, and, through her regular doctor, the cremation. They held a brief funeral the next morning, inviting a small number of Tamara's friends, and afterward welcomed others to come pay their respects.

"Then we had to go after the service in the church," he says, "in the afternoon, to Mexico City to cremate the body. And it is not our custom to do that. I tried to persuade Tamara when she was alive not to do it. But she would not accept. I felt terrible doing that. And Kizette did not want to do it. She stayed in the car. She could not handle it, and I understand it.

"So we got to the crematorium in Mexico City, and my friend Count Giovanni— who went with us—was worrying about me. He is a very dear friend, and he said to Kizette, 'Victor is very emotional . . .' And I said, 'Kizette, you must come in. You are responsible.' I had to sign on behalf of Kizette in the funeral papers. So I entered that place, and Giovanni stayed outside with Kizette because it was just one person who had to sign and witness. You have to see the body, how it is going to enter this fireplace, and then they get the ashes on the other side, so you are certain those are her ashes. I mean, one is not ready for that experience. I was not. I was not. I start to see how her feet start to burn into that fire. I can tell you: the worst. It was absolutely terrible.

"It takes some hours for the body to get completely turned to ashes, and when I saw it enter, they said, 'Okay, after so much time you have to come back and see the collection of the ashes.' Well, that's terrible. After some time, we got back, and the ashes would be in a little box—now *I* could not handle it. I mean, *really*. The Count got the ashes in the box.

"And a little later on he tried to give them to Kizette. She did not want to hold them. She wanted to take them to Dr. Elizondo. 'Oh, Kizette,' I said, 'but Tamara didn't want to do that. She asked me personally that we have to go in a helicopter, in a plane, or something, and spread her ashes on Popo. And we have to do it.'

" 'Oh, Victor. You don't. Any place—'

" 'No, we have to do it the way she wanted it.'

" 'When did she tell you that?'

" 'I don't remember. You were not there,' I said. 'Kizette, I hope you believe me. I never lie to you.' (And I never do.) 'Please, believe me,' I said, 'because now I remember, you were not there.'

"Then she: 'How could she say that?'

" 'Maybe because she loved Popocatepetl, and she always painted within sight of it, she was always painting—'

" 'Okay. Then let's do it.'

" 'Giovanni,' I said. 'Your family has helicopters. Could you get a helicopter for us, because we want to do this, because Tamara—' You see, he was my ally in all this. So he says, 'If I have to, I can. I can get it organized and all that.' And Kizette said that she could ask Felipe Ortiz-Monasterio, too. Maybe he could get a helicopter.

"All right," Victor says, pausing. It is nighttime now, and all the lamps are lit. Outside, a chauffeur awaits to take Victor's guest back across town to Tres Bambus. "The magnolia. When we came back from Mexico City with the ashes of Tamara and a little box, we place that little box in the gallery upstairs, where Tamara used to sit. We put it on top of a chest below the beautiful window. When we left the funeral home chapel to go to Mexico City, I told my mother, 'Please keep this magnolia. It has been my only companion in mourning Tamara. I want to keep it. So white, a symbol of pure friendship, please keep it.' So she brought it here, and I told her to put it in the gallery. When we came back, Kizette did not want to keep the ashes in the same house with herself. So I said, 'Tamara had two houses in Cuernavaca, Tres Bambus and the haunted house. Tamara had two houses, so back to the haunted house she goes.'

"We had to follow the Christian services before scattering the ashes. So here in Mexico, it takes nine days "for the crust to rise," as they call it. In other words, to liberate the body. And that nine days we used to go every day, Kizette and I with some American friends and other Mexicans, to the little chapel here to follow the service of the priest and the mass every day. And one day before we left, the nurse was praying in the funeral area, and she saw the magnolia, and she put a rosary on top of it—I think it was Tamara's rosary—and left it there when we went to services. And when we came back here, where the ashes were . . . very strange, the flower had completely closed around the rosary and turned blood red. And that's not all: I said, 'Kizette, how strange how the magnolia is holding like a hand the rosary. And it is like it has blood on it.'

" 'Oh, no,' she says. And then the nurse went to get the rosary away from the flower, and the flower wounds her hand. She had blood in her hand. 'Look what she did.' 'Oh my God.' 'But it has no thorns.' Then Kizette and I, we look up at each

other. We did not understand what happened. The nurse was scared like nobody else I ever saw in my life. Pale.

"Then after that shock, Kizette invited us to have supper in the restaurant downtown, and the nurse went to wash her hands, and the blood will not go away. That was a very strange phenomenon, and it was her right hand, and she said, 'I have wrapped up my hand because I wash and wash and, look, it doesn't go away. How strange. I don't understand.'

"And I was relating in my mind this moment with other moments of confusion and doubt in relation to Tamara's detachment, and I said, 'There is a signal, something has been sent.' And Kizette said, 'How strange. I have seen magnolia trees in Houston, but the flowers never turned red. Have you seen that?'

" 'Never.'

"For some reason, I have kept that magnolia here from that moment. It is here now, and you will see it with your own eyes how it is, the rosary and the magnolia, kept for so many years in the place where I placed it after that night. I told nobody I was going to do that, but I kept it."

When Victor pulls the magnolia from its hiding place in a cabinet containing books, small sculptures and other objets d'art, the flower's huge front leaves are indeed wrapped more or less like a fist around a mahogany-brown rosary. The leaves are a reddish rust color, like dry blood. The back leaves of the blossom, those not touching the rosary, are the drab, faded olive-green of most decaying magnolias.

One begins to think theoretically, to wonder about the anaerobic environment set up between dark, varnished wood and the leaves of a flower as it decomposes. Would something in the wood account for the color? And then, too, one wonders if Victor Manuel Contreras has ever read *Macbeth* or seen it performed. He does not seem conscious of the connection. And then finally one just laughs and thinks cynically: Tamara de Lempicka would love it. It's a story she would want to tell about herself. Even in dying, she yearned for the theatrical.

They had trouble renting the helicopter. Giovanni had to return home to Italy that week, but he promised he would do what he could before he left. Kizette called Ortiz-Monasterio, who had been out of the country when Tamara died but flew back for the funeral, and asked him to help out. After he had made the arrangements, Kizette called back to say Giovanni had come through. A friend of his, a doctor, had agreed to fly them up the volcano in his private helicopter. They were all to meet the next day at the local golf club. Would Felipe and Gaby mind coming along on the flight? She wanted them to be there with her and Victor.

About noon everyone gathered at the Cuernavaca golf club. A foursome putting near the ninth hole looked up, surprised to see the helicopter landing on their green. The two groups eyed each other a little oddly. When everyone was there, Giovanni's friend, the pilot, refused to let them aboard. "We are going very high into strong winds," he said, "and we can take no more than two of you: the Maestro and Señora Kizette. Otherwise, we will be carrying too much weight. Even my copilot will have

to stay down here." And he did, with the Ortiz-Monestarios, Victor's parents, and Tamara's Filipino nurse.

Halfway to the top of Popocatepetl, the wind began to batter them about. The pilot had difficulty keeping a steady ascent. Kizette had been terrified from the beginning. To give her courage, Victor had told Kizette back in Cuernavaca that he had flown in helicopters many times before, and he kept up the pretense, even though it was clear that he, too, was scared to death. Finally, even the pilot could take no more. "I will not fly over the top of the volcano," he told them. "It's simply too dangerous. We'll never get out alive."

"Can you fly us around the rim?" a pale Contreras asked. The pilot agreed. As the helicopter dipped and swerved its way round the sparkling snow-covered rim of Popocatepetl, a bright spring sun glistening off its blades, its plexiglass, its polished metal sides, Victor pulled a satin pouch from the urn and spewed the ashes into the downdrafts that were sweeping the aircraft closer and closer to the volcano itself. Victor did not mean to let the purple pouch go, but he could not hold on to it. He still had the urn in his lap. He looked at Kizette, questioning with his glance, since language was useless in the roar of wind and machine. Kizette nodded her head yes, and he tossed the urn out. They watched it fall toward the dark green treetops far below them.

It was the final gesture in the life of Tamara de Lempicka.

180

A NOTE ON SOURCES

The majority of the biographical information about Tamara de Lempicka comes from extensive interviews with her daughter, Kizette de Lempicka Foxhall and others who knew Tamara, as outlined in the Preface. Kizette also provided me with her mother's autobiographical sketches and various private papers and documents, including several huge scrapbooks kept by the artist herself throughout her life—and by Kizette since her death—of newspaper clippings, biographical pamphlets and other ephemera accompanying exhibitions of Tamara's work, and various magazine articles about her painting, exhibitions, and homes. Among these was a 200-page transcript that Tamara had retained for her own use of several days of conversation in 1979 with two Japanese authors from Parco Press. The de Lempicka bibliography is not yet very extensive. No major scholarly work has appeared, and most of the published material is biographically thin, anecdotal, and often simply inaccurate. Three exceptions deserve note, and on these I have relied heavily.

First, Giancarlo Marmori's biographical essay in the book *Tamara de Lempicka* by Franco Maria Ricci (New York: Rizzoli, 1977) is an excellent introduction to the paintings themselves as well as an accurate, faithful account of Tamara's life from the rather meager resources available to the author. I have used it throughout, but especially in the discussion of Art Deco in Chapter Five and in the description of the effect Tamara had on the press in Chapter Seven. Marmori's essay has reappeared in slightly altered forms in the French magazine *Viva* (August 1978) and in *FMR* #18, American Edition (New York: FMR International, 1986).

Second, the Houston *City Magazine* ran an article by Joanne Harrison in August 1978 called "A Portrait of the Artist," which is quite the best piece of writing yet to appear on Tamara. I have relied on it for Tamara's initial response to the Ricci book in Chapter One and the description of Tamara in Cuernavaca in Chapter Ten. The article also carries a version of several of the anecdotes Tamara recounts about herself in chapters Seven and Eight.

Third, Françoise Gilot wrote a most insightful piece called "Tamara" for the January 1986 issue of *Arts and Antiques,* from which I adapted and expanded the concept of *"the hunger,"* which plays a central role throughout this book.

For information on the Russian Revolution in chapters Two and Three, I used the following sources: John Reed's *Ten Days That Shook the World* (New York, 1935); Marcel Liebman's *The Russian Revolution* (New York: Random House, 1972); and Edward Hallet Carr's *The Bolshevik Revolution, 1917–1923,* vols. I–3 (New York: W.W. Norton & Co., 1978–81).

I found much that was useful concerning Paris in the 1920s and 1930s in *A History of Modern France, Volume 3: 1871–1962* by Alfred Cobban (London and New York: Penguin Books, 1972); *Paris Was Yesterday, 1925–1939* by Janet Flanner, a.k.a. Genêt (London and New York: Penguin Books, 1981); and *Poiret* by Palmer White (New York: Clarkson N. Potter, 1973). For the discussions of Art Deco and of painting in general, I used *20th Century Painters, Volumes I and 2* by Bernard Dorival, translated by W.J. Stracham (Paris: Editions Pierre Tisne, 1958); *Art Deco* by Victor Awas (New York: Harry N. Abrams, 1980); *Art Deco: A Guide for Collectors* by Katherine Morrison McClinton (New York: Clarkson N. Potter, 1972); *The Spirit and Splendor of Art Deco* by Alain Lesieutre (New York: Paddington Press, 1974); *Modern French Painters* by Maurice Raynal, translated by Ralph Roeder (New York: Tudor Publishing, 1928); *French Painting: The Contemporaries* by René Huyghe (Paris: French Library of Fine Arts, 1940); *Ingres* by Walter Pach (New York: Hacker Art Books, 1973); and *Ingres* by Robert Rosenblum (New York: Harry N. Abrams, 1967).

The incidents surrounding Tamara's encounter with d'Annunzio are the best documented of her entire life, and the reconstruction here is built upon several sources. First, Tamara left an autobiographical account of the encounter, which I have followed where possible. At those points where she remains silent, I have filled in from other accounts, and I have pointed out in the text where the accounts differ. I have supplemented her description of her first tour through II Vittoriale with facts about the house taken from a description of a similar tour a year earlier in *D'Annunzio* by Philippe Jullian, translated by Stephen Hardman (London: The Pall Mall Press, 1972). The two descriptions coincide so remarkably that one suspects d'Annunzio of giving basically the same dramatic tour to each of his important guests. The letters and notes passed between d'Annunzio and Tamara surrounding the events are quoted from translations in Ricci's *Tamara de Lempicka,* and many of the incidents themselves are based on "The Journal of Aelis Mazoyer, Gabriele d'Annunzio's Housekeeper (edited by Piero Chiara and Federico Rocoroni)" included in the same book.

The anecdotes throughout are the versions that Tamara told Kizette—more than once. They also appear in several of the sources. Marmori's essay includes two: the intended burning of the Louvre and the eating of the *religieuses,* both of which appear in Chapter Four. Harrison's article contains several, including those two, and Tamara's encounter with the fashion editor of *Die Dame*, the several ways in which she acquired various models for her paintings, and the run-in with a Nazi collector of her paintings. These all appear in chapters Seven and Eight. The story of her talkative model, King Alfonso, appeared in several newspapers a bit after the incident, but one can consult the *New York World Telegram* of May 4, 1939, for the more or less official version of that story.

For Hitler's rise to power, I consulted R. R. Palmer's *History of the Modern World*

182

(New York: Knopf, 1965), and I adapted the phrase "Siren of the Silent Era" from a May 1978, *New York Times Magazine* article: "Siren of a Stylish Era."

For information and background on Hollywood and its Pickfords and Swansons, I used *The American Film Industry*, edited by Tino Balio (Madison: University of Wisconsin Press, 1976); *The Rise of the American Film: A Critical History*, by Lewis Jacobs (New York: Teacher's College Press, 1969); *Spellbound in Darkness: A History of the Silent Film* by George C. Pratt (Greenwich, Conn.: New York Graphic Society, 1973); and *The Films of Gloria Swanson* by Lawrence Quirky (Secaucus, N.J.: Citadel Press, 1984). Tamara's social doings appeared regularly in the Los Angeles newspapers and in the presses of various cities that use them as feeders. The Wickershams, Bill and Ella, writing for the *Los Angeles Examiner*, kept close tabs on her. The party I mention was first described by Ella Wickersham on May 8, 1940, for example, and in his "Hollywood Parade" of August 4, 1942, Bill Wickersham enumerates visitors to Tamara's studio. The story of *Susannah at the Baths* appears in a number of papers, but the *Examiner* carried it on May 9, 1940. Georges-Michel's portrait of Tamara at the end of Chapter Nine comes from his "Une Reine du bizarre" in the 1961 *Chronique d'hier et d'aujourd'hui.*

I have indicated—as unobtrusively as possible—in the text itself the other sources I used, except for Kizette, unless it appeared obvious in a given context where I received my information. Finally, I should say here a word or two about the use of direct quotation marks in the text. When conversations appeared in the written sources or were reported to me as actually having taken place, I did not hesitate to use direct quotes. When it was clear that the source was merely repeating the gist of a conversation, or otherwise paraphrasing, I did not use direct quotes, though I often maintained the conversational tone of the information.

<div align="right">

—C.P.

</div>

189